The Many Masks of Modern Art

Theodore F. Wolff

Art Critic for The Christian Science Monitor®

The Many Masks

of Modern Art

Books from

THE CHRISTIAN SCIENCE MONITOR.

Boston, Massachusetts

The articles in this book originally appeared in *The Christian Science Monitor* from 1980 to 1988.

Book design by Joyce C. Weston, Boston, Massachusetts.
Copyediting and project management by Editorial Services of New England, Inc., Cambridge, Massachusetts.
Editorial assistance and photo permission coordination by Norma Ellman, New York, New York.
Typeset in Bembo by Compset, Inc., Beverly, Massachusetts.
Color separations, signatures and jackets printed by The Nimrod Press Printers and Engravers, Boston, Massachusetts.
Bound by Horowitz/Rae Book Manufacturers, Inc., Fairfield, New Jersey.
Library of Congress Cataloging-in-Publication Data

Wolff, Theodore F.
 The many masks of modern art.

 1. Art, Modern—20th century. I. Title.
N6590.W65 1989 89-23860
ISBN 0-87510-202-6

Contents

Introduction

*T*H E seeds for the essays in this book were planted in the early 1950s when anyone not convinced of the superiority of Abstract Expressionism over every other contemporary form of artistic expression was not deemed worthy of being taken seriously by the art world's powers that be.

They were nourished during the next three decades by frequent encounters with critics, curators, art historians, and artists, each with his or her own narrow vision of art to proclaim and defend, and with nothing but contempt for any style or mode that didn't conform to that ideal.

Throughout the years, fierce partisanship played a dominant role in the museum and gallery worlds. Not only did traditionalists and modernists revile one another, many reserved their choicest epithets for straying members of their own movements. No one was immune. When Philip Gunston, one of Abstract Expressionism's brightest stars, decided in 1969 to switch to a wildly idiosyncratic representational approach, many of his colleagues condemned him publicly for betraying not only art's finest values, but also art itself.

It was with this and many other similar incidents in mind that, in 1980, I offered a suggestion to Henrietta Buckmaster, editor at that time of *The Christian Science Monitor*'s Home Forum page. Our association—and my free-lance affiliation with the *Monitor*—went back to 1977 when I had begun a series of monthly essays on American printmakers. Apparently, reader response had been satisfactory, for within a year I was not only writing more frequently for the Home Forum, but was expanding my coverage to include the full range of 20th century art as well.

My suggestion to Mrs. Buckmaster was simple if somewhat general. Why not run a few articles—a dozen would probably be sufficient—that would focus on what good and great 20th century paintings, sculptures, prints, and drawings of all styles and themes had in common. Articles that would, in short, point out the substantive "common denominators" that underlay genuine works of art—traditional and modernist alike—no matter how wildly different they might appear at first, or how insistent certain critics might be that one particular style, and that one alone, could engender authentic works of art.

Her response was "Let's do it." And so the series, under the title *The Many Masks of Modern Art,* began on May 6, 1980. It ended, not as expected

after a dozen essays, but after 247, on October 24, 1985. It resumed, after a short hiatus and without its title, for a little over a year, ending finally on May 29, 1987.

No one, least of all myself, expected the series to run as long or to garner as much mail as it did. Obviously it had found a sympathetic audience. Readers, as unhappy as I about the art-world cant, narrow-mindedness, and divisiveness, responded with expressions of gratitude as well as of surprise that a major publication would devote so much space and on so regular a basis to a subject so far removed from the daily news.

The letters I received from artists—both well-known and yet to be discovered—were particularly gratifying, as were the declarations of support from art professionals who wished me well in what several described as my "crusade." Many expressed the belief that the time was ripe for such a series, especially since so many art writers appeared as convinced as ever that legitimacy in painting, sculpture, and printmaking could only (and should only) be conferred by a handful of self-appointed, "right-thinking" art experts serving as tastemakers. A few even went so far as to suggest that the art world hadn't improved, that things were as bad as they'd ever been in the past thirty years.

I disagreed, and in my answering letters, pointed out how much worse things had been in the 1950s and 60s. In particular, I reminded them of the large number of painters and sculptors—even printmakers—of that time who had been summarily dismissed as nonartists (even, almost, as nonpersons), by influential critics, curators, and dealers, primarily for working in styles perceived as not falling within what was then rather worshipfully referred to as "the mainstream" of American art.

But, I added, even if things weren't as bad as before, they were still bad enough.

What most concerned me was the cavalier manner in which entire categories of artists were still simply not recognized as serious creative figures. Or, for that matter, as entirely legitimate ones. Landscape painters, in particular, were regularly ignored by the critics—unless, of course, their work reflected the style or approach of such generally accepted landscapists as Neil Welliver or Jane Freilicher. True enough, such painters could, at the time my series began, find solid, reputable galleries in which to show their work (something that would have been nearly impossible in the 1950s and 60s). Important "mainstream" galleries, however, were still closed to them. And when it came to major museum exhibitions of outstanding new talent, they somehow never managed to be included, or, if by some fluke they

were, to have their work purchased for the sponsoring museum's permanent collection.

But not only landscapists suffered from the art world's narrow definitions of what was and was not to be taken seriously as art. In 1980, etchers, engravers, and lithographers who preferred to shape concrete images within the traditional disciplines of their craft rather than to "experiment" endlessly with methods and techniques (or to make brightly colored reproductive versions of their paintings), still found themselves categorically excluded from all too many major print exhibitions. And figurative painters, while increasingly tolerated since the mid-1970s, still had to walk an extremely narrow line between lingering post-World War II prejudices against representationalism of any kind and Minimalist-inspired taboos against formal and thematic "excesses" if their work was to be looked at seriously, let alone accepted as "valid" or genuine.

The art world, in short, while it may have become noticeably less narrow by 1980, still tended, much too often, to judge the art of the day by externals, by the particular fashionable style it affected or the clever manner in which it claimed to be new, original, or significant.

At a time when Americans were beginning to take pride in their ability to see beyond race, nationality, and religion in their dealings with their fellow men and women, they were still looking at art with surprisingly innocent or prejudiced eyes. Did a peculiar-looking abstraction in a small gallery have the same "look" as certain accredited modernist masterpieces in New York's Museum of Modern Art? It did? Well then, it must be a "real" work of art. On the other hand, many Americans who subscribed to the better art magazines knew enough not to admire Andrew Wyeth's paintings (no matter how they might secretly have liked them), for it had been made very clear to them by any number of critics that Wyeth was not to be taken seriously. Not only was he a sentimentalist and a ruralist, he painted in a "regressive" realist manner that automatically deprived him of any right to be called an artist in this day and age.

Confronted by this state of affairs, serious art lovers couldn't help but wonder what had become of commitment to quality and to critical objectivity, to the insistence on seeing rather than on merely looking, to the judicious balancing of knowledge, sensibility, open-mindedness, and experience that had always been considered crucial to any genuine critical or appreciative approach to art.

Those qualities were still present, of course, but not often enough where they were most needed: at the higher echelons of the gallery world;

among the most spectacularly successful and influential of the newer dealers and collectors; and among the increasingly powerful museum curators whose approval or disapproval could significantly advance or impede the careers of younger artists.

This then, was the situation of the art world when I initiated *The Many Masks of Modern Art* in 1980, and the way it's been, with a few improvements here and there, since that time. Tolerance has grown, if not so much for the other person's ideas and modes of expression, then at least for his or her right to be called a serious artist. Critical writing also tends to be somewhat less dogmatic and exclusionary, quite possibly because most readers simply won't put up with the harshly judgmental, even pontifical, attitudes assumed by a number of critics a decade ago. And probably most significant of all—because the galleries and what's shown in them constitute the backbone of today's art world—dealers are now more inclined to show work representing a wide variety of styles rather than to concentrate on art that reflects one particular point of view.

On the other hand, a few art-world issues and problems have either arisen for the first time during the last decade, or have recently become more serious. Auction prices, especially for heavily publicized works of Impressionist, Post-Impressionist, and modern masters, have jumped to astronomical levels. No matter how one looks at it, spending $53.9 million for a second-rate Van Gogh and $17.05 million for a Jasper Johns is nothing short of madness. Couple that with the trendy collecting habits of many of the newer, blatantly socially ambitious art buyers of the 1980s, and one begins to understand the public's growing perception of art as the latest and most fashionable plaything of the upwardly mobile and the very rich.

There's also the issue of hype, which becomes more of a problem every year, and which beclouds so much of today's writing on art that it's often difficult or impossible to determine where objective, independent critical opinion ends and subsidized puffery begins. All this wouldn't be so serious, of course, if hype weren't so capable of invading and polluting responsible writing on art. Or if more readers could, or cared to, distinguish the one kind of writing from the other.

I had been mulling over these matters for quite a while when I was approached about the possibility of publishing fifty or so of my *Many Masks of Modern Art* essays in book form. It seemed like a good idea, especially since a few of those essays were written as recently as one or two years ago, and the older ones were essentially as relevant today as they had been in 1980 or 1981.

Choosing fifty-six essays from almost three hundred was no easy task. Since my original selection of artists had included both the very famous and the unknown—and almost every level of recognition in between—I felt my much shorter list should reflect that range as well. But most important, I wanted the book version to reflect as great a diversity of styles and creative attitudes as the original *Christian Science Monitor* series.

I also decided to resist the temptation to edit my earlier writings, and to leave them as originally published—except, of course, for errors of fact or grammar. In a few instances, pictorial substitutions were made, either because color reproductions of the black-and-white art work used in the series were not available, or because other examples by the same artists seemed more appropriate for a book format.

The essays follow essentially the same sequence they did in the *Monitor*. Most are from the series' early years when I was still defining the issues and clarifying ideas, rather than from its later period when quite a number of the essays could perhaps best be described as "variations on a theme." And I've included the piece that drew the largest reader response: "Face to Face" describes my thoughts and feelings while studying a rediscovered self-portrait sketched by me in 1942 at the age of sixteen. It was published on December 4, 1986.

Finally, I dedicate this book to Henrietta Buckmaster, without whose vision and encouragement the essays contained here would not have been written.

Theodore F. Wolff

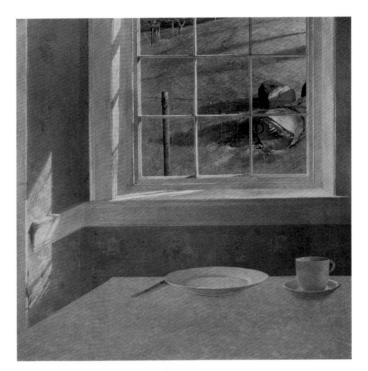

Andrew Wyeth
Ground Hog Day

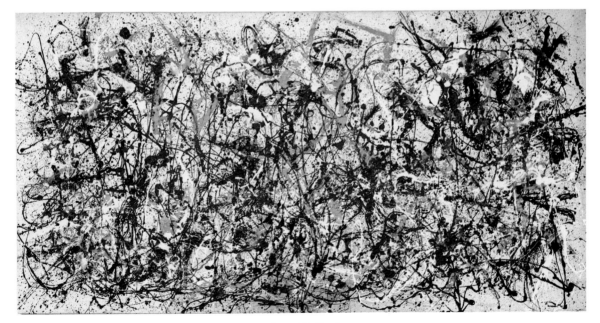

Jackson Pollock
Autumn Rhythm, 1950

20th Century Art—
Introducing a Broader View

I'D love to be their guide, should Rembrandt, Michelangelo, and Cézanne ever return to this world for a day of museum and gallery viewing.

What would they think of Picasso and Matisse? Of Klee, Mondrian, and Miró? How would I explain Jackson Pollock to them? Or Pop, Op, Hard Edge, Minimal, or Conceptual art? What would be their reaction to the photo-realists, Calder's mobiles, or David Smith's stainless-steel constructions?

Would they accept Wyeth and Hopper? Diego Rivera? Or Benton, Grosz, Dali, and Moore? Would they have the vaguest notion of what Beuys is trying to do?

I suspect they would be confused and upset. Perhaps not Cézanne so much because he would recognize his influence in much of what they had seen, but Rembrandt, I think, would be depressed, and Michelangelo would most certainly fly into a rage.

Such reactions would not be surprising considering how foreign this art would be to them. But what *is* surprising is how many of us living in this century feel the same way about much of this art even though it was created by and for us. Although we accept one or another of its schools or styles we generally reject the rest — and usually with anger and contempt.

How sad to view art so narrowly and to feel that one must take sides in its appreciation! To prefer one kind of art over another is one thing, but then to condemn the rest is to make a mockery out of art. We still fail to see that art's function is less to please and lend support than to give evidence of a greater order, that its role is to extend our perception of the nature and function of life.

Art is the sworn enemy of fragmentation and of any philosophy that sees life as a collection of bits and pieces. Nothing is ever created which is not instantly in dynamic dialogue with everything else, and every work of art militates against categories, compartments, and the bottomless pits into which we otherwise place those who disagree with us. Every work of art illuminates a tiny facet of the whole, and is as crucial as any other.

Nothing about 20th century art is as disturbing as its warring factions, its schisms and its accusations of heresy and illegitimacy. The battle for modernism is far from over as long as large segments of our population continue to maintain that something is art only if it approximates the appearance of physical reality, or if it follows the strict rules of tradition. And the battle for reason in art is not over as long as representational art is considered regressive or irrelevant by its very nature.

It is time we gave legitimacy to the term "20th century art" by expanding it to include the full range of art produced in our century — barring only such works designed specifically to flatter us or to demean our sensibilities. Or are we so fearful of contamination from art not acceptable to our peers that we prefer blinders to the pleasures and insights such art might give us? Are we going to remain the prisoners of prejudice as was the collector of very "advanced" art who, at the end of an appraisal of his abstract paintings, apologetically hauled an Andrew Wyeth watercolor from his closet? It is valuable, he said, and should be insured, but could it be put on a separate list? He had bought it recently on impulse and liked it very much, but he feared his friends' ridicule should they hear of it.

Andrew Wyeth and Jackson Pollock. Those names alone make my point! We are so programmed to think that the first is our most wonderful artist and the second our most reprehensible — or vice versa — that we fail to examine them seriously as painters.

I am disturbed by this division of the art world into "good guys" and "bad guys." If the distinction were based on quality it would make sense, but predicating it upon stylistic affiliation doesn't — unless we accept the notion that everything of artistic value is contained within one tradition or that the nature of art is such that it must follow one path and one path only.

Since I can't accept either premise, it occurred to me that writing some essays detailing alternative points of view might be in order. These I envision as gentle and informative, and designed to help make the art of our age a little more accessible without in any way demeaning or oversimplifying it.

My intention is to remain nonpartisan within the framework of a passionate concern for art. The only "bad guys" flushed out into the open will be those who violate the principles of art for sensationalism, publicity, or monetary gain. Other than that, the only issues at stake will be honesty, integrity, talent, and good faith. That, and the ability to see the other person's point of view.

The Full Diversity of Art

F O R a brief moment when I first saw the painting reproduced on page 5, I thought it was an abstract painting.

But then, in a flash, I recognized a ladder, the top of a second ladder, a section of rope, and a patch of sky. It all fell into place. What appeared to be an abstract image suddenly became the inside of an old building — probably a steeple — with ladders running up to a skylight.

Over the next few weeks I showed the photograph to several friends. With one exception they all saw it first as an abstraction. Those whose tastes ran toward nonfigurative and abstract art tossed the photograph aside as of no interest once they realized it had an identifiable subject, and those who preferred their art to resemble the world around them sat up and took notice only after realizing the image in the photograph was not abstract.

How odd! The picture remained exactly the same, and yet our willingness to take it seriously changed dramatically with our perception of its pictorial frame of reference. It was of interest and possibly good only if it belonged to the category of visualization we accepted as art.

What happened in the split second we realized the image was not abstract, that it was actually a rough pictorial transcription of something the artist had seen?

For one thing, we broke the picture's code. We grasped the point of its shapes and tones and recognized the specific reality from which the image derived. For another, our personal memory banks raced to see if this kind of image corresponded to our definitions and feelings about art. If it did, machinery was activated, buttons were pushed, and we responded with approval and acceptance. If not, the image was rejected and discarded as irrelevant.

For a split second we were exactly like a computer being asked a question. Depending on our programming, we responded with a "yes" or a "no." It's that programming which concerns me. Too few of us — art professionals included — are careful about how we organize what we put into that portion of our "computer" labeled "art." Possibly we don't care and haven't questioned our attitudes toward art in years, or perhaps we have built philosophies and theories of art upon such narrow premises — traditional or modern — that we can only react positively to something that fits very precise and narrow specifications.

Of these two positions, the second disturbs me more because it often results in the arrogant dismissal of everything not in line with a particular style or point of view.

We must break ourselves of this age-old notion that a culture or society can find expression in only one artistic style. The days of neat national and stylistic distinctions are over. In this open and increasingly interconnected age, it is more appropriate that a Wyeth watercolor, a Shahn painting, an Albers print, and a piece of conceptual art share space than that any one be held as a true representation of this century and the others as false representations.

I can't help but feel that Andrew Wyeth and Jasper Johns have more in common than Wyeth has with his uncritical followers or Johns has with his. Art is art, and it comes about when highly sensitive and alert creative spirits engage totally in the realities, issues, ideas, and forms of their time. Art is unique human identity given symbolic form. And that form, by its very nature, cannot be predicted. Art can be large or small, major or minor, but it cannot be better or worse. Do we despise flowers because they are not as tall as trees? Or trees because they are not as colorful as flowers?

Neither should we judge art by one standard. Art is as diverse as the plant and animal kingdoms, and has its own rare orchids and common garden grasses, its exotic jungle beasts and domesticated household pets. All we can really do is perceive how true and consistent a work is to its own species. Beyond that we enter the area of the imponderables: how do we compare, let alone judge, the relative qualities of a moose and a rabbit, a pine tree and a weeping willow?

Art pops up wherever and whenever it is needed or wanted. But it follows its own laws. Just as one would not expect moss to grow in a desert, or cactus in a rain forest, one cannot expect the indigenous art of one region or culture to resemble that of another. And yet we persist in the notion that there must be one true style of art for all.

It's not that simple.

Twentieth century art is like a huge tree. It grows, and so must push beyond itself. That is a creative act. But is the twig that extends the highest necessarily the most creative? Or the truest? What would we think of the person who claimed that only the highest twigs and the deepest roots of a tree were important?

I would think about him as I do about the person who tells me that only the most advanced and experimental art of our day is important, that

Andrew Wyeth
Study for Toll Rope

all the rest is irrelevant. Or as I would about the person who tells me that something can only be art if it makes a mountain look like a mountain on canvas, or makes grandpa look like himself in stone.

Awakening to a Deeper Consciousness

*E*DVARD Munch's *The Cry* is the soul-cry of our age: its cry of alienation, anxiety, dread and horror. The cry heard in no man's land in World War I, in Guernica, Buchenwald, Hiroshima, Vietnam, and Cambodia. In Harlem and Siberia, in our prisons, hospitals, and mental institutions. In "me first" and indifference to others. In despair in the middle of the night, and in casual theft and destruction.

It is the cry of an age desperate to be born — but dreading where that birth might lead. . .

What an extraordinary age this has been! And what extraordinary art it has produced! In sheer complexity, innovation, and profusion, no previous age can match it.

And yet there is something odd and unsettling about it. It is restless and self-absorbed. Instead of looking outward, it looks inward. It seems unsure of its identity, even, at times, uncertain what makes it tick.

Today's art is multifaceted and hard to define. A great deal of it is diagnostic. It pokes and probes. It x-rays. It schematizes and improvises. At times it bubbles over with laughter, at others it is calm and serious.

But whatever form it takes or mood it expresses, all the art of our time has one thing in common: a profound awareness of Munch's reverberating cry.

I don't mean that all artists took their cue from this work; rather, that its emotional content is so central and crucial to our time that anyone truly aware of this century's realities has heard and responded to it.

I can't help but feel that what differentiates our age from those of the past is that in this one we have been rudely awakened in the darkest hour of the night, and are sitting up with a wildly beating heart listening intently for

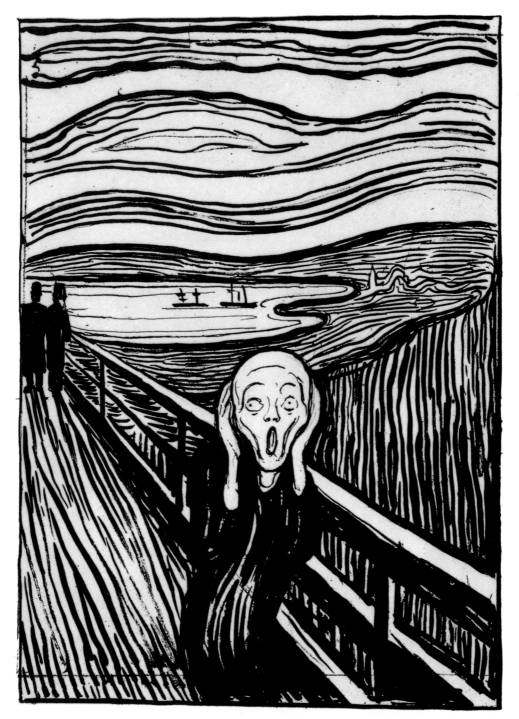

Edvard Munch
The Cry, 1896

something both within ourselves and without. It is that awakening to something sensed rather than heard that tempts some to seek refuge in absolutism, totalitarianism, indifference, sensationalism, and even oblivion.

This anxiety and disquiet will not go away until we understand and face up to what causes it, until we establish a more positive attitude in the face of this erosion of identity. Art, because of its intuitive and prescient nature, and because it is now free to probe into the deepest recesses of human consciousness, is ideally suited for this process of self recognition and reaffirmation.

Every work of art is a symbol, a metaphor, something drawn from and yet running parallel to our everyday reality. Like a dream, art both reveals and conceals — and leaves it up to us to decipher its clues. But of what earthly good — except for diversion, entertainment, or decoration — is art if it doesn't grasp the nature of our age? If it doesn't attend to the dilemmas that threaten to tear us apart? Or try at least symbolically to resolve our yearnings and our feelings of impermanence?

Many of us are so caught up in our daily routines that we gloss over the void that exists at the center of our culture. We improvise daily hoping that no crisis will erupt to upset our neatly balanced house of cards.

But the art of today will have none of that. Brutally or gently, it presents us with symbols reflecting the full range of human experience. It may tease like Klee and Miró, tantalize like Matisse and Calder, challenge like Orozco and Kline, confront like Picasso, Nolde, Dix, or Kollwitz, exult like Pollock and Still, monumentalize like Braque and Moore, or schematize like Albers or Mondrian. It may present us with a bittersweet evocation of a simpler life like Wyeth, or project a subjective vision of the improbable like Ernst, but whatever its form, it exists in direct response to the heartbeat, hopes, and dreams of 20th century man.

Munch was the first to sense and to give voice to this cry for 20th century identity. My first glimpse of *The Cry* many years ago was one of recognition. Here indeed was a voice of the age. And the more I considered it, the more convinced I became that it was the dividing line between 19th and 20th century art.

Just as one doesn't need to swim until one is in the water, so art did not have to open itself up, try so hard to define itself, improvise so desperately, push so hard against its technical and conceptual frontiers — all and everything the 20th century has done — until that cry informed the universe that the rawest of demands had been touched; that man was once again in desperate need to know who he was and where he was going.

Munch's cry announced man's awakening to a deeper consciousness, and gave voice to the amazement that followed that awakening. Once that cry was heard, the 19th century was no more.

He also gave voice to our dismay at discovering that our snug little boat of perpetual progress was adrift. And that, sink or swim, drift or find a destination, it was up to us to accept our dilemma and to chart a fresh course.

Art is a language, a highly oblique one I'll admit, but a language nevertheless. And so we should look first for its "message," the quality, idea or attitude it was created to articulate and project, before we check it out for orthodoxy of style, faithfulness to tradition, or brilliance of technique.

I, for one, would rather have a clumsy messenger who stammers, but who has something of value to impart, than an elegantly dressed courier with lovely manners and beautiful speech who has little or nothing to say. Some centuries are fortunate enough to have both. We apparently are not. But the point is that we are living in *this* century and not another.

Morality and the Art of Georges Rouault

*P*ROBABLY the most interesting response I've had to this series so far was a telephone call from an angry reader who insisted that I was very wrong in claiming that morality had a place in art — and who then proceeded to list the contemporary artists whose work had suffered the most from what he called "moral contamination."

It was a fascinating list. Kollwitz, of course, headed it, with Rouault, Beckmann, Kline, Giacometti, and Bacon following close behind. Picasso was also included (for *Guernica*, I suppose), as well as Nolde, Kokoschka, and Orozco. By the time my caller had finished, he had dismissed fully two thirds of the major art of this century as impure and contaminated, and had only given his approval - with a few exceptions including Braque and Matisse — to art that was totally abstract, essentially decorative, or light-heartedly representational.

I tried to argue that Mondrian (whom he made a big point of applauding as our most important modern master) was one of the great moralists of 20th century art, but he was having none of it. "No," he said, "Mondrian always managed to keep himself above morality."

Since the ability to keep oneself "above" morality is beyond my comprehension, I stopped arguing and let the conversation dribble to a halt. I even allowed my caller the last word, which was: "Rouault was a disgrace to French art, especially to the tradition of Monet and Cézanne."

Once I had cooled down, I began to consider the nature of his list and what it implied. What struck me first was that every one of the artists on it put passion before perfection, and that those who headed it made conscience a primary condition of their art.

Of them all, Rouault has fared least well these past 25 years. From being considered one of the six or seven major painters of this century, and a great graphic artist, he has sunk to where he is now considered only one of a dozen or so better French painters of his period, and one of its major printmakers.

While prices for his paintings have slowly increased over the years, they do not begin to compare with the astronomical figures his major contemporaries now command. Even his prints fare only moderately well.

And yet he was a superb painter, an important printmaker, and one of the very small handful of artists to have made a genuine contribution to the art of the book.

When we add to that the fact that he was the most profoundly religious artist to have appeared in Western art in a long while (I personally would say since Rembrandt), we must shake our heads in disbelief that he should be so relatively ignored.

But the reason is actually quite obvious — and my telephone caller put it squarely on the line — Rouault, of all major 20th century painters, is the most "contaminated" by morality. Only Kollwitz has a "worse" record, but the fact that she was primarily a printmaker puts her into a separate category.

The problem with Rouault is that he demands passionate participation. We can't just sit back and enjoy his work for its color or design, or even for its subject matter, for all these qualities are so irrevocably meshed with his profoundly moral vision of reality that to study them for only a moment is to be drawn totally into his way of seeing things.

Rouault's art is a crucible within which human foibles and sufferings are transmuted through creative passion into glowing, gem-like, and lumi-

nously interior pictorial manifestations of the redemptive and regenerative power of love.

In that crucible, molten images of pain and anguish are introduced to help awaken our compassion and our conscience, never to shock or dismay — and certainly never to seduce. Rouault was probably the least playful of contemporary artists, the least likely to amuse. But what he may have lacked in lightness of heart, he more than made up in compassionate love and spiritual fervor.

Like lava and diamonds, a Rouault painting was fashioned under the most intense pressure and at extreme white heat — although in this case the pressure was creative and the heat was emotional and visionary.

And because it was created under this pressure and at this heat, Rouault's art can withstand most everyday stresses and strains, and can serve as a source of moral support and sustenance for those of us to whom art speaks deeply and truly.

That is, it can if we let it.

My telephone caller obviously wouldn't, or at least he resented that so large a degree of participation was required of him. And he is not alone.

For roughly 25 years we have preferred art from which most living passion and concern has been drained or burned away and which has remained cool, detached, and antiseptic. We called it everything from Pop art to Minimalism to Photo-Realism, but while it may all have looked different on the outside, it was much the same inside: clever, vacuous, and zombie-like. Only an occasional artist here and there was able to transcend style and create art.

Although much of that was probably a reaction to the intense and often heavy-handed emotionalism of Abstract Expressionism, I think an even more important reason was the overwhelmingly complex nature of our space age, and our preference for art that codifies its realities rather than intensifies them.

I remember vividly the eagerness with which my friends and I awaited the first art to come out of Germany immediately after World War II. The country of the Expressionists, we felt, would undoubtedly produce such extraordinary images of war and its effects as to put Goya and Picasso to shame. But what appeared was only mildly decorative and watered-down 1930s abstraction. The horrors of war were obviously too close to be turned into art.

I suspect much the same thing has been true of late. We have been so numbed trying to comprehend clusters of apparently contradictory realities

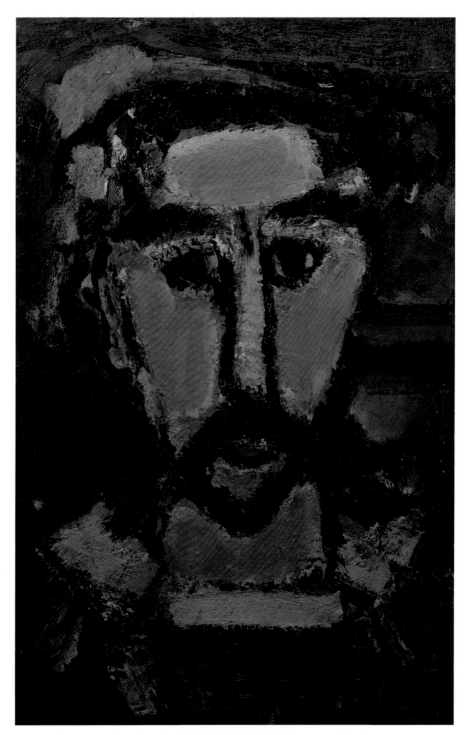

12

Georges Rouault
L'Homme du Cirque, 1936

that our art has been hard put to fashion anything that is more than skin deep. And after more than two decades of skimming the surface, a part of us prefers even now to keep it that way.

But I don't for a minute believe that our hunger for deeper nourishment has diminished. If anything, judging from the fact that our museums are busier than ever, and from the even more exciting fact that the gallery world is bursting with rich new talent, we want this nourishment more than ever.

We won't get it, however, as long as we insist that art remain clinically antiseptic and smilingly serene, and deny that morality and spirituality also have their proper place in art.

The Question of Identity in 20th Century Art

*T*HERE is a tendency on the part of certain artists to sweep the darker side of life under the rug — and then decorate the rug with beautiful designs.

Not so Alberto Giacometti, whose subject matter is human existence painted and sculpted as simply, starkly, and fully as he himself experienced it.

Unlike Edvard Munch, who cried out to the heavens in dread over his deepening awareness of human frailty, Giacometti calmly accepts his.

Munch asked, "Without God, can there be man?"

Giacometti asks, "Without God, who is man?"

And asks it without anger, petulance, or fear. Asks it simply as the primary question in his search for self.

Giacometti is one of the very small handful of major 20th century artists whose art is predicated on the questions "Who am I, and where am I going?"

And who risks everything to find out.

I must admit that I am heavily prejudiced in favor of this kind of artist, the kind who not only doesn't sweep the dark side of life under the

rug, but who also pulls the rug back to see what lies hidden underneath, and then tosses it aside to get to the business of cleaning it up.

But these artists are hard to find. And for the simple reason that altogether too many artists, once they have peeked under the rug, spend the rest of their lives playing with what they find rather than confronting it and turning it into art.

In many ways this is understandable. Freudian theory and dogma made it very clear in the early decades of this century that what was under the rug should be brought out into the open. And Surrealism, coming on the scene about the same time, insisted that painting this material as it was exposed to the light was the new and primary mission of art.

It was a doctrine hard to resist, for it gave license to the idiosyncratic and gave birth to the notion that the artist who had direct symbolic access to his unconscious was in many ways semi-divine. Viewed in this light, the artist who attempted to impose rational values upon this raw material, or tried to shape it according to reasonable goals, was guilty of trying to subvert the truth of unconscious inspiration. Hadn't human will, the argument went, already done enough to stifle genuine creativity?

Small wonder, then, that so many artists were perfectly content to play with or at most rearrange attractively what they found under the rug. The assumed near-sanctity of the unconscious made any tampering with its symbols, forms, or environments something very close to sacrilege.

The trouble with this uncritical compliance with Surrealist theory was that it tended to create a formal universe hermetically sealed off from human reality. A universe within which everything was everlastingly still, arid, and alien and where art tended more toward the visually exotic than to the emotionally and spiritually relevant.

What Surrealism did have going for it was a profound sense of what this century had lost when it turned its back upon the past. Its aching voids and endless spaces reflected our cultural homesickness for greater and more monumental times. Surrealism, of all the major art movements of the 20th century, remembered what it was like to be great. Its tragedy was that its monuments were artificial ones constructed from the rubble of what had been torn down — and that its space was the void previously occupied by powerful beliefs and powerful gods.

Giacometti was a Surrealist until 1935, when his views and those of the movement began to differ — and he was "officially" expelled. This break had been precipitated by his renewed interest in working from life and by his increasing fascination with the processes of perception.

No longer satisfied with the inventive and emotionally detached games played under the protective canopy of Surrealist dogma, Giacometti turned to grappling with the nature and the act of seeing.

This opened the whole question of the optical phenomenon of reality — the relationship between a figure and its enveloping space, the relationship of man to the void and of being to nothingness. At the same time, he claimed to have little or no interest in the philosophical or metaphysical implications of these questions, claimed only to be interested in the dynamics of perception, in the aesthetic application of these questions to his art.

And there is no reason to doubt him, for he was an artist before all else, and so to him life's most profound questions could only engage him through the realities and the issues of art.

This is something too little understood by the general public. To a profound extent, an artist *is* his art, his craft, his medium. Art is not merely something he uses to clarify his position or to give point to his vision of life, but is, rather, the very substance of who he is and what he wants to say.

Paint squeezed onto a palette by Van Gogh underwent a profound transformation as it encountered his sensibilities and then burst onto the canvas as a living part of that artist's creativity. The same was true of the more monumental Cézanne, the more delicate Lautrec, and the more exuberant Matisse. Each of them became a bit more himself by the externalization and projection of a portion of his creative identity onto canvas.

The same was true of Giacometti. By struggling with the problem of what he actually saw of a figure within enveloping space, he was also struggling with the problem of who he was within his enveloping universe.

Now I realize I am on dangerous ground, that neither Giacometti's writings nor his recorded interviews substantiate such a statement. But I have what I think is irrefutable evidence for my position. And that is the work itself, the thousands of drawings, paintings, and sculptures Giacometti produced from 1935 on.

If ever there was evidence of soul-searching, it is here in these stark, direct, frontal studies of humanity within a totally 20th century space predicated both upon Surrealist void and Cubist structure. *Diego* is a good example. It is about as typical a piece from his hand as one can find, and it literally begs the question of identity.

"Who am I?" it asks, "embedded as I am in the middle of 20th century perceptual and philosophical realities — and where am I going?"

These questions are asked with infinite patience, and without shouting or crying out.

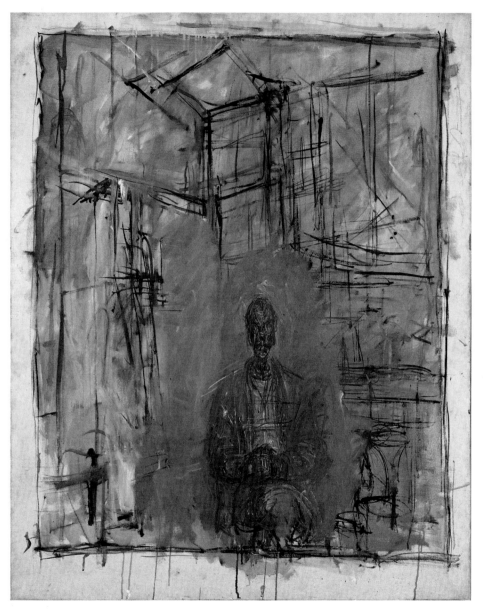

Alberto Giacometti
Diego, 1953

The painting itself is the questions, the questions Giacometti asked
over and over again, day after day, as he confronted the evidence before him.
He never found the answers, but his questions remain among the most pro-
found and disquieting ones of our century.

The Narrow Thread of Humanism in Modern Art

HUMAN dignity and courage have found no greater voice in this century than in the art of Käthe Kollwitz.

If Edvard Munch's *The Cry* is the soul-cry of our time, the cry of an age desperate to be born but dreading where that birth might lead, then Kollwitz's images of human vulnerability and grandeur are our silent reminder that all fears must be faced, and that man is responsible for his fate.

Certain works of art in this century have struck bedrock — and have held fast, permitting us to anchor our perceptions of ourselves and of our time upon the insights transmitted through these works. One thinks of Picasso, Matisse, Brancusi, Braque, Mondrian, and Pollock, each of whom fashioned at least one such work.

Also central to our time is the art resulting from fishing expeditions into the unknown. This art is created by individuals who cast their sensibilities and skills — even their identities — into dark, uncharted waters, and then reel in little hints and clues of what lies hidden in the form of lively and exotic paintings and sculpture. Klee, Miró, Ernst, and Calder spring to mind here.

And then there is the art that puts human emotion and experience before formal concept, dogma, or style, the art designed to gain our complicity in matters of social, spiritual, and political concern.

Although many of these artists tend to be a bit hysterical and two-dimensional, there are a few who care deeply enough for what moves them to seek out and to gain access to the deepest and most mysterious areas of human creativity. And, once there, to learn how to fashion their anguish, rage, concern, or evangelical fervor into art of extraordinary clarity and effectiveness. Rouault, Beckmann, and Grosz belong here.

Käthe Kollwitz was another of this very small band. To her, art was inexorably bound to compassion. And yet she took the art of making art very seriously. If forced to choose between compassion and art she would have said that that would be like choosing between being human and being a woman. But she was almost alone in feeling that way. Twentieth century art has had a difficult time with the human side of its identity. It looks in the mirror and tends to see something other than what is there.

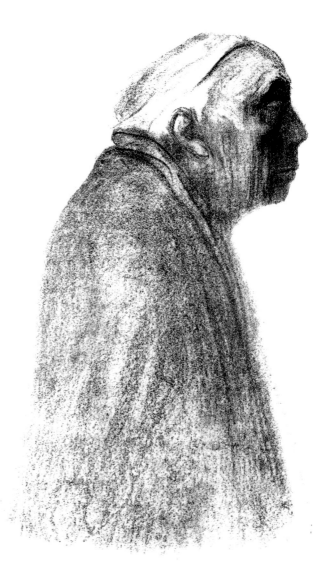

Käthe Kollwitz
Self-Portrait in Profile Facing Right, 1938

This century's art has committed the vast bulk of its creative resources to tremendous voyages of exploration and discovery. Most of our important artists spend their entire lifetimes exploring not only the planets and galaxies of the future and of alternative universes, but also the possibility that 2 and 2 are 3, and that reality is never what we see but always what we know.

Of these, Picasso was our most important. He was our Columbus, Sir Francis Drake, and Prodigal Son all rolled into one, a swashbuckling genius who always sent home greater treasures than we could ever have imagined.

But there were others who felt restless at home. Mondrian took to his tower to chart the infinite and the absolute. Chagall flew back to childhood. Dali went fishing for exotic creatures of the deep. Giacometti went off to try to bring identity into focus. Pollock pushed forward into uncharted country and found a new continent. Bacon extended himself to the borders of reason; and Reinhardt waited in the darkest night for the first flush of dawn.

No matter where one looked, art was either probing or digging, sailing off or opening up. No sooner had something new from a previously unexplored region been hung up to be admired, than it was overshadowed by something even more strange and wonderful. Viewing art soon became much like watching a fireworks display: great fun as long as the colorful bursts topped one another, but terribly dull once the peak had been reached.

During all this time Kollwitz saw no reason to leave home. There was more than enough material for her art where she lived. Since art was a social and moral imperative for her much more than it was a philosophical, aesthetic, or spiritual ideal, she had only to look around her to see what needed to be done.

And what needed to be done was obvious. There was human suffering to be reconciled with human promise; reality to be faced and accepted; death, whose meaning had to be proved; and life, whose joys and pleasures had to be celebrated.

She tackled them all in numerous drawings and prints, and in a few pieces of sculpture. While the rest of 20th century art was exploding all around her, she kept right on searching for the most telling and provocative gestures and images with which to give form and expression to the compassion and love she felt within her.

She cared passionately, not only as a woman, but also as an artist. Although there are those who claim she doesn't belong in the pantheon of authentic 20th century artists because she put the human before the formal, the face before the mask, to deny such a place to her reflects discredit upon the art of our time rather than upon Kollwitz.

Her art carried a heavy burden of responsibility. Not only did she want it to move us deeply, she also wanted it to heal and to reconcile, to give some measure of meaning to what it had stirred within us. That the formal aspects of her art are concerned with shaping the profoundly known (rather than the as-yet-not-known), the ideal, or the magical, has nothing to do with the quality or the importance of her work, unless we insist that 20th century art is by definition limited to these latter categories.

Kollwitz was a talent rather than a genius. But then so were Mondrian and Rothko, who increasingly and deservedly have earned our respect. Without the element of genius, all art becomes a matter of opinion, dedication, and integrity. The difference between a Mondrian and a Kollwitz is the difference between areas of concern rather than degrees of truth. They, and all artists of integrity and talent, reveal moments of reality rather than an overall vision of it.

And yet there are times when an artist of talent has a glimpse of the totality, a burst of genius. Such moments are rare, but their existence cannot be denied. They can come late in life, at the beginning of a career, or any place between.

Munch's *The Cry* was such a moment. And, much later and much more quietly, so was Kollwitz's last self-portrait.

Severing the Umbilical Cord

MUCH of the art of this century deals with reduction and elimination, and conjures up an image of a man taking apart a boat in the middle of the ocean in order to determine the minimum support he requires to stay afloat.

Or an image of a writer trying to distill all he knows into one perfect sentence with which to begin his book.

But then there is the art that *begins* with nothing and invents its identity and form as it goes along.

Laszlo Moholy-Nagy created such art. On a blank piece of paper or on a bare canvas — and with nothing but a clearly worked out formal image in mind — he produced works that bear absolutely no resemblance to anything else on earth.

And yet he began as a realist with strong expressionistic overtones. Some of his early drawings rival Schiele and Kokoschka in characterization and effectiveness. But he gave it all up, completely changed his style and point of view, and spent the rest of his life creating geometric images.

20

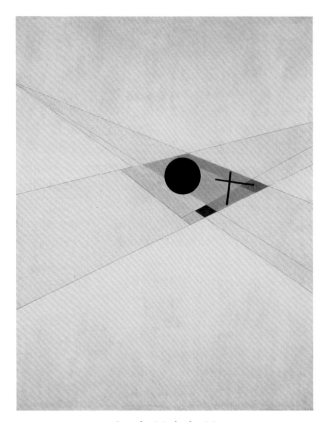

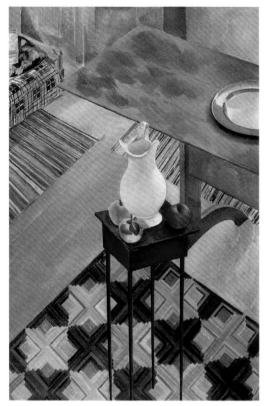

Laszlo Moholy-Nagy
AXL II, 1927

Charles Sheeler
Interior, 1926

He switched because he wanted to enter the mainstream of 20th century art. To his mind, the painting of our age — thanks to the discoveries of Cubism — was freeing itself once and for all from the tyranny of physical reality and appearance, and no longer required validation on the basis of its resemblance to, or derivation from, natural objects or events.

He felt, in other words, that art could begin with a line drawn on canvas and that it could, by its freedom from resemblances and approximations, create a whole new reality and identity for itself in areas never before entered by painting or sculpture. As he saw it, art was entering a new age and needed a new language and vocabulary to give it form.

Charles Sheeler, an American contemporary of Moholy-Nagy, saw things very differently. Although he too was greatly influenced by Cubism — as well as by Constructivism — and was also very anxious to create art of cultural significance, he could never quite rid himself of the notion that

art began in reality. And not only in the reality of the mind and spirit, but in the reality encountered through sight, touch, and smell.

And so, much as he admired the revolutionary formalists, he could not do as Moholy-Nagy did and break completely with his past. Even his most abstract-looking early paintings are so drenched in naturalistic associations that one immediately senses and perceives the landscape or still life from which the picture was derived. All lines, shapes, forms, textures, and colors in his art had their point of origin in the everyday world.

And yet, Sheeler built his paintings from the ground up much the way Moholy-Nagy did. Nothing was left to chance, everything was planned and ordered with almost mathematical precision.

This quality of precision is apparent in the paintings by these two artists reproduced on page 21. And these pictures have even more in common. The focal point of each — the black circle in the Moholy-Nagy, the white pitcher in the Sheeler — lies just slightly to the right and above the center of the composition.

Both these forms sit at the apex of a triangle whose base is the bottom edge of the picture. The slightly leaning cross-like shape to the right of Moholy-Nagy's black circle is a modified version of the table leg and its brace in the Sheeler. And the subtle sense of upward-right movement from the lower-left corner, which both works share, is emphasized in the Moholy-Nagy by the darkened right corner of the central rectangle, and in the Sheeler by the sweep of the curved portion of the table leg. One could even make the point that the mouth of the pitcher — which creates a roughly circular form — and the black circle are the hubs of their respective compositions.

And yet, for all that, the differences between the two paintings far outweigh their similarities. For one thing, the Sheeler is rich in associations. We don't just see the painting, we are flooded by memories and feelings triggered by what we see *in* the painting: by our memories and feelings about comfortable, old-fashioned rooms, handsome checkered rugs, elegant antique furniture, possibly someone we loved who once had a room like this. We may even remember that our own white pitcher needs mending.

Depending on our interest in the formal aspects of art, we may or may not also be aware of how exquisitely everything in the painting has been arranged, how beautifully the various rug and couch patterns play against one another, how perfectly the plate on the table balances the couch and anchors various movements. And how delicately the curved table leg completes a highly complex series of thrusts into space.

22

If we are aware of these things, a period of adjustment between small tensions and balances takes place. The associative elements are weighed against the formal. And since Sheeler *was* an artist, and was able to steer a central course between both realities, the end result of the viewing experience is a wonderful feeling of completeness, harmony, and balance.

Moholy-Nagy, on the other hand, would have declared all such associations irrelevant to today's art and would have claimed that they created a form of dependency upon memory and fact that interfered with the viewer's full appreciation of the art of painting.

And he would have added that what he and others like him had tried to do was to destroy this dependency once and for all by severing the historical umbilical cord between nature and art.

The Sheeler represents a centuries-old tradition, which includes Vermeer, Chardin, and Cézanne. He has updated it by modifying it in the light of 20th century formal discoveries and attitudes, but it is solidly traditional nonetheless.

The Moholy-Nagy, on the other hand, represents a new beginning. His tentative ventures beyond the historical borders of painting have resulted in few dramatic changes in our overall perception of art. Except as teacher and catalyst, his influence has been minimal. And yet he represents the tradition of art in this century that feels it must push forward and beyond at all costs.

What interests me most of all is how well Sheeler looks today even though he was, in 20th century terms, a conservative. And how serene Moholy-Nagy looks today, even though he was a revolutionary.

Focusing on the Irreducible

WE identify an art through its craft, savor its character through its style, and gauge its significance through its form.

Style expresses a point of view. It can be elegant, animated, turgid, lyrical, cramped, drab, etc. It tells us about the artist's attitudes toward himself and toward the world, and reflects how he wants to be seen, how he postures, and how blatant or seductive he can be.

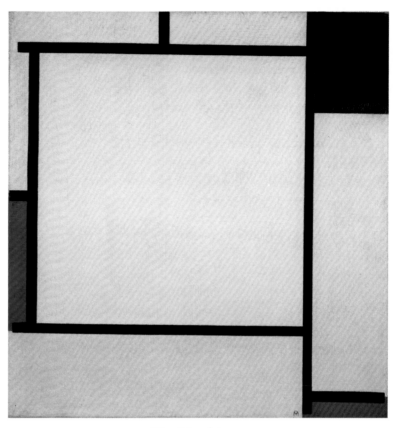

Piet Mondrian
Composition 2, 1922

Form, on the other hand, is the artist's verdict on reality, his deepest and firmest decision on the meaning and nature of life. It represents his perception of the point of stability between the momentum of self and the realities of others, and reflects his insight into laws and circumstances *beyond* his own. It is an act of transcendence over passion, and his recognition of the need for resolutions and reconciliation.

Two of this century's most dedicated advocates of art as form were Piet Mondrian and Edward Hopper. Both artists distilled and compressed their vision of reality into the most compact of images, and were ruthless in the elimination of everything in their art that didn't contribute to the most emphatic articulation of that vision.

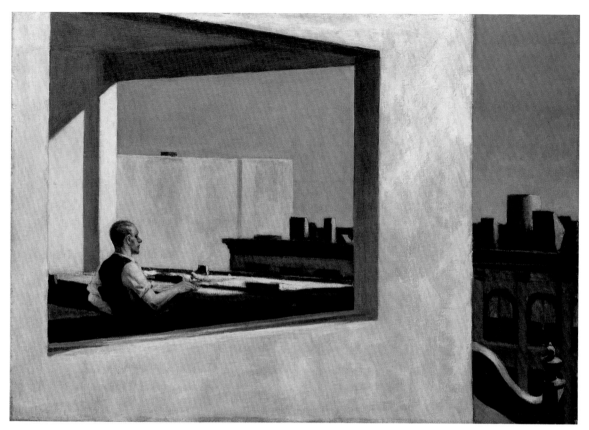

Edward Hopper
Office in a Small City, 1953

But while both focused intensively on the irreducible, they disagreed violently on what it was.

Of the two, Mondrian was by far the more puristic and absolute. He boiled his art down to the very minimum and divorced it from any association with the appearances of physical reality. It could be said that the basic difference between Mondrian and Hopper was the difference between seeing the sun as a perfect circle and seeing it as round and hot. Or the difference between seeing grass as green and seeing it as green and growing. To Mondrian, the way the world looked had nothing to do with art. He was willing to risk censure and ridicule in order to free painting from the tyranny of illusion. He threw all of his eggs into the basket of formal reduction.

25

And indeed, that is how Mondrian's critics do perceive him: as an artist overly concerned about codifying reality, as too involved in painting the skeleton of life to see its flesh-and-blood humanity.

Art, these critics remind us, has to do with man, for man shapes and forges it, draws enjoyment and meaning from it. It is his cultural litmus paper, weather vane, compass, and lightning rod all rolled into one.

But what, they ask, do Mondrian's three or four intersecting lines and his few touches of color have to do with man and his realities? Can one feel uplifted by looking at them? Or delighted? Or comforted?

No, they say, and so his paintings cannot be art. We recognize neither ourselves nor our world in them.

They feel divorced from Mondrian's art, incapable of identifying or empathizing with it. Its perfection and finality block any attempts to enter into creative dialogue with it.

They feel art should be vulnerable, should reflect something of man's imperfections and questionings. They are more than willing to give over to art, but first must feel that its formal resolutions are relevant to, and drawn from, man's fears, loves, and expectations.

They prefer that art's beauty, wholeness, even its unique kind of perfection, come about within the sensibilities of the viewer, and not be spelled out too precisely on the canvas. A painting should suggest perfection, not attempt to paint it, or the viewer is deprived of his chance to experience the formulation of such "perfection" in himself.

A work of art, then, exists to trigger a response or a quality in the viewer. To attempt to paint that quality itself is to paint only its idea.

That, they claim, is all Mondrian did, and so what he produced was not art.

Hopper, however, was to them another matter. He invited everyone into his canvases and into his inner feelings. We know exactly where we stand with him. We recognize his anxieties, doubts, and hopes as our own, and so are respectful and impressed by the way his art gives them formal significance.

Hopper's pictorial form is the outward manifestation of his attitude toward life. It tells us that aloneness is the central human condition, and that man's salvation and greatness can only come about by confronting and surmounting the pain of that loneliness. But it must be done with fortitude and equanimity.

That vision of human reality and of human courage is the irreducible element in Hopper's art. Every shape, line, tone, and color in his work con-

tributes to it. Even the quality of light for which he was famous has its roots in the desire to create an atmosphere of clarity. The wide windows, large expanses of buildings, and the sunlit surfaces in *Office in a Small City* all do their bit to establish this painting's haunting sense. But they also give dignity and serenity to the scene by the sensitive way they have been fashioned and composed.

By applying all his skills and sensibilities to the creation of an image that stabilizes and transcends human alienation, Hopper permits us to share with him some of the elements of his personal dignity and courage.

Mondrian saw things very differently. To him the irreducible was the intersection of vertical and horizontal lines and the primary colors. To him these simple means signified the division of life into its fundamental oppositions, and thus served as the basis for an art of spiritual truth. To him art staked out new frontiers and established guidelines for the extension of the human spirit.

Mondrian risked everything — he had been an extremely good realistic painter — to chart new ground. If the art of today is seen as a growing tree, Mondrian was one of its highest and most extended twigs.

Hopper, on the other hand, was a bit further down. A solid branch, perhaps, or a portion of the trunk. He wasn't aiming for the sky, but he was helping to nourish those who were.

The Influence of Dogma in American Art

I can remember walking into John Steuart Curry's Madison, Wisconsin, studio around 1940 and seeing his large and recently completed oil study of *John Brown* on a low easel.

I remember most vividly how proud he was of his accomplishments in breaking new ground for American art with his painting *Baptism in Kansas*, which the critics claimed had brought art back to American soil. Not that he was the least bit arrogant about it. It was just that it was taken for granted by a large segment of the American public that Curry, Thomas Hart

Benton, and Grant Wood had arrived at the style and the point of view that would finally guarantee the future greatness of American art.

But that was not to be. Within a few short years Curry and Wood were gone, and Benton was left to fight the good fight all by himself. Regionalism, the art movement that believed that American art could only truly be art if it represented the face and the manners of America and that had seemed like the grand beginning of something new, had turned out to be the last brave flickering of something old.

By 1950, the American art world had changed dramatically. With the American Scene movement and Midwestern Regionalism discredited, and with European post-World War II art incapable of immediately regaining its prewar prominence, New York became the art capital of the world. To be more precise, it began to resemble medieval Rome insofar as it rapidly became not only the seat of artistic power and influence but also the seat of dogma for that all-powerful movement known as Abstract Expressionism.

For sheer arrogance of attitude in matters pertaining to art, and for pure dogmatic self-assurance on issues of creative theory, I doubt that there has ever been another period like 1952–58 in American art. The "truth" about art was finally known — and whole generations of figurative and old-line nonobjective painters became nonpersons as far as the art world was concerned. Careers ended abruptly or were thwarted for no other reason than that the artists concerned were content to continue painting as they always had. Even such major and recently acknowledged figures as Edward Hopper and Charles Burchfield were put into limbo or became little more than this country's tolerated but token representational painters.

In one sense, this housecleaning was a good thing, because it removed from our museums some of the worst paintings this country has ever seen. (I'm not speaking categorically here about any movement or tradition, but of individual artists of various stylistic persuasions whose work simply didn't measure up.) On the other hand — and this far outweighed its benefits — this arrogant housecleaning proceeded to contaminate a great deal of what art and its creation was all about.

One began to get the distinct impression in the late 1950s that conformity to the prevailing style or styles was all that mattered in art, and that the only reason artists painted or sculpted was to be accredited as true believers. An art career, for anyone hoping to be taken seriously, became as precarious a matter as tightrope walking: one slip, one error in judgment, one word of appreciation for an artist condemned to professional oblivion, and the aspiring artist could be disgraced and his future work ignored.

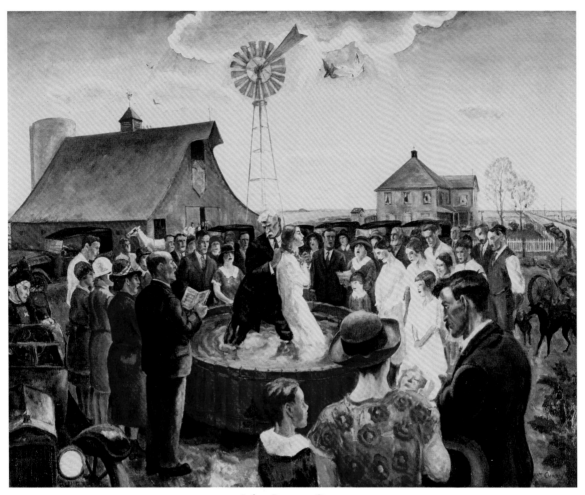

John Steuart Curry
Baptism in Kansas, 1928

Three or four important art magazines became the actual source of creative and career information for thousands of young artists throughout the country. A teenage painter might learn how to stretch canvas and how to mix paint from an art instructor in his local art school, but he learned from his favorite art magazines the really important things such as: which were the recognized galleries, which dealers had the most influence, which art writers were willing to look at art in studios, which collectors were be-

ginning to support which new movements, and which art words were "in" and which were "out."

One could drop into any art school in San Francisco, Seattle, or Madison, Wisconsin, and hear exactly the same art patter, the same secondhand and recently read ideas, and the same notion that all that mattered was to have a Whitney or a Modern Museum exhibition by the time one was 35.

Doing the *correct* thing rather than the *right* thing became the order of the day. A young artist quickly learned to attune himself to what the highly sophisticated and easily bored art world wanted, or learned to exist as a nonperson as far as that art world was concerned.

From 1956 on, I watched generation after generation of talented youngsters stamping into New York to exchange their special uniqueness for the increasingly empty and shrill manifestations of orthodoxy and peer approval. It was, to put it mildly, a depressing sight.

But then, around 1976, things slowly began to change. A measure of good sense — even an element of fun — began to return to the art world. The trend-watchers decried it as a return to rampant eclecticism, as a betrayal of noble ideals, as evidence of creative decay and cultural mediocrity.

What disturbed them then, and now, is the absence, after almost 50 years, of the bandwagon mentality that dominated our country's art from the time that Curry, Benton, and Wood led us to believe that future artistic greatness was finally assured. To that generation, this style or movement or philosophy had found its truth: that we must all climb aboard the bandwagon or be left behind.

I think — I certainly hope — that we have left this simplistic notion of art behind us once and for all. And that we can continue to go down New York's Madison Avenue, across 57th Street, and throughout SoHo and NoHo, and see an endless variety of art. The quality is seldom first-rate, but was it ever? Who says quality must come from conformity to an ideal and not from within the artist's special uniqueness?

For the first time in my memory, American art is not dominated by one or another set of powerful leaders, by all-powerful trend-setters, or by clearly defined and closely observed rules and dogmas on the true nature of art. For once we seem to understand that, while a master artist can inspire, agitate, and help a youngster to find himself, he cannot pass on to him through word or dogma what the secret of art is, for the simple reason that neither he nor anyone else really knows.

30

State of the Arts: Confused, Contradictory, Healthy

EXCEPT for kittens, clowns, and babies, no subjects are more dangerous for an artist to tackle in this day and age than sailboats, seagulls and lighthouses.

To attempt to draw or paint any of these is to risk one's credibility as a serious artist. And for good reasons. All too often pictures of such subjects are nothing but transparent attempts to seduce our sympathies by appealing directly to our more sentimental and less critical natures, to subvert our ability to judge a work of art objectively by calling upon our love for furry kittens or white sailboats against blue skies.

It's a low trick and one that works altogether too well. But we have learned to protect ourselves by becoming suspicious of paintings with so-called popular subjects. The only trouble is that such a reaction has made it too easy to go to the other extreme and to declare that pictures of sailboats and lighthouses cannot be art *because* they portray such popular subjects.

Now that's a simplistic solution that denies the viewer the responsibility to make his own reasoned judgment on the merit of a particular work of art. It permits him to decide negatively on the basis of subject matter alone.

Simplistic, perhaps, but far from unusual. As a matter of fact, it is a central fact of life for a large number of artists working today whose art all too frequently suffers rejection on the basis of style or subject matter.

Our century has produced hundreds of such artists. Unwilling to climb aboard the bandwagon of modernism which, despite all statements to the contrary, has been the fashionable route to success during most of this century, and, at the same time, unable to give their allegiance to the dead tradition of academic realism, these artists are forced to hammer a personal art out of raw experience, observation, and whatever traditional skills and themes they feel still apply to an art indigenous to our day and age.

Above all, these artists are pragmatists who deal only in what they know, can see or touch, or have experienced. They deal in hard evidence and are as far from the true believers of modernism as one can imagine.

Stow Wengenroth
The October Afternoon, 1964

Confronted with a Motherwell, they see only blobs of paint, and with a Klee, nothing but childish scrawls.

But while they may be derisive about modernism, they take themselves and their art very seriously. As a whole they are truly dedicated to the notion of creative integrity regardless of where it may lead — which for most of them means a limited following, a minimum of financial rewards, and no serious critical recognition whatsoever.

I've known a number of these artists over the years and have a hearty respect for them and for their work. Of them all, one stands out, both for the quality of his art and for the genuine humility he displayed toward that art.

Stow Wengenroth represents the very best of the conservative American tradition of lyrical naturalism, and occupies a position in the graphic arts very similar to that occupied by Andrew Wyeth in painting. Both artists represent that quality in our natural temperament that will never feel truly at home in an urban community.

Wengenroth is this country's master of black and white. No one else was able to orchestrate gradations of greys against areas of blacks and whites as well as he, and always within ordinary forest scenes, coastal views, or whatever other bit of local landscape he decided to turn into art. He was the ultimate master at hiding all traces of the scaffolding upon which he erected his compositions. His entire art was directed at drawing our attention to the natural wonders that had enchanted him.

Remarkable as he is, he is not unique. Artists sharing his point of view can be found everywhere. Although great pride is taken today in the fact that art exhibitions, held in cities throughout the United States, are as sophisticated and "in" as any in New York, it is actually more extraordinary that working in these same communities are artists of all ages, whose only creative interests lie in transforming their personal experiences and their knowledge of local landscape or customs into art of truth and integrity — without any concern about what is going on in the art centers of the world.

I cannot imagine anything worse than a nation of artists taking their cues from what is shown along a few blocks of galleries in New York. But I felt quite differently at one time. I felt that with the dramatic emergence of Abstract Expressionism after World War II, we were finally about to rid ourselves of the confusions and contradictions rampant in American art between the two world wars. That our art was finally about to gain some measure of clarity and consistency.

Well, nothing much has happened. Or perhaps I should say that little was clarified and that little consistency has appeared. We have had some truly remarkable art these last 40 years, but things seem as confused and as contradictory today as they did in 1947.

I've come to the conclusion that that is how it should be, that any notion of a universal style of art for us is utterly naive and simplistic. It is, in fact, anti-life and anti-art to wish for such a thing.

I've come to the conclusion that art is and should be as rich and varied as humanity itself, for there is room in it for all types of temperaments, points of view, and subject matter.

And this brings me right back to Stow Wengenroth and to hundreds of other conservative artists of talent and integrity who devoted their lives to portraying what they saw and knew.

Translating the Principles of Nature

I'VE been convinced for some time now that Alexander Calder never made any of his mobiles or stabiles, that he went for a walk one day many years ago in one of our wilder forests and stumbled upon a clearing in which mobiles and stabiles were growing in rich profusion. And that he quietly brought some out — and then went back for more every time his supply ran low.

How else can one explain the uniqueness, the logic, the working perfection of these fabulous objects? No, they're not the creations of an artist's mind and sensibilities, but a separate and special species of nature discovered by Calder while out on a walk.

Imagination and fantasy aside, that is pretty much what these constructions of steel, aluminum, wire, and wood actually are. They have an identity that is complete and final, and yet they resemble absolutely nothing else in life. They move, they enchant, and they delight — and are as real and as intact as anything else in the world around us.

What better proof do we need to accept the fact that Calder, probably

Alexander Calder
Red Lily Pads, 1956

more than any other artist of this century, was totally and intimately in dialogue with nature? That nature told him what to do, and that he did it? And that, by taking the impulses and insights sent his way and translating them into art, he produced works that not only celebrate life but clue us in to some of life's universal principles as well?

Modernism takes great pride in its independence, but often has the most difficult time choosing between an arbitrary independence and one predicated upon full compliance with the principles of life. Without the need to validate its identity by conforming to the outward appearances of nature, art today is free either to will its identity into formal existence, or to discover its identity by responding to and translating complex sets of impulses and intuitions into shapes, colors, and materials.

Both methods can produce art and both can produce attractive but empty decoration. Nothing is more crucial to modernism — and to art in general — than understanding which creative factors lead to art and which others lead to pointless doodlings and impressive but empty facades.

It is one of the seeming paradoxes of life that a four-year-old child can create a primitive form of art by scribbling for a few minutes with crayons, and that an intelligent and highly skilled adult will often produce an empty and lifeless painting or sculpture after days and weeks of intense and serious effort.

But if one thinks about it for a moment, there is nothing paradoxical about it.

A four-year-old child can turn on an electric switch and flood a room with light, while an adult — even one with an advanced academic degree — can sit in darkness in a corner of that room for the rest of his life trying to invent light out of thin air.

It doesn't matter if we turn on a switch, strike a match, wait for the dawn, or rub two sticks together; in order to have light we must adapt ourselves to its principles or be content to remain in the dark.

Art is like that too. We can tap it, but we can't force it.

That is a simple rule, and yet is seldom understood or accepted.

Art is, above all, packaged life, energy, and vitality. The artist is the packager, the transmitter of that life — never the originator. It is he who senses how and where the life he carries will take form. It is he who senses where the obstacles are least fierce — and where life as art can crash through and find expression and form.

The object of art is to carry life forward, and it will do so regardless of how odd or trivial the form it takes might seem. If the times aren't right

for a Michelangelo or a Cézanne, art will find its voice in the dribblings of a Jackson Pollock or the dipping and moving wires and pieces of tin of a Calder.

And, if the times aren't right for a Michelangelo or a Cézanne, no amount of energy expended sculpting or painting like them will be of any avail.

The great lesson of Calder is that he found himself as an artist by following and respecting his intuitions. He is like the man in his garden at night who senses precisely where a firefly will flash even though it is pitch black — and who moves to that exact spot with an open glass jar.

An exhibition of Calder's art is as lively as a roomful of happy children. And yet this can be deceptive. Although these mobiles and stabiles may have a childlike quality, they are the product of a man who also had the shrewd and magical talents of a Merlin.

Each piece is a miracle of exquisite adjustments and precise placements, of the perfect combination of detail and broad, sweeping line, of delicious wit and elegant curve. It is crucial that a particular work have six disks rather than five or seven, and that a thin chain supporting a floating red shape consist of nine links rather than eight.

Everything counts in a Calder, and is there for a particular reason — although that reason may be difficult to put into words. He didn't copy nature or transcribe it literally, but caught the patterns, rhythms, balances, and movements made by the elements of nature. We may not find trees in his art, but we find the movements made by trees and tall grasses in the wind. We may not find people, animals, birds, or fish, but we will find shapes and forms swaying, dipping, and moving about that are like personages in their own special way. And we will find such things as moving curves and colorful objects in such perfect balance with one another that they activate and stir vague and fugitive memories of infinite beauty within us.

Even if Calder didn't find his mobiles and stabiles in a wild forest, he also certainly didn't *make* them. At the most he helped them find their own identities, and he did that by refusing to force either his materials or his sensibilities into other than natural directions, and by listening very closely to what nature had to say.

Paul Klee: Letting Spirit and Intuition Take Over

*T*HERE is something about the art of Paul Klee that makes us want to laugh and cry at the same time.

Perhaps it is its combination of joviality and vulnerability, its perfect fusion of the outrageous and the tender, its affectionate regard for the silliness of mankind that makes us feel this way.

Or it could be the simple delight it takes in the way certain colors leap into life on certain kinds of paper, the way a scratchy ink line can meander like a stream through fields of blue-green, the way a little black arrow can indicate tragedy for a place or person in a lovely watercolor no more than five inches high.

Whatever it is, it is present in every one of Klee's works. Even his most exquisite and colorful paintings pulsate with subtle reminders of the infinitely fragile preciousness of life.

No other 20th century artist has been as alert as Klee to life's most fugitive and delicate nuances and vibrations. The scope of his creative sensibility is staggering. And what makes it all the more remarkable is that his capacity for formal invention matches it.

He was one of those rare artists who could experience life in terms of color, shape, line, or texture. No twig could snap but that he saw it as a jagged, lacerated line — or as two browns ripped apart by black. No bird could fly but that he saw it as a cascade of varying blues, or as a swooping white line against a red field. Ideas were translated into linear and coloristic structures as quickly as they appeared. Or, and this must not be forgotten, lines or smudges of color could alert his memory to something he had seen, and he would transform these lines and colors into images of the sea, or deep, dark woods, or into a fantastic zoological garden.

For Klee, creative impulses derived as readily from his craft and medium as from nature. He was as likely to fashion a picture out of what was triggered in his imagination by the interaction of certain colors as out of what he had seen or felt. He was open to any and all possibilities, and ready to snap up and use everything life offered him as raw material for his art.

A large part of Klee's focus was on beginnings, on the first tentative rustlings and stirrings of life as it made its way toward physical realization.

Paul Klee
Dance You Monster to My Soft Song!, 1922

He was particularly adept at catching the quirky hesitancies of young life pushing its way clear of obstacles and deterrents, at tracing the meandering path life took between the earthly brackets of birth and death.

There is an extraordinary regenerative quality to Klee's art. It renews itself much as a spring of clear water does, and probably for the same reason: it remains close to and in direct contact with the deep sources of its being.

I've always had the odd feeling about Klee's work that he planted the seeds of each drawing or painting when he first touched ink or paint to paper, and that, having done so, he let the spirit of the picture and his own intuitions take over. His images grew as naturally as bean sprouts and little furry creatures. Having come to life, they then sat back and waited to be named.

The titles of his works, often as not, did pop into his head some time after the pictures themselves were finished. And what titles they are! *Senile Phoenix*, *War Destroying the Country*, *Death for the Idea*, *Laughing Gothic*, *Temple of the Sect of the Green Horn*, *Nightflutterer's Dance*, *The Mount of the Sacred Cat*, *Message of the Air Spirit*, *The Limits of Reason*, *Portrait of a Complicated Person*, *Child Consecrated to Suffering*, *Lady Demon*, *Sailboats Rocking*, etc., etc.

And, of course, *Dance You Monster to My Soft Song*!

In this fantastic evocation of a friendly monster, Klee presents us with an image we sense is still in the process of being made. There is a tentative quality to it that begs the question of what is really going on. Is the monster already dancing — or is he about to? What kind of music is it: piano or record? — and does it matter?

I personally think it doesn't, that the point of this picture lies in the way a few lines, color washes, and dots somehow magically end up as a fantastic image representing a totally mad and wonderful creature, which Klee labeled a monster. And that this "coming into being," this "is it this or is it that?" quality is precisely what keeps this picture provocative, witty, and forever "dancing."

Purists, I suspect, object to this random sort of creativity. They will insist that art be preordained, that the artist should know what precisely he is going to do, and do it without any improvisations or deviations along the way.

Now, although great works of art have resulted from that approach, art is flexible and open to other creative methods as well.

One of the most fascinating and rewarding of these is a kind of pictorial "musing," a kind of visual "thinking" with color, texture, shape, or line.

With this approach, the artist permits his imagination and sensibilities free reign to wander where and how they will. Colors call to and respond to other colors, lines interact upon shapes, textures erupt out of smooth surfaces — all without conscious control. Only when sensibility and intuition are blocked will the artist allow experience and skill to see what they can do to resolve matters.

Klee was a consummate master of this method of working. He understood that trust in one's intuitions and sensibilities could result in as consistent a creative method as tight and rigid control over every step of the creative process. All it required was an alertness to whatever happened on the paper — and the ability and willingness to follow through.

But to do that an artist has to be in step with the rhythms and patterns of growth, has to be able to gentle and prod the pictorial image along much as the sun and rain incite the growth of delicate living things.

Compared to the glories of Michelangelo's Sistine ceiling or Rembrandt's studies of humanity, this may not seem like much. But the truth of the matter is that very few artists have this gift. Paul Klee was one of the few who did, and one of the very few able to bring it to life in others, both by example and through teaching.

Because he ventured into formal territory previously held to be the domain of children and thus not to be taken seriously, because he insisted that art could exist in the simplest color patches and the scratchiest line drawings, and because he devoted many years of his life to teaching generations of bright young talent at the Bauhaus, Klee opened up the world of art to countless painters of fine sensibilities but limited traditional skills.

There is hardly a nonrepresentational painter alive today who hasn't been influenced in one way or another by Paul Klee — if in no other respect than in purity of intentions.

Warhol: A Mirror of His Times

G IVE respectful initial exposure to almost anything in the way of painting or sculpture, keep on presenting such work year in and year out in gallery and museum exhibitions. Then get the press to cover these shows as newsworthy events, and before long the work and its maker will be so firmly entrenched in the public's consciousness that to question the importance of either the artist or the work will seem petty, naive, and critically beside the point.

"After all," the argument will run, "this artist is now so firmly established, is so much a part of our culture, our society, our times, that he or she can no longer be judged on matters of artistic quality alone, but must be viewed as a celebrity, an event, a superstar whose fame and notoriety transcend mere criticism."

Of course that is not as easy as I've made it seem. No amount of money or influence can create a reputation out of nothing. Something tangible must be provided by an individual — if not something of quality and substance, then at least something of a more transitory nature. If the artist and his work don't respond to the profound and persistent questions of his time, then at least they must cater to some of its more fashionable whims and fantasies.

Andy Warhol, in this respect, is probably the most fascinating art phenomenon of our period. Commercial artist, painter, filmmaker, portraitist, stylistic trend-setter, social celebrity, Warhol made it a point to be in the public eye ever since his first moments of fame as a pop artist in the very early 1960s. Success, fame, and celebrity, as a matter of fact, were so crucial to him, were so much a part of his creative identity and formal equipment, that to imagine a failed Andy Warhol is to imagine a contradiction in terms.

The roots of the Andy Warhol phenomenon lie deep in our contemporary willingness to accept the notion that art can be both an active and a passive act. They derive from our belief that an artist can as legitimately claim the title of creator for detecting, unearthing, and reshaping symptoms of decline and decay as he can for reactivating and regenerating subtle indications of life and growth.

In other words, we want to believe that art is not necessarily and by

Andy Warhol
Green Coca-Cola Bottles, 1962

43

definition life-obsessed and passionate but can function just as well as a coolly diagnostic and morally neutral recorder of events, attitudes, and foibles — as a mirror and nothing more.

Now that's all well and good. But what, in the midst of all this broadening of the definition of art, do we do with the word that has always been, and I think always will be, central to art: the word "create"?

All dictionary definitions of the word insist upon its highly active and positive nature: "bring into being," "cause to exist," "give rise to," "originate."

Nowhere do I see it defined as "mirroring," "reflecting," or "passively accepting."

That art is dynamic and life-oriented before all else is so fundamental to my personal feelings and to my considered judgment that to accept listlessness, boredom, languor, redundancy, banality, even decadence, as legitimate themes for art strikes me as one of the most perverse positions ever held in art's long, adventurous history.

Such a position contradicts art's primary reason for being, its pulsating need to connect with life and to give it form and symbolic actuality.

One might as well say that a fish doesn't need water to swim or that a kite doesn't need air to fly as to say that art doesn't need creative passion and direction to survive.

And yet that is precisely what Warhol's art is trying to tell us. In a world dynamically alive to the passions and potentials of life, his paintings, prints, and films insist that man is little more than an accident, a freak of nature, and that it is pointless to think that anything can be done about it — so why make a fool of oneself by trying?

To honor Warhol and to give him superstar status for art that clearly articulates a philosophy of resignation, indifference, even creative helplessness, suggests that the contemporary art world needs to examine its priorities a bit more thoroughly than it has of late.

I don't suggest there's no room for Warhol. Far from it. We need him as a choice — one that can remind us how dangerous the sterile and the banal can be to art. What I object to is the disproportionate amount of attention given his work from the moment it first appeared, the piles of laudatory words written about it, the critical attempts to prove that it represents one of the great geniuses of our age.

Such desperate efforts to assure him and ourselves that his voice was a profound one worthy of the greatest attention is an awful indictment of the turn modernism has taken these past 20 years. That this great and varied

movement, which has always advocated life, passion, clarity, directness, simplicity, should be willing to associate itself with a hyped-up mediocrity causes one to wonder if modernism hasn't possibly run its course.

Perhaps it has. But art itself hasn't, as the hundreds of new exhibitions, opening every month throughout the country and abroad, testify. I am continually amazed at the seemingly endless supply of imagination and vitality that our younger artists are pouring into the mainstream of contemporary art. It is very comforting to see how life and art go on — regardless; comforting to see that creative passion and persistence have survived after all. Our younger artists, by and large, have the insight and the plain common sense to see through some of the false gods created by their elders.

Reconciling Art with the Primal Forces of Life

ONE of the most intriguing photographs of recent art history is a 1951 group portrait of 15 American artists. They are shown posed in a cluster, some seated, others standing. None of them look particularly distinguished, yet this small band of artists altered the course of mid-20th century painting. They all, in varying degrees, were active participants in the shaping of what we now call Abstract Expressionism.

Strictly speaking, this group photograph is not complete: Franz Kline and Hans Hofmann are missing, and Arshile Gorky had died three years before. Also, one or two of the artists included had only the most peripheral connection with the movement. Even so it is a remarkable document, for in it we find Abstract Expressionism's prime movers: Jackson Pollock, Clyfford Still, Willem de Kooning, Mark Rothko, Robert Motherwell, Ad Reinhardt, and Barnett Newman.

And, seated in the foreground, looking more like a college football player than a successful artist, is Theodoros Stamos.

Stamos, although still only in his mid-20s at the time, had been in on the ground floor of this crucial movement. His early paintings—subtle, quasi-abstract evocations of germination and growth—had shared the same

biomorphic vision found in the early works of Rothko, Gottlieb, Baziotes, and Newman. And his subsequent evolution into a more abstract style had been both natural and logical within the broad historic premises of Abstract Expressionism.

However, it is not his position as a first-generation member of that movement that I want to discuss here, but as a painter whose growth during three and a half decades of some of the most dramatic and turbulent art activities of the century has been at all times consistent with his private creative vision. And as an artist whose growth was actually accelerated after particularly painful reverses.

Although I've liked various works of his since my first encounter with one of them around 1948, Stamos has never been one of my favorite contemporary painters. I really don't know why. I suspect it has something to do with the sparsity and severity of his style. I could respond to it, could respect both what he was trying to do and what he had actually accomplished — but I could never really warm up to the paintings themselves.

That, however, has changed, at least as far as his most recent work is concerned. And thereby hangs a tale.

For Stamos, the 1970s were extremely difficult and painful. The art world, watching him suffer severe personal and professional setbacks at the beginning of the decade, wondered if he would ever again attain professional stature — or even be able to paint. The feeling, in many quarters, was that his career was over.

Although Stamos himself speaks of this period as nine years of hell, he didn't give up. He did, however, feel the need to detach himself from the competitive art world, and to try to redefine himself and his work. In the process he returned to his native roots, to Greece, and most particularly, to the Greek island of Lefkada. Here, living in a much simpler and more primitive life than he had before, and surrounded by the basic earth realities of sea, land, mountains, and sky, Stamos sought the means for his personal and creative renewal.

Utterly romantic as it may seem, this is exactly what happened. And what's more, it worked.

The first proofs of this have appeared over the past two or three years in a few galleries in New York and in an exhibition or two. Most noticeable was the change in imagery away from the geometrically precise forms of his "sun-box" series of the 1960s to softer, more atmospheric, and quietly elegiac compositions to which he gave the collective title *Infinity Field — Lefkada Series.*

Theodoros Stamos
Infinity Field—Lefkada Series, 1980

Their utter simplicity intrigued me. Most of them consisted of little more than two or three colors and forms, and a narrow — sometimes straight, sometimes irregular — band or two. Both his paintings on canvas and his smaller works on paper revealed a mastery of color and a quiet elegance not present to such a degree in his work before. I was oddly moved by them, and felt that here was something very much worth investigating further.

I was right, as I discovered one morning a few months ago in the artist's studio. He was about to leave for Greece, where he now spends half of each year, and was preparing his most recent work for shipment to his gallery.

He showed me a baker's dozen of just-completed paintings. It was a remarkable experience, for what I saw was evidence of an artist truly coming into his own. Not dramatically and with bugles blowing, but quietly and subtly.

These were simple and gentle works, totally devoid of theatrics or showmanship, for Stamos is no painterly gymnast like Picasso, inventing and performing one astonishing feat after another. Nor is he a Pollock, crashing through the accrued forms of centuries to score one breathtaking artistic triumph. No, he is much closer to a deep, narrow, and quiet stream that flowed originally with semiconscious direction, was forced underground to locate its primary sources, and has reemerged sparklingly clear and purposeful.

The usual way to discuss new work like this is to analyze it along formal lines, to grapple with the issues of structural invention and stylistic significance, to ask why certain shapes are less geometric than those in earlier paintings, why a particular blue occurs so often, and what the verticality of an image signifies.

Appropriate as that approach may be in other situations, it seems totally beside the point with these paintings. Simple and unpretentious, they stand complete and without need of explanation.

What comes across most particularly in these paintings is bittersweet human experience. While they also subliminally echo age-old Mediterranean cultures and realities, and transcribe memories of sea, sand, and sky into two or three flat areas of color and a few lines, their primary reality is the transfiguration of human pain, doubt, and suffering into the simplest possible images of reconciliation with the primal forces of life.

And the miracle of it is that this is accomplished without recourse to specific human imagery and within a totally nonrepresentational style.

In the deepest and truest sense, Stamos's paintings are classical. They are fashioned in harmony with nature but without dependence on nature's outward appearance. They exist as living things, humble perhaps, and simple, but with an integrity and a vision of life and of art that is entirely their own. But they are also more than that. They are the formal distillation and vindication of ideas and impulses that first saw the light of day over 35 years ago in the formative period of Abstract Expressionism.

These recent works of Stamos are among the most quietly elegant paintings of recent art history. They are also among the most beautiful. If modernism is indeed dead or dying, as is so often claimed today, I can think of no finer swan song to its genius than these lovely works. If, on the other hand, it is only temporarily indisposed, it could do much worse than respond to what lies embedded within these simple but extraordinarily pregnant works of art.

Chagall: Art as a High Wire Act

IT seemed, in the 1960s, that every home in America had at least one Marc Chagall lithograph or reproduction. And that every serious collector had at least one of his oils or watercolors.

Collecting Chagall threatened to become a national obsession — and friends reported that much the same thing was happening in Europe and Japan. Only Miró among the modern masters had a similar effect on collectors, decorators, or the average homeowner who wanted something both modern and colorful on the walls.

And that wasn't all. Chagall was commissioned to create large public works, including windows for the synagogue of the Hadassah Medical Center near Jerusalem and for the cathedral at Metz, a ceiling for the Opéra in Paris, and murals for the Metropolitan Opera House in New York. He was, in short, very popular and very much in demand.

The sad thing was that he was already past his prime, and that both the large commissioned works and the paintings and prints with which he

49

was flooding the world art market at that time were only pale versions of the magnificent art he had produced between his arrival in Paris in 1910 and the middle 1950s.

It was not a case of diminished vigor — he was still hard at work into his nineties — but of a slackening of creative imagination, a lessening of interest in the art of his art, and an increasing dependence upon its surface charms and its subject matter. Unlike Miró, whose paintings and prints have become simpler and more powerful as the years go on, Chagall seemed more and more content to relax and to produce increasingly pretty and decorative variations of his early masterpieces.

It is, to my mind, one of the sadder tales of 20th century art, and one that should constitute a warning to every artist — major or minor — who reaches a plateau of success in his work.

Chagall was born in the Russian town of Vitebsk in 1887 and studied at the Imperial School for the Protection of the Arts until he moved to Paris. Once there he was drawn toward the most advanced movements of the day, took what he could from Fauvism and Cubism, and participated in the *Salon des Indépendants* and the *Salon d'Automne* of 1912. His first one-man show was held in Berlin in 1914.

He returned to Vitebsk during World War I, became commissar of art after the Revolution, and founded and directed the Vitebsk Academy until his resignation from it in 1920. After living for a while in both Moscow and Berlin, Chagall returned to Paris in 1923 and held his first retrospective there in 1924.

His early work was based on three main ingredients: a rich memory of the folklore, ritual, and iconography of his Russian-Jewish background; a passionate love for rich, sumptuous color; and a solid compositional sense augmented by a highly personal adaptation of Cubist formal principles. With these three cornerstones, Chagall could take his art anywhere and do almost anything with it. People could float through the air in it or appear upside down, cows could sit comfortably in the sky, fish could sprout wings and fly, lovers could lie in huge bouquets of flowers, Russian villages could exist comfortably on the vertical. All that and much more was possible because it was all done with great verve and flair — and because it was subjected to strict compositional control. For all its exuberance and fun, Chagall's art at that time was as carefully grounded in geometry as any of the Cubist paintings of Picasso and Braque.

This is obvious in his *Green Violinist*, a later (1923–24) version of a subject Chagall had painted as early as 1912 and again in 1919–20. In this

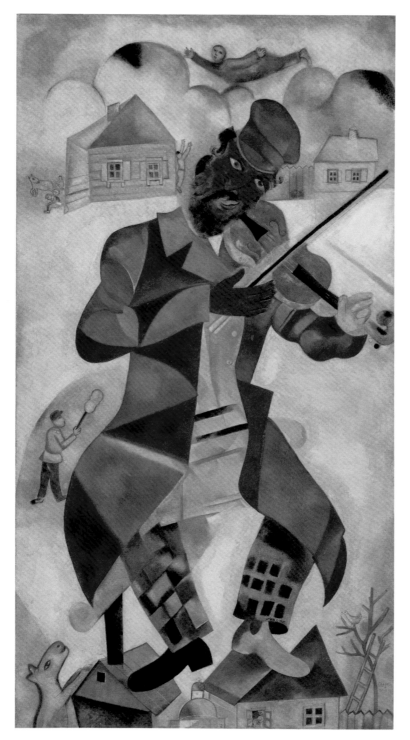

Marc Chagall
Green Violinist, 1923–24

work geometry plays as important a role as subject and color, and very much determines the nature and quality of what we see before us.

But it's geometry that playfully calls attention to itself rather than modestly sinking out of sight to serve as the painting's invisible scaffolding. For this is an art that puts as much emphasis upon its geometric skeleton as upon its subject matter. And that makes as much fuss over the near-abstract patterning and shape of the violinist's coat as it does over his humanity and character.

This is an art that plays both ends against the middle, and that carries it off with great aplomb, wit, and style. It's a highwire act in which the rich, deep sentiment of Chagall's Jewish heritage is played off against the crisp, pragmatic formalism of 20th century, post-Cézanne art. And in which both, as a result, are given new dimensions of meaning.

Chagall, through his art, humanized Fauvism and Cubism, and brought some of the rich Jewish folklore of his Russian background to the attention of the world at large. And he did this with such joy and great good humor that his art, which at times touched greatness, always remained human and accessible.

Small wonder, then, that he should prove so popular, and that his paintings and prints should be known and loved throughout the world.

But there was trouble in paradise, and it took the form of a too easy facility, and Chagall's apparent belief in the myth of his own creative infallibility. In the course of producing the increasingly vast numbers of paintings and prints his collectors began to demand in the 1950s, Chagall began to grow careless and casual in his approach to his work. But who was to tell at first, for his pictures were so full of fun and life, so colorful and warm, that this carelessness was generally perceived as one more bit of evidence that he was one of the few major contemporary artists who put human and sentimental values before formal ones. And that his repetition of subjects and forms, his increasingly sketchy technique, were proof of his genius rather than an indication of painterly flaccidity and artistic evasion.

Whereas the power and effectiveness of his earlier work had resulted from his extraordinary ability to fuse exotic subject matter, sumptuous color, and strict compositional control into powerful and even, at times, magnificent works of art, these later works, increasingly dependent upon tried-and-proven Chagall images, a few scratchy lines, and a dozen or so areas of bright colors, ended up as little more than pretty and rather spry decorative works.

This is especially true of his color lithographs, which have become

52

such a staple of the contemporary fine print market. Bright, colorful, open, and very expensive, these prints can be found wherever original prints are sold. Although they no longer have quite the status that the prints of Johns, Dine, Warhol, Rauschenberg, for example, now enjoy, they still hold their own among vast numbers of serious collectors around the world, and are as much in demand as ever.

I'm not by any means trying to say that Chagall was not a very major 20th century artist, only that overproduction and carelessness caused him to water down his art to the point where his later works are barely half as good as those done during the first 40 or so years of his career. Chagall brings into sharp relief the fact that we must not allow our overall affection for an artist to becloud our critical judgment of his work. We do not honor an artist if we support him in his weaknesses and evasions — we honor him only if he is stirred to do his best.

Sculpture Pregnant with Meaning

ONE of the great problems confronting early 20th century sculpture was that it had no Cézanne upon whom to draw. By that I mean that sculpture lacked the kind of seminal figure that painting, in the first years of this century, had in Paul Cézanne. It was Cézanne, after all — aided to a great extent by Van Gogh and Gauguin — who opened the door to 20th century painting and gave it legitimacy and direction.

Auguste Rodin, the last great sculptor of the 19th century, was, unfortunately, just that: a 19th century sculptor whose influence upon this century's art was, for all practical purposes, nonexistent. If anything, it was against him that most of the innovative sculptors early in the century rebelled.

And so sculpture had to start out cold, had to establish its modern identity and direction all by itself.

Modernism, both in sculpture and in painting, was generally viewed by early 20th century artists as either a formal truth to be pursued at all costs

Constantin Brancusi
King of Kings, early 1930s

54

(a kind of artistic Holy Grail), or as a huge warehouse of pictorial devices from which the artist could pick and choose whatever seemed appropriate to the creative task at hand.

Needless to say, those who saw it as truth generally looked down upon the others as unimaginative opportunists whose work, while evidencing talent and skill, nevertheless could not seriously be called art. Any attempt to apply the discoveries of a formal purist or innovator such as Matisse or Braque to an art of humbler objectives was rejected by the purists as a compromise and an evasion of modernism's basic tenet: to seek out the truth in art regardless of where it might lead or what its practical applications might be. Just as science was divided into pure and applied, so was art divided into what was true and what was contaminated by practical or commercial considerations.

This issue of artistic purity and formal truth became the central issue for the younger sculptors and painters who emerged during the years preceding World War I. And since perfection and truth in art have usually been associated with simplicity and cohesiveness, and more recently with irreducible form, the artists of that period soon found themselves painting circles, squares, triangles, and lines, and sculpting the most elemental and primeval of forms.

Chief among the latter was Constantin Brancusi who reduced sculptural form to its basics: to the egg shape; the slab; the box; the ball; the rounded, elliptical shape that resembled a stone worn smooth in a stream; and so on. And with these forms he created sculpture of such simplicity and truth that it quickly became a crucial part of the formal vocabulary of 20th century art.

Brancusi's creative inventiveness was so exceptional that one could almost say that he willed the sculpture of our century into being. But art is never created in a vacuum. There are always precedents and inspirations for everything in art, no matter how novel or unique such art may at first appear. In Brancusi's case, inspiration and precedent came from several sources: from primitive sculpture, from the simplest forms in nature (such as the shape of an egg, or the movement of a bird in flight), and from the spirit of Eastern religion and art. He drew from all of these, but the most crucial thing about his art came from within himself — and that was the conviction that the new form of sculpture he envisioned was not only relevant to the times, but true to the ultimate goals of art as well.

Such vision and persistence were doubly remarkable if we remember that when he came to Paris in 1904 there was nothing even remotely resem-

bling abstract sculpture to be seen there or anywhere else. Rodin was still king and sculpture was entirely representational.

Brancusi almost immediately set about stripping sculpture down to its essentials. He distilled and compacted the complex into the simple wherever he could, and became the great master of omission, of knowing how to reduce the irrelevant into the relevant.

But while his art may have looked abstract, it never really was. If he was drawn to the perfect shape of the egg, for instance, it was not only for its form, but also because of the mystery and promise the egg contained. Perfect it might be, but one day it would break open and life itself would emerge.

It is this profound sense of containment, of being based in life, that sets Brancusi's art apart from the more abstract work of his younger contemporaries. Even his pieces that resemble smooth stones somehow retain a quality of "pregnancy" about them, as though they contained life, or were as much like seeds as like stones.

His forms, absolutely simple as they may be, always resonate with qualities felt rather than seen. His famous *Bird in Space*, for instance, is not an abstract and stylized bird, but a work representing flight itself.

And his *King of Kings*, while it may at first resemble a totem pole, can more accurately be read as a sculptural sentence, a short alphabet of forms stacked vertically rather than arranged horizontally.

Brancusi's vision of a sculpture of containment and of essences has persisted right up to the present, and will most likely continue for a long time to come. His influence has been widespread and profound, although, like Mondrian — in some ways his counterpart in painting — he spawned very few genuine followers.

It is both too easy and too difficult to follow someone like Brancusi. Too easy because it requires little talent to mimic his art, and too difficult because his standards were so high that to follow him within such a simple format, and then to fail, was to announce publicly the paucity of one's talent and imagination.

Brancusi was, without any doubt, one of the pivotal figures of 20th century art, and one of its two or three most influential sculptors. His ideas and his forms were the inspiration for numerous contemporary sculptors, including Henry Moore and Isamu Noguchi. He was one of our most determined visionaries. If ever a 20th century creator sought the Holy Grail of art it was Constantin Brancusi, and if any ever found it — even if only for a moment — it was he.

Satire: A Tricky Business

\mathcal{S}ATIRE in painting seldom works, although it thrives in drawings and prints.

I suspect that is so because the graphic arts are the traditional means through which social, moral, and political ideas have been given their most direct and immediate pictorial form. And because the artist who uses the etching needle or the lithographic crayon to express himself does so for different reasons than the one who uses paint.

Even so, satire in any medium is a tricky business for it is usually based on anger or frustration, on the need to score points against a person, an institution, or an event. But anger and frustration in themselves are not art; these emotions must be fully assimilated and translated into appropriate images and forms before they can even begin to resemble art.

If, while painting or drawing such an image, we let our emotions get the better of us, we will very likely produce a shrill and hysterical work without universal significance. On the other hand, if the target of our satire is too immediate or topical, our painting or print may lose relevancy once the source of our frustration is resolved or removed. For instance, satire directed against a particular political figure may be highly effective and interesting while that person is in power, but will usually lose its impact once he or she is out of office. . . . Unless, that is, it was more than just a political or social cartoon, and was a genuine work of art.

Such indeed was the case with George Grosz's bitterly impassioned drawings and prints aimed at the corruption and political insanity in Germany before and during Hitler's rise to power. It was also true of Otto Dix's acidic swipes at the mindlessness of war, and of Max Beckmann's allegorical revelations of man's inhumanity to man.

These, and other German Expressionists, took the moral, political, and social excesses of their time to heart. But their anger against these abuses generally found suitable pictorial form, and was never permitted to spew forth as pure hate.

This respect for art is also evident in Picasso's prints and drawings condemning fascism in Spain, and, later on, satirizing the relationships between men and women.

But satire has also taken much gentler forms, and has also dealt with less deadly human foibles and idiosyncracies.

57

The 20th century has been particularly rich in this gentler kind of satire. From Klee's 1903 etching *Two Men Meet, Each Believing the Other to be of Higher Rank*, through Pascin's witty comments on leisure-time activities, Calder's delightful wire sculpture satires (such as *The Hostess*), Dubuffet's marvelous jibes at human snobbery and the macho male (*The Inflated Snob*, and *Will to Power*), to Steinberg's delightfully inventive take-offs on almost every aspect of contemporary life, we have been treated to one sly dig after another directed at the vagaries and pufferies of human existence.

In some way, even Miró and Cornell get into the act. Many of Miró's apparently abstract paintings are actually subtle jibes at human self-importance, and Cornell was obviously indulging in satire in some of his boxes and collages — although in his case, the enigmatic nature of his art makes it a little difficult to tell exactly against whom or what his satire was directed.

And yet, while satire — bitter, sardonic, or gentle — runs like a thread throughout 20th century art, it has been most successful in the graphic arts.

This becomes particularly clear if we examine the thousands of prints produced in this country between the two world wars, and compare them to the paintings done at the same time. In many ways the period 1920–1940 was the golden age of American printmaking. This is true even if we take into account the years immediately preceding it, when etching reigned supreme, and the present day, when original prints (as well as pencil-signed mechanical reproductions masquerading as prints) are to be found in almost every home, public building, or corporate office.

The big difference between printmaking now and then is that prints today are generally designed to serve as colorful, dramatic, even highly decorative objects hung and enjoyed on walls, while the prints of that earlier period were often as not intended to be studied in one's hands, and then tucked safely away in a portfolio or box.

Collectors loved to hold and savor such satiric prints of the 1930s as Peggy Bacon's *The Social Graces* or Martin Lewis's *Strength and Beauty* because they were so full of charming, loving detail. And because each of these details resulted from years of shrewd observation.

High on the list of artists of that period who used satire to good effect was Grant Wood. Although most famous for such paintings as *American Gothic* and *Daughters of the Revolution*, he also produced a few lithographs that rank among the best American prints of the 20th century.

Honorary Degree is a particularly welcome piece of satire because its

Grant Wood
Honorary Degree, 1938

59

barbs are directed as much against the artist as against the age-old practice of awarding honorary degrees. In this print, it is short, chubby, moon-faced Wood himself who is rather apprehensively accepting the (to his mind) possibly undeserved degree, and who is overwhelmed by the austere dignity of the two gaunt representatives of the academic world. Even the Gothic window behind him adds to his apprehension, and we can't help but feel that he is asking himself, "Who, me?"

This is a most gentle poke at a system that has been known to confer honorary degrees for services rendered — or promised. But Wood wasn't interested in indictments so much as he was in human nature and in art. And so he made his point all the more effectively by underplaying it, and by handling it with dignity, compassion, and subtle good humor.

In this respect he was typical of many of the printmakers of his time whose satire remains alive for us today. By trying their best to see human problems and actions in the light of human nature, and to forgive even while they were accusing, these artists kept their sense of proportion while many of the more hysterical political satirists around them were losing theirs.

Private Treasure Troves

*H*IDDEN under the floorboards of old attics, embedded high within the trunks of tall pine trees, and buried deep under bushes and boulders in various corners of northern Canada and southeastern Minnesota are little bundles of childhood objects: toys, school records, comic books, letters, Indian head pennies, photographs, even a few foreign stamps.

They are all mementos of my days as a very young boy, things I had collected and then ritually buried at appropriate times. As far as I know all but one of these hidden treasures are still intact: that one, a small packet containing, among other things, a peacock feather; an Indian arrowhead; a rattle from a rattlesnake; a toy mouse; and a short, handwritten history of an underground kingdom, was recently sent to me by the people who now live in the house my family occupied many years ago. They had done some renovating in the attic and had found my youthful treasure trove.

I was reminded of all that the other day while viewing a large exhi-

bition of Joseph Cornell's wonderfully enigmatic and mysterious boxes. They also are personal and private treasure troves, tiny universes of memorabilia, records of ideas, impulses, and carefully worked-out fantasies. But they also represent the musings of an extraordinarily creative sensibility. The big difference between his boxes and my bundles is that, while mine resulted from haphazard childhood impulses, his came into being as the carefully planned and constructed works of a highly sophisticated and intelligent adult.

I should, as a matter of fact, have put the word "original" before "sophisticated and intelligent," for originality was probably Cornell's most outstanding characteristic — that and his talent for artistic magic. He had the uncommon knack of transforming the commonplace and jumbled into the significant and orderly, not dramatically or spectacularly but quietly and gently and with a sense of inner integrity that puts his "magic" closer to the kind that slowly transforms an acorn into an oak tree than to the kind that theatrically turns a frog into a prince.

As an artist, Cornell went "with the grain" of his creative intuition, not against it. He never violated the rhythms or the rules of life or of art, but, rather, sought them out. And because he did, because he always searched for the essential and the universal within even the most exotic combinations of forms and subjects, his art draws us to it, causes us to take the time and trouble to "enter" his private little universes. And we do so with the same delight and curiosity with which Alice followed the White Rabbit down the rabbit hole.

But to do this, Cornell needed to create what amounted to a new art form: the small, totally self-contained box within which anything and everything belonged wholeheartedly and inevitably — once it had entered.

In the process of creating it, he transformed the acts of accumulating and collecting, poking around in secondhand shops and back-issue magazine stores, studying old movie magazines, clipping photographs of birds, portions of old master paintings, items from catalogs, etc., into as much of an artistic technique as traditional painting on canvas or carving in stone. And he so perfected the art of the visual seduction that it is difficult, if not impossible, for us to come upon one of his boxes without peering in to see what is going on inside.

What *is* going on inside these small stage set or diorama-like boxes is always interesting and usually downright fascinating. For Cornell manages to engage us on any number of levels: from the purely imaginative in subject and theme to the subtly exquisite in design and color, the delicate and sturdy in craftsmanship, and the vibrantly open in spirit and implication.

Specifically, his boxes contain seashells, butterflies, marbles, postage stamps, photographs, maps, twigs, starfish, soap bubble sets, eggs, paper cutouts, vials, reproductions of famous paintings, chicken wire, cork, and much else. These sit on ledges in front of, or are glued to, every sort of background — from ordinary wood and paper to fancy atmospheric textures, maps, charts, simulated bushes. In short, anything and everything is included — as long as it adds a proper nuance or contributes an interesting shape, line, texture, or color.

There are, however, quite a few boxes that contain only one central object, often behind a window-like construction and with a small number of other objects located around the edge. *Untitled (Medici Boy)* is one of the simplest of these and is also one of his best known. It is masterfully illusionistic, for what appears at first glance to be a figure of a boy in Renaissance costume turns out to be merely a carefully cropped portion of a painting. Its art lies in its ambiguity, the remarkable way its reality and illusion are kept in poetic tension and in the overall elegance of its construction. Although only 18 1/4 x 11 1/2 inches, this work is both mysterious and lovely, and totally enigmatic.

More than most, the art of Joseph Cornell is an art of indirection, of innuendo, of witty, whimsical, even outrageously startling, juxtapositions in which the point lies not so much in what the objects in the box are or represent as in what they and their relationships to one another suggest or imply.

All this, of course, brings him close to the Surrealists, although he was never one in the strict sense of the word. While he was certainly intrigued and stimulated by the aesthetics of Surrealism — its incongruities and inconsistencies, its exotic and startling juxtapositions, its irreverences, even, to an extent, its wicked humor — Cornell was too much of a philosophical classicist to join them in aiming for a disruptive rather than a healing and unifying artistic effect.

The original Surrealists were deadly serious revolutionaries out to jolt European cultural and social tradition out of its historic complacency. Their primary goals were disorientation and disaffection, and their art was their crucial weapon in bringing about these objectives. Art, to them, was an aggressive social and political act.

Cornell saw art more as a beautiful and enigmatic balloon sent up for all to enjoy and ponder. His objectives were artistic and poetic, and found their ultimate expression in the quiet contemplation of enigma, paradox, and symbols: what they are and how they came to be.

Joseph Cornell
Untitled "Medici Boy", 1953

One word should stand out in any discussion of Cornell's art, and yet I've never seen it used. That word is love. Love for art, for his subjects, his objects, his craft, his tools, his materials, and, most of all, love for the mysteries, ideas, and ideals he espoused in his work. Love permeates his creations, and is, I'm personally convinced, what his art is all about.

What I find most extraordinary about Joseph Cornell is that he managed to create such a totally original and living art on such a vulnerable scale during the period of our century's maddest excesses. As a result, his work has served as a gently alternative voice to the more flamboyantly aggressive art of the past four or five decades. In a large sense, his art *is* a precious treasure trove, a kind of spiritual time capsule created and kept safe for future generations.

Freshness, Joy,
Guiltlessness in Art

ONE of the most welcome things about much of the newer art emerging today is its freshness and exuberance, its crispness and the way it sparkles with life. Those who paint "realistically" do so without the anxieties and guilts of their elders, who often felt that to paint in that fashion was in some odd way a betrayal of their identity and authenticity as 20th century creators. And those who paint in any of the "nonrepresentational" modes do so with a directness and verve seldom seen since the late 1950s.

Although there is a great deal of complaining going on in critical and curatorial circles about the confusion art seems to be in today — and a great deal of envious finger pointing to the glories of the recent past — I suspect that the truth of the matter is simply that painting is slowly shaking itself free from the extraordinarily heady experience of living through almost a century of modernism, and is rather nervously awakening to the first glimmerings of a new period in art.

Modernism, quite simply, has been a nighttime and essentially interior experience, one full of dreams (and nightmares), ideals, and absolutes, with more than its share of demons and saints, dogmas, damnations, and salvations. Its greatest moments: Fauvism, Cubism, Constructivism, Expressionism, Surrealism, Neoplasticism, Abstract Expressionism, Conceptualism, etc., have all been creatures of the mind and of our interior sensibilities, products of a collective creative will that sought its truths with eyes shut — except for the sideways glance to see what the other fellow was doing.

After the bright and sunny noontime of Impressionism, and the late afternoon glow of Cézanne and Van Gogh, painting withdrew into the shade of evening, and then into the deepest realities of the night. Edvard Munch cried out for all of us, with the terror born of new and only partly understood perceptions, and his cry haunted us and haunted our art until it lost itself somewhere in the passions and the dramatic wilds of Abstract Expressionism.

Now I realize that this reading of recent art history suggests an oversimplification, that by emphasizing modernism's emotional content rather than its structurally innovative and highly formal nature, I appear to be

viewing the art of this century in the light of its occasional tendency toward hysteria rather than in the light of its brilliance and extraordinary originality. And that, as a result, I ignore, and possibly even deny, the large bulk of what constitutes its genius.

That is not my intention. My sense of awe at what this century has produced in the way of original and innovative art remains as great as ever. In fact I suspect that the art of this century will fertilize the art of the future in ways we cannot as yet imagine. What I would like to point out, however, is that we are delaying the advance of that art by our continuing preoccupation with the "how" and "what" of art — its mechanics — and by not paying sufficient attention to its "why" - its primary reason for being. And by our insistence that art be played according to the rules set up by previous generations rather than according to the artists' intuitions and insights.

It should be fairly obvious by now that much of today's most highly regarded art shows increasing symptoms of being little more than the recycled art of five, ten, or twenty years ago; that it is caught in a rut, and that with very few exceptions it is, like a phonograph record whose needle is stuck, going around, and around, and around. . . .

And that even when attempts are made to get out of this rut — as Frank Stella did in his most recent works — the attempt is still being made in the "old" way, by, as in his case, seeking greater density and ambiguity rather than opting for greater clarity or simplicity.

Fortunately, not everyone sees it that way, especially many of the very young artists still getting their feet wet, and a few of the older ones who have evolved to the point where they are now free to kick off all traces of formal dogma or technical constraint, and to attack their art with the utmost simplicity and directness.

Ida Kohlmeyer is one of these artists. She is a painter of such freshness and exuberance that I was convinced upon first seeing her work a few years ago that she was one of the new crop of youngsters bursting upon the scene. I was particularly impressed by the vitality of her color and by the directness of her touch, qualities that caused her paintings to appear as bright and colorful as a bouquet of flowers, and as immediate as a smile or a friendly handshake.

I soon discovered, however, that she has been around for quite some time, that she had, at one point, been a student of Hans Hofmann and had both known and been influenced by Mark Rothko — that she was, in other words, a veteran painter.

But although that was the case, it didn't show in her work — which

Ida Kohlmeyer
Circus Series 3—No. 1, 1978

was as fresh as a daisy and free of all evidence of heavy-handed profession-
alism or the desire to show off acquired skills. While it appeared as simple
as a child's, it proved upon closer examination to be as subtly and shrewdly
painted as many a work that loudly proclaimed its complexity and impor-
tance.

Color is Kohlmeyer's greatest asset and the element, above all else,

that makes her work sing. *Circus Series No. 3* consists of 36 squares, each of which contains at least two colors — most of them bright, even, at times "hot." This means that roughly 100 bright and intense colors are pulsating away within the larger square of the composition. And yet they are kept in perfect — if lively — balance. Each color maintains its special relationship with the form and the colors in its own square, relates beautifully with the others in its sector, and holds its own perfectly within the composition as a whole. The overall effect is of casual, informal, vibrant colorfulness — of great joy and fun.

The squiggles and simple forms within the squares add their own particular quality to this effect, for they manage to intrigue the eye just enough to add a tiny bit of visual counterpoint. They are emphatic and clearly defined enough to help cushion the colors, and yet are not so precisely detailed as to isolate and separate them from one another completely.

I've made it a point to follow Ida Kohlmeyer's work, and it's a pleasure to report that her paintings become simpler, more exuberant, and more sprightly all the time. And that she more than ever shares with her younger contemporaries the conviction that life and vitality belong emphatically in art. While this "younger" art may not yet (or may never) have the depth or monumentality of modernism's masterpieces, it does, on the other hand, partake of their vivacity and sense of the new.

By emphasizing the freshness, the joy, and the guiltlessness of art, painters like Ida Kohlmeyer — and all her contemporaries, young or old, who feel as she does — are helping to advance this new dawning, this new adventure in art. That may sound overly optimistic and highly romantic, but then, new beginnings generally do.

Art: Denying Chaos, Defeating Despair

*I*N the most general sense, there are two basic types of artists: those for whom art is a response to and a denial of chaos, and those for whom it's the answer to despair. But there are artists who are drawn to art for other reasons: a passion for color, a facility for drawing, or possibly a strong sense of design.

The question I would like to pose, however, is whether or not what these individuals produce is truly significant art, or if it is merely something pleasant, attractive, or imaginative to look at and enjoy. Something that can lighten the corner of a room or add a bit of visual charm to a magazine or book.

Isn't there, for all the talent and imagination that go into it, generally something missing in such work? Something that can evoke deeper jewels of feeling and experience than mere sensory pleasure or enchantment? Something that goes right down to the heart of human reality, purpose, and worth?

I personally think there is, and I think that that missing element is profoundly rooted in the same two basic needs that motivate the true artist: the need to deny chaos by projecting order, and the need to defeat despair by giving form to purpose and significance. And that any work calling itself art that doesn't in some way address itself to one or the other (or both) of these needs is not art.

Art's most profound goal is to put us and to keep us on the track, to remind us of life's wholeness, harmony, and design — and to help detach us from feelings of negation and insignificance. It can do so in many ways and within many forms. Mondrian's importance lay in his vision of wholeness and perfection; Klee's in his vision of the eternal, springlike reemergence of life from within even the tiniest of forms and events; Hopper's in his certainty of the value of courage and commitment regardless of doubts and fears; and Pollock's in his total faith in intuition and impulse.

Any artist worthy of the name grapples symbolically with the basic questions of life. But he must also win that battle in some form or other, or what he produces will have little meaning or value. A work of art is always

David Ray
Self-Portrait, 1980

a victory, tiny or great, over those forces that erode our beings or derail our sense of the quality of life.

The problem lies in recognizing these "victories," especially if they appear in startlingly revolutionary or dramatically traditional forms. Or if they frankly and openly acknowledge their debt to art history. It is difficult, for instance, for us to accept the fact that an artist who draws specific creative sustenance from Leonardo and Piero Della Francesca as well as from Munch and Picasso can speak as pointedly to our time as one who draws only from Pollock and Miró — or from any of our more recent cultural heroes.

It's the rare artist today who can apply Renaissance formal ideals to 20th century themes without appearing overly exotic or archaic. Or without creating an art that is vapidly decorative. The challenges and the problems of attempting such a thing are enormous — and the chances of failure are great.

But there are those who try, and David Ray, a younger, self-taught, and deeply dedicated painter, is one of them.

When I first saw Ray's paintings some years ago I thought he had bitten off more than he could chew, that what he hoped to achieve required an impossible level of commitment and talent, professional skills of the highest order, and a cultural climate that would encourage his vision rather than ignore it. In particular, I felt that his lack of formal training could easily defeat him, since he was putting himself directly in the ring with some of the greatest names of the past.

He has, I'm pleased to report, proven me wrong — except for some technical problems that still arise because of his lack of formal training. And he did so because I failed to grasp the depth and passion of his vision, the ferocity of his integrity, and the dogged determination with which he would tackle all problems head-on. He stuck to his guns through thick and thin, and has, in the past three or four years, begun to produce some rather remarkable works of art.

Almost all of his works deal with the human figure and with its ability to give expressive form to mankind's dreams, aspirations, moods, and metaphysical implications. Every painting of his is a painstakingly conceived and meticulously plotted enigma that we are invited to ponder in all its ambiguity — or to try to unravel and interpret according to our own wishes and needs.

He doesn't, however, make it easy for us, for his paintings stir up aspects of our unresolved and rudimentary selves we would usually rather let lie. And these tentative and sometimes disturbing qualities, which often

take the form of vague but persistent feelings of unease and disorder, demand attention and resolution — or they insist on being allowed to return to their secret lair deep below our everyday levels of awareness.

David Ray's best paintings, called into being by his own need to find order and significance through art, confront these feelings of unease and disorder and symbolically transform them into clear intimations of certainty and order. What makes his task particularly difficult, however, is his need to create an art that is *both* a denial of chaos and an answer to despair. His art, in other words, must not only be well, even exquisitely, ordered, it must also project a sense of serenity and peace through subjects that personify and project these qualities. He has been very successful with paintings that have had to do with sleep or with contemplative moods, and that have, at their best, something of the inner grace and serenity of Eastern bronze and stone Buddhas.

He has also produced a succession of rather extraordinary self-portraits. While these are often very 16th century Northern European in style, they are nevertheless very "modern" in mood and in the kind of self-awareness and self-determination they project. With few exceptions these self-portraits include broad references to Ray's notions of the artist's overall role in society. Thus his 1980 *Self Portrait*, in which he portrays himself balancing an interior-lit pumpkin on his leg, hints at the artist's importance in bringing illumination to the world.

Having written that, I have to smile, because Ray's symbols are never that two-dimensional or obvious. They function as much to evoke mood and mystery, to imply and to resonate, as to make an intellectual point. Their significances go deep, and to say of them that they mean thus and such is to miss their point. If anything, they create more mysteries than they explain.

I feel extremely optimistic about Ray's growth as an artist. During a recent visit to his studio, I noticed that he was hard at work on a large painting of his wife and the family dog. Although it was at best only half finished, it was already a step forward from the picture he had finished the month before.

It is a distinct pleasure to see such steady growth in an artist who is going his own way without concern for artistic fashion. And he is not alone, as one can easily discover if one looks beyond the galleries and museum exhibitions and snoops around a bit in artists' studios. There is a great deal more going on "underground" than we realize.

Looking at Art with the Heart, not the Head

I have been greatly taken to task by a friend for ignoring the role of sensibility in art, for making such a fuss over art that resolves contradictions and restores equanimity, and for paying so little attention to art that enriches and enchants by virtue of its simple vibrancy, its wholehearted *goodness* and quality.

It's all very fine, he says, to discuss the virtues of artists whose work represents great moral and formal battles fought and won. But how about those creators whose art represents exquisiteness of sensibility, whose paintings and sculptures give form and substance not to human resolutions and victories but to human refinements and sensitivities?

Why, in other words, give pride of place mainly to the grand, majestic figures, to the Michelangelos, Rembrandts, Cézannes, and Braques, and secondary positions to the more gentle Raphaels, Renoirs, Redons, and Klees? Why see art so exclusively in terms of grandeur and monumentality, when it can also be found in a sketch of a flower, in the flash of a firefly, or in the movement of goldfish in murky water?

He's right, of course. Art, to most of us, does denote a victory of sorts. And I think this is particularly true of us Americans for whom beauty without pain or guilt seems a little frivolous — unworthy of our pilgrim forefathers. Art *does* have the right to exist unencumbered of such feelings if it wishes, to be free to celebrate the pure quality and vibrancy of life, to sing like a meadow lark, or to twinkle like a star.

The only problem is that it is sometimes difficult to distinguish between something that is charming and pretty and something that is beautiful and truly artistic. There is a world of difference between an actual bouquet of flowers and one painted by Odilon Redon — even though the superficial resemblances between them might be extraordinary. Much as I love flowers, I have yet to receive directly from them the gentle jolt of pure gratitude for just being alive that I get from even the most modest of Redon's tender studies of them.

Simply put, beauty reveres life and makes us aware of and grateful for it, while the merely pretty teases and promises, but provides us with nothing other than itself.

Robert Natkin
Epiphany, 1989

One contemporary artist who is well aware of this distinction is Robert Natkin, who has spent a considerable portion of his creative life bringing it into sharp focus through paintings, watercolors, and prints that are subtle evocations of the gentler, more ineffable levels and dimensions of our physical and spiritual universe.

He has done so at considerable risk, for there is nothing so difficult or so dangerous as the pursuit of beauty in art. It is as elusive as the proverbial bluebird of happiness, and just as hard to pin down.

Natkin has succeeded where so many have failed because he has had the innate good sense to approach beauty as though it were a lovely butterfly awaiting transportation to a special and mysterious garden rather than as that same butterfly destined to be mounted on a board. By that I mean that he coaxes and cajoles his colors, shapes, textures, and lines *toward* their final

destinations on his canvas, and doesn't push and pull them about as though they were puppets on his string. He *evokes* the qualities and dimensions of feelings he wants to communicate and share, and thus he is as much magician as artist, as much planter as harvester.

His art is the result of a loving and shrewd reading not only of life and of the Old Masters but of modernism as well, and it lies in direct linear descent from the art of Monet, Bonnard, Klee, and Rothko.

Although he has produced a variety of other works, I am particularly enchanted by his very large amorphic paintings into which we are drawn, much as the huge landscape canvases of the 19th century transported us into untamed forests, spectacular mountain vistas, or vast, empty plains. Only here, we enter an abstract, coloristic, and textural universe in which we journey between and among an extraordinary variety of delicate textures, flat areas of color, fine gradations of hot reds or deep, cool blues, energetic linear squiggles that move in and out like friendly fish, irregular blobs, circles, squares, and triangles, while, overall, is a deeply luminous, multidimensional atmosphere both ocean-deep and sky-clear. And all wrapped up and transcended by a vision of art that is beautifully evocative, lyrical, exhilarating — and absolutely his own. A vision that has produced an art that suggests music, long walks through magical gardens, or deep, underwater landscapes.

Natkin, in other words, is not a formal purist, a designer and architect of abstract compositions intended to stand strictly on their own without any reference to other things, places, or events. He is a visual poet whose apparently abstract images actually exist to enchant us with intimations and evocations of things we can sense but never quite see.

Now, while I and large numbers of his fans and collectors (and the latter include major museums as well as private individuals) may find this utterly commendable, there are certain elements of the critical community who do not, who see his work as pleasant and pretty, but not much else.

It's an easy trap to fall into as far as Natkin's art is concerned. And the situation isn't made any easier by the fact that his paintings are so accessible, so easy to respond to. One needs very little (if any) art-historical (ancient or recent) information to be caught up by his work, and certainly no complex explanation of its intent or purpose to enjoy it. It quite simply *is*, and we need only take that first responsive step toward it. After that, the work itself takes over.

Now this would seem ideal: the work is rich and appealing, and the viewer need only move toward it for the enchantment to begin. But alas, that is much too simple for many of us.

After a century of assuming that all art worthy of the name must first be difficult if not almost impossible to grasp, and that any art that is lovely and appealing at first glance must be superficial and trite, we are now hard put to know what to do with art that gently beckons us toward it rather than dares us to understand what it is all about.

I know, because I felt much that way about Natkin's paintings myself several years ago. It was only after spending a long day working in a room dominated by one of his mural-size canvases that I began to sense that a great deal more was going on in them than I had at first thought. Since then I have taken every opportunity to see more of them.

As a result, I now believe that Natkin has painted a number of the loveliest paintings produced in recent years. But I did not know that until I let my feelings and my heart — and not my head — lead me to that realization. And in the process, I learned more than ever that there is indeed a great deal more to art than monumentality or grandeur or verisimilitude, that beauty *is* a matter of sensibility as much as of formal resolution. And that it can be warm and friendly as well as cool and austere.

Charles Burchfield, American Maverick

IN art as in life, a little ecstasy can go a long way. A touch too much, or a failure to handle it properly, and what started out to be an expression of joy can easily turn into an embarrassment.

What moved the artist may not move us, or may violate our sensibilities in the form he has chosen to express it. We may feel forced to over-respond to something that would, in normal circumstances, hardly touch us at all.

Difficult as it is for some to understand, profound emotion is not in itself enough for the creation of art. To become art, emotion must be broken down and reassembled as paint, as color, texture and line, as smoothness against roughness, as dark against light, or as "hot" colors against cold. It must be translated from a received experience into an active, projective, and

pulsating one. But, most of all, the artist must manage to convince us totally and without qualification that what he asks us to feel is not fraudulent, is not designed to deny reality or to serve his ego, that it is life-enhancing, vital, and true.

And what is true of gentle feelings and emotions is magnified a hundredfold when dealing with passion or ecstasy. The number of artists who have successfully translated passion into art can be counted on the fingers of both hands, and those who have truly given form to ecstasy can be counted on the fingers of one. For every Michelangelo, El Greco, or Van Gogh, there are dozens of excellent painters of quieter, more subtle and gentle moods.

The problem lies in giving full expression to what is felt. I would guess that the ratio between what the "average" artist feels very strongly and deeply about, and what he or she can satisfactorily communicate through art, is roughly 5 to 1. In the case of a major master, that would drop to about 3 to 1, and for one of the truly greats, 2 to 1. (It is my personal conviction that the only creative individuals who can fulfill or fully "express" themselves are the genuine mystics. And only because their "medium" is their own total being and identity — not something exterior to themselves such as paint or color.)

On the other hand, since great art signifies great content, it's also safe to assume that a Rembrandt or a Beethoven felt and experienced life on a level most of us do not, or do so only infrequently. And that their greatness lay not only in how beautifully their art found its formal resolution but also in how that resolution reflected their vision of the value and significance of life.

The artist and the man, after all, make up a single entity, and are never detached from each other. At least that's the way it is with someone who *is* an artist, someone who finds and expresses himself within and through his art — be it on the level of a Vermeer, a Grant Wood, or the youngster down the street who spends all day and part of the night hard at work at his easel.

Art itself is fairly common, and exists whenever an individual can symbolically give voice to his feelings or experience — and can convince others of its legitimacy. But significant art, art that articulates and gives form to more than just one individual's realities, is relatively rare. And great art, art that encapsulates and gives form to mankind's deepest stirrings and intimations of meaning, is rare indeed. It's not because we lack enough great men or women, or enough magnificent talent, but because the circumstance of finding a great human being and a great talent coexisting within the same person is incredibly rare.

Charles Burchfield
Winter Light, Backyard, 1949–60

When we do find a true fusion of human quality and of artistic talent, we should accept it with pleasure and gratitude — and not complain that that talent may not be as big as Rubens's or as great as Vermeer's. For one thing, this does no good — an Edward Hopper can no more become a Matisse than an apple can become a pear — and for another, such carping prevents us from appreciating the qualities the artist does have, qualities that could enrich our lives if we only let them.

We should first determine if a work of art is true, and *then* determine if it is significant or great. Artistic truth is a personal matter (there are potentially as many artistic truths as there are human beings), and it is downright silly to assume that art on that level must be realistic, or abstract, or whatever, before it can join the community of man. Significance or greatness, however, can be a different matter, and to ignore the fact that a particular period finds (or thinks it finds) its deepest and truest voice within one style rather than another is equally silly and unrealistic.

But any age has its mavericks, artists who go their own way regardless of prevailing style or fashion. These can be either rugged individualists like Goya or Blake, whose art stands very much alone, or active revolutionaries like Cézanne or Picasso, who not only create a new style, but spawn a host of followers.

This century has produced both kinds of mavericks, but only the latter type, the revolutionaries (Matisse, Klee, Pollock, etc.), has achieved major fame and glory — and, ultimately, critical respectability. The other kind (Rouault, Kollwitz, Balthus, Spencer, Wyeth, Hopper, Tanguy, Graves), while well known and beloved by many, always remains somewhat beyond the critical pale.

A mid-20th century American artist, a maverick in his youth and in his later years (although a fairly typical American regionalist during his middle period), who has not yet achieved the full level of critical acceptance he deserves, is Charles Burchfield.

A Burchfield exhibition is always an outstanding event for me. I can immerse myself in his vision of the world, and share with him his enthusiasms and passions, even his exultations and ecstasies for the many faces of nature, for the humming heat of August, the flash of sun breaking through during a blizzard, birds singing in a swamp, the resurgence of plant life in spring, trees bursting upward toward the sky, or the chill of approaching winter.

And I can do so because he totally convinces me of the legitimacy of his feelings and of the fact that his art is not intended to deny or evade reality

but to illuminate it — that it is life-enhancing, vital, and true. And this applies even to his most ecstatic and visionary images, works in which colors, shapes, and lines vibrate and sing out with a passion that is almost as raw and as direct as life itself.

Although I love and admire his art deeply, I cannot claim that it achieves greatness or that he was one of the tiny handful of painters who were totally successful in translating ecstasy into art. (Place even the best Burchfield next to Van Gogh's *The Starry Night* and Van Gogh's superiority becomes immediately apparent.) But he was one of the very small band of artists who tackled this level of feeling through their art and who succeeded in creating marvelous paintings that truly sing out and resonate with the passions of life. He had the rare gift of speaking simply and directly with his own voice in an age in which artistic priorities differed greatly from his own. He stands very much alone and I love him for it — just as I do Samuel Palmer, Blake, Redon, Bresdin, Ensor, Graves, or even Grandma Moses. In a world too full of conformity, I say bless them all!

Giving Credit Where Credit Is Due

*I*T says a great deal about the climate of the art world that I hesitate, even now, to admit publicly that one of my most pleasant memories of the 1970s was the Normal Rockwell retrospective I saw in 1972.

To discover that Rockwell could paint beautifully when he wanted to, that he was not just the sentimental and simplistic illustrator we all knew, gave me great pleasure. So much so, in fact, that I told everyone I could to see the show. Some did, and thanked me for recommending it; a few more went and disliked it, and one acquaintance refused to even discuss it, stating most emphatically that while he had never seen any of his originals, he didn't "need to because Rockwell was a hack and everyone knows it."

The show was a smashing public success, both in New York and in other cities, but received very little critical attention. And when the show *was* reviewed, the critics by and large didn't know what to make of it.

Norman Rockwell
Love Ouanga, 1936

Those who weren't completely patronizing saw Rockwell's paintings as a form of camp, as interesting only on a technical level, or as visual evidence of mid-20th century American nostalgia for simpler times and places. These critics were willing, it seemed, to view his work in any fashion except the way it should be viewed: as the serious work of a serious man, one who did, admittedly, turn out a great deal of straight commercial illustration, but one who also produced roughly two dozen extraordinary narrative paintings, works that were so sensitively conceived and beautifully painted that they will, I'm convinced, be hanging in our museums when a great deal of what is hanging there now will be gone and forgotten.

I know that the very possibility of this happening is deeply upsetting to many — just as it is upsetting to many that the Metropolitan Museum, in setting up its recently opened André Meyer Galleries devoted to 19th century European art, saw fit to give over one of those galleries to the paintings of the despised French Academy. But art history has a way of taking a broader view than do those who live through a particular period, and can usually detect quality even in works deemed heretical or irrelevant in their own time.

Now, I'm not predicting that Rockwell will ever be considered one of the great artists of this century, only that time will prove that he did occasionally produce some extremely good work, and that those paintings of his which are of that caliber will be given their respectful due — while the rest will be assigned to the oblivion they justly deserve.

There can be no doubt that Rockwell's production was uneven, that most of it was trivial, even, at times, embarrassingly hackneyed. He had a difficult time avoiding the obvious and overly sentimental: little boys were invariably freckled and gawky, had big ears, and loved baseball; little old ladies were kindly and loved nothing so much as to give cookies to children and to beam at evidence of young love. And everyone was God-fearing, patriotic, hardworking, and respectful of motherhood, apple pie, and the sanctity of marriage.

It was a simple world in which right was obviously right and wrong was obviously wrong, and everyone knew the precise distinctions between them. If things did momentarily go astray, one simply went to kindly old Aunt Evangeline or to the local minister or priest for help.

Nostalgia and sentiment were Rockwell's stock in trade, and no one knew better than he how to utilize them. His best works were predicated on profoundly human situations: a farm boy having a last word with his father before leaving for college; a couple checking to see that their children were safely tucked in for the night; the Thanksgiving prayer in an ordinary diner. No matter if what he painted was joyous, funny, poignant, or sad, it was always based on human experience, always told a story or projected a human mood. This was an art in which what man did and how he felt was what was primary in art, not "self-expression," abstraction, or formal innovation.

How then could any mid-20th century American critic, raised as he had been on the notion that formal matters were what counted in art, take Rockwell's storytelling and sentimentality seriously? How could he do anything but turn away from his kindly little old ladies, freckle-faced children, and checker-playing Uncle Harry — and see all that as trivial and beside the point of art?

He really had no alternative but to ignore, even to ridicule, what Rockwell produced. Even if he rather enjoyed some of Rockwell's illustrations, possibly even admired the skill with which they were done, he still had no acceptable frame of reference within which to approach them favorably as a professional critic.

The solution, of course, to appreciating Rockwell is simple and obvious: set aside for the moment all modernist critical criteria and look at

these paintings as storytelling vehicles whose painterly precedents go back to the art preceding that of the Impressionists. Now this is not as reactionary as it may sound. We're willing enough to do it while responding to the work of the latest New Realists and photo-realists, and to some of the more intriguing narrative paintings that are once again becoming somewhat fashionable. Doing so is really not difficult, and once Rockwell's trivial pictures have been separated from the few good ones, we will discover that there is enough excellent Norman Rockwell material left to make it more than worthwhile.

One of these days someone is going to take a good, hard look at Rockwell's entire production, and will select from it enough material for a small but eye-opening exhibition. Such a show, carefully, even ruthlessly, screened to include only the very best of his paintings, would probably occupy only one gallery in one of our major museums, but it would, I'm certain, go far to establish Rockwell as one of our minor 20th century American masters.

A page of art history is turning — has, probably, already turned — and what is coming into view is causing us to change some of our century-old attitudes and opinions about art. Any insistence that only the art that reflects our point of view belongs in our museums will do nothing but prove that we are as old-fashioned and out of touch as any of Rockwell's country bumpkins.

Kinesthetic Experiences
Re-attuned by Athena Tacha

*F*EW centuries have worshipped order as much as ours. The idea that this increasingly perplexing world could be neutralized or controlled through intellectual, social, political, or aesthetic systems has had an extraordinary appeal to our age.

But order is a complex matter and exists in many forms. It can be based on fear and imagined threats to one's security or identity, on rigidity of personality — or it can result from a search for meaning, for what is

reasonable, balanced, life-enhancing, and most appropriate for humankind.

Art's identity, to a large extent, derives from such a search, and from what this search uncovers of life's intrinsic rhythms, patterns, and laws. In the process, art enters the unknown and makes itself thoroughly at home. It senses, registers, and transmits information back to the culture and society through the artist's intuition, sensibility, and intelligence — and thus serves as civilization's litmus paper, weather vane, and lightning rod all rolled into one. But it can also serve as chart, map, and compass for the future — and as a prefiguration of what can and will be.

Among the various means art takes to convince us of the truth of its insights and forms is orderliness: as design, as rhythm, or as a regulated progression of events. We are comforted and calmed by the orderly, even if for no other reason than that it suggests control over the chaotic, the threatening, and the unreasonable.

All in all, art has been both well and poorly served by order in this century — witness modernism's remarkable formal innovations, and the deadly sterility of the state-controlled. With this kind of experience behind us, we tend to be extremely open to all forms of experimentation and improvisation in art — and suspicious of any attempts by another party to exercise even the slightest degree of control over our sensibilities and our aesthetic responses.

Because I share this suspicion, I was wary of my enthusiastic initial response to the art of Athena Tacha when I saw it in a show recently. Her scale models and drawings for environmental sculptures, whose identity can only be fully established by walking up, over, along, or down their carefully orchestrated steps and forms, struck me as extremely beautiful but possibly also a bit totalitarian in intent. After all, doesn't she plot every movement we make by varying the height, depth, width, inclination, direction, and regularity of the steps we take up, along, and down her sculptures? And doesn't this suggest subtle authoritarian control over our freedom of choice and movement?

This bothered me a bit until I realized how "musical" these multilayered and lyrically geometric sculptures were, especially *Nine Rhythms (Fragments From a Dictionary of Steps)*, a scale model that consisted of nine stairlike structures made of balsa wood and painted different colors. My eye, moving up, along, and down each of these structures' numerous steps and landings, registered patterns and rhythms in space and time that echoed those made by musical instruments playing musical notes.

It was a lovely experience (the various colors added an additional di-

mension of visual pleasure), and so I tried to imagine what it would be like to actually walk up and down the stairs of the full-scale and completed work. It seemed to me that if one gave over to the experience and really took one's time to truly savor it, it would be quietly exhilarating — and not at all the sort of experience that left one feeling controlled or manipulated. Any more than one did listening to music or reading a book — both activities that demand total attention and the willingness to allow the creator to set the pace and the regularity of movement into time.

The question, of course, is what all this walking and climbing signifies. Here I shall quote the artist: "In many ways my sculpture is comparable to dance. Naturally, it exists in real space and relies greatly on visual means (including color). Yet it can be fully experienced only through body-locomotion, and therefore through the element of time and physical participation of the human body. . . . One, and perhaps the only, way to perceive time, is through the displacement *in space* of one body in relation to another, i.e., through motion. Repetition of motion can structure time, give it a perceptible 'form' — a rhythm. Many regularly repeated movements (e.g., the rotations of the earth and the moon) create cyclical rhythms that structure or measure our time. The most familiar biological clock, our body, contains a number of cyclical rhythms (heartbeat, breathing, etc.). Normally, walking is also such a rhythm, a regular beat due to the fact that we have two legs of similar structure and length, and a steady relationship to the pull of the earth. However, walking depends on other factors as well — our physical condition, our mood, our will; and above all, it is determined by the ground whose configuration can alter the walking rhythm in terms of regularity, speed and direction. . . .

"However, one can manipulate walking by changing the ground's configuration, by controlling the environment's visual stimuli and by subtly altering the body's relationship to gravity. . . . By disrupting the usual expectations about walking, ascending and descending, I try to re-attune our sensitivity to kinesthetic experiences. . . and to create a rich variety of temporal patterns, a different feeling of space and a new awareness of gravity."

A particularly beautiful example of her work, and one that clearly illustrates her overall intentions, is *Charles River Step Sculpture*, designed (but never built) for a 750-foot-long area along Boston's Charles River at a spot across from Boston University. Tacha had decided on the site after a walk along the river during which she became acutely conscious of the "inhuman character of American riverbanks: there is no pleasant place to sit, or to get a hot drink, and no way to walk down to the river."

Athena Tacha
Charles River Step—Sculpture, 1974

Water — its flow, but also its double nature as solid (ice) and liquid — became the source for her sculpture. Since the area she chose was divided into two by a train line, she decided to use angular, crystal-like forms on one side, and curvilinear forms on the other, but with both opening up into flowing expanses and alluding to related aspects of nature, such as cascades, lava flows, and sand dunes.

The final effect, as we can see in the photograph of her scale model, is quite stunning. Walking within this environmental sculpture, and moving

wherever its forms indicate (and one has several choices) — or merely viewing it from various vantage points — would have to be a fascinating and pleasant experience. And since the point of her art is to enrich our perceptions of ourselves and of our relationship to our environment — to make us more aware of the nature of our existence — it would be a humanizing and possibly a liberating experience as well, with the work's underlying rhythmical order serving to expand our sensibilities, not to control or manipulate them for any ulterior purpose.

Tacha, in other words, uses order to instill a sense of purpose and meaning into the consciousness of those participating in her art. She does not regiment our responses, as would be the case in totalitarian art, but, rather, invites us to participate in a physical activity that creates rhythms and patterns in our minds and sensibilities as we walk with her through time. And the result, as is natural to art, is a sense of harmony, design — and of beauty.

The Eccentricity of Ivan Albright

ECCENTRICITY has played a considerable role in 20th century art. In addition to the work of the Dadaists, Surrealists, Expressionists, Pop artists, etc., we have had the highly idiosyncratic art of Stanley Spencer, Francis Bacon, Ernst Fuchs, Jean Tinguely, Red Grooms, and Paul Wunderlich; the visual trickery of M.C. Escher and Victor Vasarely; and the dense and convoluted worlds of Ivan Albright and Jean Dubuffet. Throughout this century and on every level of achievement, there have been artists more concerned about dramatizing their individuality than about conforming to an ideal or a fashion, and those who preferred to probe and give form to the odd, the exotic, the idiosyncratic, rather than to the ordinary, the safe, and the typical.

Personally, I'm all for it even though eccentricity has a way of making pictorial mountains out of artistic molehills — of causing tiny talents to believe themselves giants. For eccentricity in art to be valid, however, it must

be deep-seated and indigenous to the creator, not something worn externally like a purple cape or a mask. It must derive from the artist's character, from his commitment to his humanity and his vision. And, while it may sometimes take on an air of frivolity and of abandon, it cannot of itself be frivolous or abandoned, but, rather, utilize these qualities to illuminate deeper and more inaccessible realities.

If truth be told, eccentricity, in the long run, is more of a liability than an asset to an artist, for it is something to be taken into account and "forgiven" before the art itself can be accepted. El Greco's eccentricities as an artist were, after all, not really "forgiven" until the very early years of this century, and Blake's are still unforgiven in certain quarters.

The main reason for this is that we generally recognize that eccentricity in art can be an excellent cover for lack of talent or originality. It's much too easy to invent and to concoct (often with brilliant technique) pictorial extravaganzas whose real reason for being is to impress and to call attention to themselves and to their creators. I am particularly aware of this whenever I view large numbers of one-person exhibitions by ambitious but as yet unestablished artists, and find myself confronted by an occasional work that is the pictorial equivalent of someone wearing a clown suit while thumbing his nose, pointing to himself, and standing on his head.

And this kind of thing isn't helped any by the circus atmosphere generated and upheld by certain portions of the art press — and by some of the museum curators who assemble the increasing number of "new talent" shows confronting us every year.

If I didn't know better I could easily begin to share the opinion of those opposed to any form of "modern" or nonrepresentational art that there is a strong tendency today to turn art into a carnival act, into a sideshow of freaks. And to agree with them that the age-old virtues of discretion, balance, taste, harmony, are being shoved aside by grossness, vulgarity, and calculated eccentricity.

But I don't agree, because I know from personal experience that the eccentric and often vulgar works that tend to dominate these "new talent" museum shows are the exception rather than the rule as far as the art world as a whole is concerned. However, there is much excellent innovation and "conservative" art all around us that isn't given equal prominence because it is either too modest or too discreet — or because it isn't supported by impressive critical verbiage. It simply boggles the mind to see show after show of highly talented artists — and then to see none of these artists (or at most two or three) represented in the museum shows — to see instead (among

87

Ivan Le Lorraine Albright
*The Poor Room—There is no time, no end, no
today, no yesterday, no tomorrow, only the forever,
and forever and forever without end, 1941–62*

otherwise excellent pieces) things of such crudity and vulgarity, of such calculated artificiality, that it requires the wildest sort of imagination to label them as art.

Now, there's nothing wrong with eccentricity — if it's basic to the artist. And there's nothing wrong with vulgarity as such in art; it can even the balance with the precious and the esoteric. Nor is a touch of crudeness out of place in works that attempt to present a rounded picture of reality, or to poke a bit of fun. If there were, we would have to disregard Bruegel, Rubens, and Rembrandt, and, in our own day, Picasso, Miró, and Dubuffet.

What I object to is vulgarity and crudity for their own sakes — or as the expression of a point of view that delights in doing outlandish or offensive things for no other reason than that they haven't as yet found their way into art — and are thus certain to create attention.

To some artists, the best proof of their own existence comes through the performance and the acceptance of their art. By creating art, and by creating a response in others through that art, they prove to themselves that they really exist, that they — and what they think and feel — are real.

For such individuals (and I'm by no means claiming that all artists feel this way), the act of creating art is to a large extent the act of saying, "Look at me. Notice me. Be moved or excited by what I've made — and thus acknowledge my existence!"

If such an artist has talent, if he grasps and works somewhere within the *Zeitgeist* (and thus speaks for his time as well as for himself), and if he has sufficient detachment to view his work critically, there is no reason why such a person should not be able to create art.

Ivan Albright is such a contemporary artist, and has created a few marvelous works of art and a larger number of works of uncompromising vulgarity. What history will say of the latter I do not know (although I'm certain they will be around for a long time as object lessons in technique, if nothing else), but I'm quite positive that those half-dozen or so paintings of his that can be called art will be rated among the most fascinating American pictures of this century.

They will also, I believe, be considered among the best — not only because of the ideas behind them, but also because of the intriguing questions they raise on both symbolic and physical levels. For physical they are, with superreal surfaces that insist on being touched if for no other reason than to determine the true nature of their extraordinary detail.

Albright's art rivets our attention (and, in his best work, sustains it) by the device of freezing time and then encrusting the entire surface of the

canvas with maximum detail. We are literally wrenched out of our normal sense of time by the frozen clutter of his compositions, and find that our sensibilities are momentarily trapped in a world within which there is no air, no time, and no movement.

What happens next is entirely up to us. We can feel uncomfortable and turn away, or we can be fascinated and intrigued, can even feel a kind of awe at the patience and persistence of this artist, who must — and does — spend years on a canvas such as the one on page 88. If we are truly drawn to the work, it won't be long before we want to know all we can about the artist, who he is, how he paints so precisely, and, most of all, why he does it in the first place. He will, in other words, have impressed himself upon our consciousness through his art. And we, in a way, will have verified that he truly exists.

Humanity in Art

*T*HE simple, straightforward, and compassionate depiction of mankind in painting and sculpture was one of the first and most serious victims of 20th century modernism.

If man was depicted at all by the modernists it was largely when he was in the depths of despair or felt alienated (Munch); redeemed through suffering or faith (Rouault); anxious and disturbed (Kokoschka); tormented and angry (Beckmann); courageous or vulnerable (Kollwitz); formally fragmented or distorted (Picasso); turned into decoration (Matisse); metaphysically distracted (Giacometti); stylized and monumentalized (Moore); forced to serve an artist's very private and idiosyncratic vision (Dali); dehumanized (Warhol); and so on. Throughout this century, regardless of what he might have been in actual life, individual man and his realities were little more than a device, a projection, a mask, a symbol, or a shape for whatever theoretical, expressive, or formal purposes the modernist artist had in mind.

Modernism, quite simply, had other things on its mind. If it wasn't rearranging circles and squares, raising color to its maximum pitch, inventing visual superstructures, or probing deep into the unknown — or any of the numerous other activities and interests it was engaged in — it was crying

out in anger or in terror at the world's condition, or warning us that all we knew was dying and that it was time for new beginnings.

Humble, simple, individual man seemed terribly unimportant next to the formal dynamics and ideals of 20th century modernism, or the collective goals of entire nations, societies, or systems. And man was no better served by nonmodernist art, which, for all its finger-pointing at modernism's dehumanization of art, did little more for the "ordinary" man than academically present him in the artificial guise of a Rembrandt, Manet, or Sargent painting; dress him up to serve some political or moralistic purpose; or paint his body and face, but seldom his humanity.

For every Robert Henri, George Luks, Augustus John, Lucien Freud, Graham Sutherland, Andrew Wyeth, or Alice Neel who has tried to portray man pretty much as he was, there have been hundreds and thousands who saw man merely as a convenient peg upon which to show off technical skills, score a political point, or call out melodramatically (or through sure-fire sentimental subjects) for sympathy.

Now I know very well that art and the depiction of man are not necessarily the same thing, that art can (and does) have an identity quite separate from that predicated upon transcribing or mimicking physical appearance. Even so, I can't help wondering why recent art has so consistently failed to look at men and women as real people — especially since we take so much pride in calling this "the century of the common man."

We have stared at one another, that's true enough; have focused our attention upon the human face and body as though their truth and meaning could only be found by precisely recording every pore, blemish, wrinkle, whisker, or body joint. Or by freezing human action, and then recording it so perfectly in plastic or plaster that anyone coming across such a figure in a museum has a powerful urge to touch it to see if it is only a thing or a living person.

It *is* impressive, but it tells us nothing about ourselves — except that there are people willing to devote their lives to making precise human dummies and then call them art. We have generally not concerned ourselves in art with human character, or with human emotions. We have, in fact, done our best to drain all evidence of feeling, emotion, and humanity from the large (often huge), frozen, inhuman paintings and sculptures that we have produced of one another of late. And have, as a result, produced startlingly "realistic" and "true to life" works (Chuck Close and Duane Hansen) of human beings whose images, while drawn from life, are actually oriented more toward sterility and, ultimately, toward death.

I can't help but feel that there is more humanity and more truth in the passionate dribblings of Jackson Pollock, the lively mobiles of Calder, the bold and merry shapes and colors of Miró, the subtle formal relationships of Richard Diebenkorn, than in all these carefully but woodenly executed paintings and sculptures of supposed human beings. After all, in art as in life, it's the spirit that counts — not acres of pores, wrinkles, or whiskers, or a frozen and minutely rendered figure that serves nothing but to call attention to the cleverness and the patience of the one who made it.

There are few things more difficult in art than to sit a man or a woman in a chair and to paint him or her simply and directly as a real human being. Too many factors can get in the way: a primary concern for paint quality; for clever composition or lovely design; for brilliance of draftsmanship or subtlety of color; or for "depth" of psychological interpretation. These and dozens of other things can get in the way, and the resulting picture, while possibly well painted, will probably be no more a study of a real human being than a blueprint is a true picture of a house.

How often, as we go through museums and galleries, do we see a painting that is so *specifically* human in character and spirit that we feel almost in the presence of an actual man or woman? Not often, and that includes old masters as well as recent art.

I'm pleased to report, however, that I have, over the past several years, come across paintings by a contemporary American that have precisely that quality of simple and direct humanity. They are by Raphael Soyer, one of the grand old men of American art, and a painter who has recorded the face and the people of New York as few others have, either before or during his time.

I first became familiar with Raphael Soyer's paintings (and of those of his brothers Moses and Isaac) during the period of the Regionalist and American Scene movements, when paintings of farms and small town activities were as common as abstractions are today. Soyer's pictures of subway riders, people waiting in unemployment offices, or elderly folk staring bleakly out of the canvas seemed like the urban version of what was being painted in Wisconsin or Iowa. I liked them well enough, but thought them a bit simplistic and overly melancholy, and so could not get very excited over them — especially after my first heady taste of Picasso and Miró, and then of Pollock. And that feeling of interest without particular respect persisted throughout the years. I admired the way Soyer stuck to his guns and refused to follow painterly fashion, and the way he grew as a painter. But that was about it.

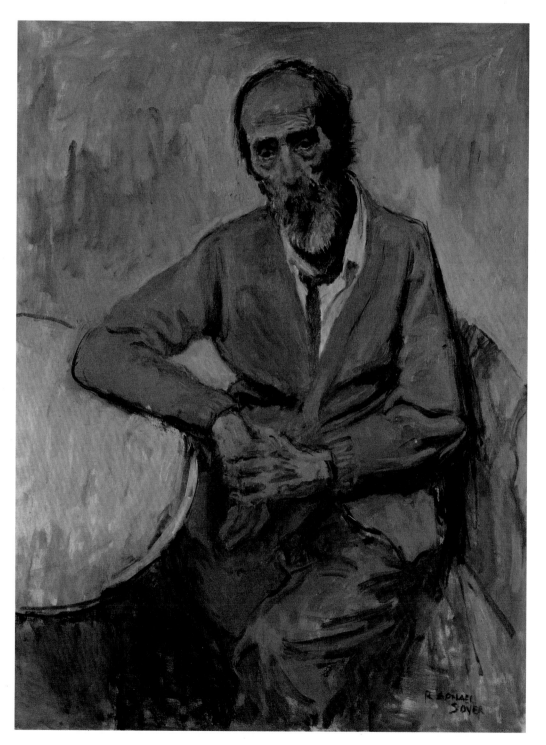

Raphael Soyer
José De Creeft, 1980

Until about ten years ago, that is, when I came across some portraits he had recently painted that were not only lighter and more delicate in hue and tone but also less melancholy in mood. I became very interested, and started looking for more — and have, with almost every new one I've seen, become more and more of a fan.

Raphael Soyer is one artist who *does* have the rare ability to sit a man or a woman in a chair and to paint him or her simply and directly as a human being. And he does so without worrying overly about "good" composition or "correct" drawing, for what he hasn't learned by now about such matters has nothing to do with his art anyway! And so he concentrates his attention upon his model's character and individuality, upon his or her humanity, and creates, as a result, not a mask or a symbol, or a rendering of surface reality, but a painting of a very real person.

Creative Intuition in Art

I recently went over a portfolio of drawings I had made during my art student days and found, among the usual life studies and still life drawings, a handful of abstract drawings. I can remember taking these to a favorite art teacher and asking him what he thought of them. I had added that I liked them very much, because they had come about during a period of intense excitement. They were nothing, he had replied — and suggested that I go back to doing what I had been doing all along.

I followed his advice, even though an inner voice told me that my feelings for those drawings probably indicated where my true direction and creativity lay. Now, over 30 years later and looking back, it is obvious that my inner voice had been correct, for those few abstract sketches are by far the best things in that portfolio.

One of the most difficult things to do in art is to paint, write, compose, without anxious concern for what one's peers will think. It's all too easy to box oneself into a position where what one creates is little more than a shrewd composite of what everyone else is doing or thinking — or where it represents a safe middle position at the center of several conflicting contemporary points of view.

Now, I don't mean that we shouldn't maintain a deep and healthy involvement with the ideals, imagery, language, goals, and priorities of the culture and society into which we are born. Nor that we shouldn't concern ourselves with the opinions and values of our peers — only that we should understand that art is not a matter of consensus and committee, that art is nothing if it isn't the clear and direct expression of its creator's identity, values, interests, ideals, and passions; that in addition to subject and form, art has personality and character, for an uncommitted and toadying art is as far from its true nature as an uncommitted man is from his.

Thirty years ago I would not have dared write the above for publication. What, I would have asked myself, would my professors and friends think of me for writing about the true nature of art and of man as though I knew what they were? Hadn't my long and intensive intellectual training been partly designed to convince me that the true nature of both art and man was beyond human comprehension? Was I not convinced that our perception of either or both was continually in a state of flux and that truth itself was relative, open, and contingent upon events and interpretations? With all this to take into consideration, who was I to make judgments about the nature of anything, least of all something as profoundly complex as man or art?

But it's not easy for a youngster to follow his intuitions about art if authority, tradition, and peer pressure are arrayed against those intuitions, especially if ambition rears its head and advises circumspection. What complicates it even more is that we are confused about the nature of creative intuition and believe it invariably seeks out the ineffable, the subtle, and the abstract — that creative intuition is always fragile, delicate, and vague.

We still do not really care to accept the fact that the nature and quality of life intuitions differ from individual to individual. Since creative intuition is insight into how an individual can best relate to or be creatively fulfilled within his personal or universal potential, it stands to reason that everyone's intuitions differ at least to a degree (and in some instances dramatically) from those of all others. Thus, one young painter might find his creative intuitions leading him into the realm of nonobjective art, another might find himself coming into focus as a painter of stormy seas, and yet another might find that it isn't painting at all but photography that best meets his inner needs and requirements.

Each and every creative individual must find his or her uniquely individual voice. This is the primary task — together with the acquisition of the necessary skills to shape that "voice" into whatever the artist's inner vision directs.

Roy De Forest
Canine Point of View, 1974

All this sounds easier than it is, especially since the exotic, the merely different, and the cleverly inventive can so easily be mistaken for the genuine and the original. And since our new and younger artists are so frequently pressured into committing themselves as artists long before most of them are ready.

What often results from this is a cacophonous and sometimes hysterical jumble of works that does little but dramatize its creators' frustration, ambition, and creative immaturity. Rather than permitting their art to emerge and to develop in the manner of a spring becoming a stream and then a river, these artists pour all their energy into the manufacture of pictorial gimmicks to satisfy the art world's all too often indiscriminate taste and its desire for instant novelty.

Those on the outside of the creative process should also realize the

need to exercise a form of creative intuition when viewing, buying, or judging art. Intuition must join hands with an inquiring, appraising, and knowledgeable eye.

Roy De Forest is an artist I originally viewed with considerable suspicion. His slightly mad and zany paintings and assemblages, in which almost anything happens in conjunction with some of the most outrageous combinations of colors, textures, objects, and scribblings, struck me as frivolous and trivial, if not downright silly.

And yet I found that there was something irresistible about them, something so good-natured that several times I found myself returning to them in order to understand why I couldn't just ignore them. What particularly challenged me was how oddly appropriate even the zaniest of their colors or details were to their overall compositions, even though at first glance they appeared to have been included without rhyme or reason.

With a few exceptions, I found that what had originally appeared as a confused jumble of childishly executed shapes, colors, and objects was actually a rather sophisticated pictorial statement operating under an odd kind of inner logic all its own, the kind of logic that permits some individuals to wear dramatically mismatched clothing — and yet carry it off with aplomb — or lends fascination to tales told by children.

And that is precisely what De Forest's works are: childlike inventions and pictorial tales that hold their own in our adult world by the nature of their external obedience to the artist's private inner world of impulse and imagination. An inner world of memories, loves, fears, fascinations, and dreams — all coexisting within him, and springing forth naturally and spontaneously through the courtesy of his creative intuition.

It is this spontaneous outflow of highly accessible, imaginative inner material and excitement that determines the nature of De Forest's art — an overflow that has put a powerful stamp upon the art of our time. This greater accessibility to inner resources and imagery has resulted partly from our increased curiosity about the internal workings of human personality, but mainly because we have spent the better part of this past century searching for quicker lines of communication between the artist's inner realities and his art. And we have, in the process, seen fit to give creative intuition the pride of place in the creation of works of art.

Morris Graves: Art in Fleeting Glimpses

*E*VERY culture and society has a few brave souls who live out their lives at the absolute frontiers of their age — who, while there, probe into and speculate upon what lies beyond — and then somehow manage, with the help of talent, logic, intuition, and faith, to encapsulate symbolically what they suspect the vision might be.

These frontiers may be in science, mathematics, philosophy, metaphysics, the arts — in any number of other disciplines, or in combinations of them all.

One such combination fuses art with metaphysical speculation and experience, and produces an art that is both profoundly physical and highly suggestive. An art that combines sensitivity with color, line, texture, form — with intimations of immortality, spiritual intuitions, a sense of the awesomeness of the unknown, and an ache for universal meaning and significance. An art, in other words, that possesses an eager openness toward any and all hints of what might lie beyond human knowledge, definition, or classification. It also raises questions about, and suggests alternative interpretations of, the reality we see, touch, smell, hear — or think we understand so well.

Although most artists, by the very nature of their creative focus, feel this sense of wonderment and awe before the unknown, the number of those who devote themselves specifically to the search for pictorial approximations of these concepts is extremely small. And for good reason: art and metaphysics, while close in spirit, are far apart as disciplines, and call for vastly different talents and commitments.

It's the rare artist who has the talent and the inclination for both. Among those few in this century who have, however, none managed more successfully than Piet Mondrian to fuse art and metaphysics into a perfectly unified and integrated pictorial image. In his simple, geometric paintings, the largest possible vision of reality was symbolically represented through the interaction of absolutely vertical and horizontal lines in conjunction with simple combinations of the primary colors. His paintings are still this century's most perfect icons of spirituality, albeit a highly rarefied and dogmatic version of it.

Morris Graves
Winter Still Life #1, 1983

But another visionary artist, whose relationship with the unknown may be more tentative and inquisitive than dogmatic, is Morris Graves. He is an American painter/draftsman whose provocative works have projected a note of subtlety and mystery into the mainstream of American art for over 40 years.

He has not, however, influenced that mainstream to any significant degree, for his art is altogether too private and intuitive to become part of a tradition. As a result, he remains, together with his American contemporaries and peers Tobey, Marin, Burchfield, Dove, and such Europeans as Redon and Klee, a master of true and vital accomplishment but of little formal influence.

Not that his art has not had its effect, has not exerted its own quiet sort of influence — only that it has done so very subtly and by projecting an awareness of gentler and more radiantly interior alternatives to the pas-

sionate abstractions and grandiloquently projective works being produced at the same time.

Graves's alternatives emphasize art's role as an evoker of subtle interior moods and otherworldly musings and intimations — which can be seen as an aid to meditation, rather than as a pictorial presenter of physical facts or as a shrewd organizer of nonrepresentational shapes, colors, patterns, or designs.

Graves is the least "professional" of artists. His delicate, elusive, and highly suggestive paintings seem more to have sprung spontaneously into being, or to record fragile evidence of the passings overhead (or within) of intangible but profoundly real and mysterious forces, than to have come about as the result of professional concerns.

An exhibition of Graves's paintings presents us with the extraordinary feeling that we are observing an exquisitely honed, creative sensibility waiting, with watchful urgency, at the frontier of human knowledge for something to "pass by." And then, when something does (or appears to), we see it take shape through his art.

It may be something so intangible and fleeting that to capture it on paper becomes as difficult as capturing the flash of a golden fish deep within muddy waters, or the bursting into momentary light of a firefly. But whatever it is, and fugitive as its appearance may be, Graves is the contemporary best suited by talent and temperament to register its presence and its appearance on paper.

This is his unique talent, and the one that has kept him facing outward (as well as inward) toward the unknown at a time when most of his contemporaries were concerning themselves with the formal and physical stretchings of the act of painting.

Graves hunts and fishes for evidence of the divine; he is a follower of its spoor and traces. If anyone will ever register even the gentlest caress of an angel's wing, it will be he. And, if intimations and intuitions ever take physical form, he will be among the very first to recognize them for what they are.

Technically, Graves's art resembles that of the Far East more than that of the West, for it tends more toward suggestion and nuance than toward definition or verisimilitude. It seeks out variations of grays, browns, silvers, salmon pinks, and blacks rather than the brilliant hues of sunlight. Even in his recent floral paintings, the touches of brilliant color in the flowers exist more as reminders of what color can be than as frank expressions of it.

Graves's art exists between the present and actual and the imminent

and possible. His images, as often as not, are in transition from one state to another, from one dimension of reality to another, and so do not have the detailed precision of, say, a Wyeth, for whom reality is crystal clear (if a bit melancholy), or the haunting starkness of a Hopper, for whom reality was a matter of courage and stamina in the face of alienation and despair.

Judging from his art, reality for Graves is an eternally ongoing process of question and transformation, a dynamic, ever fluctuating (to our eyes) series of overlapping images and appearances. To peel off one layer of meaning is to reveal the next one in depth — or at least to catch a fleeting glimpse of where it might be found.

Art, to such a creative spirit, is neither a feast for the eyes nor an arena for the emotions. It is, rather, a launching pad for the spirit and a landing area for truths wishing to make themselves known.

As a result, his art must be viewed differently from that of Monet or Soutine. Or of Kline, Noland, Johns, or Dubuffet, for that matter. It must be seen as suggestion rather than as fact, as process rather than as destination, as spiritual rather than as temporal.

To look at it in any other way is to miss its point and thus miss the essence of its rare and haunting beauty.

I Like It, but Is It Art?

IS Jasper Johns's painting *Three Flags* really art? Most art critics and writers on art seem to think so — to say nothing of a large number of painters, collectors, art students, dealers, and art lovers. As well as, most certainly, the Whitney Museum of American Art, which now owns it.

The general public, however, still has doubts. At least that is my impression from having asked a few of them about it, and from having overheard the remarks of others standing in front of it.

Most of them know this painting cost $1 million when it was bought in 1980. And they know that Johns is generally considered one of the small handful of major painters alive today, that he is even, in certain quarters, considered a great artist, one of the few significant shapers of art since World War II. They are also impressed by the fact that the Whitney treats this work

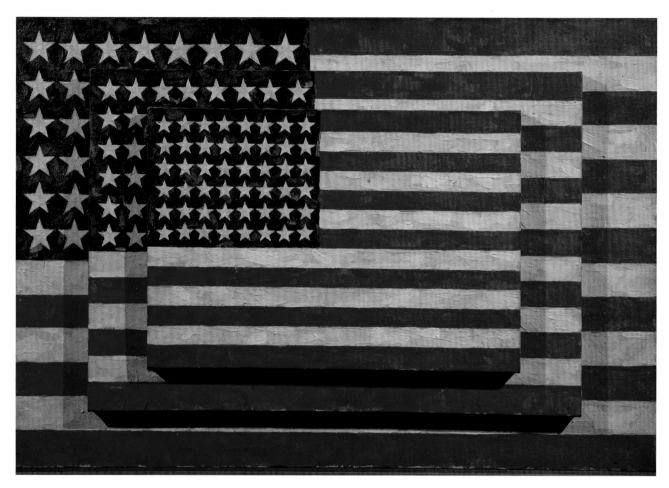

Jasper Johns
Three Flags, 1958

as one of its star attractions, very much the way the Metropolitan Museum treated its new and very expensive Rembrandt and Velázquez paintings when they joined its permanent collection a few years ago.

What they don't understand, however, is why this medium-sized, three-layered painting of three American flags should even be considered art, let alone be worth $1 million, or be considered worthy of hanging so prominently in a major museum.

It's a good question, and an important one, for this painting, executed in 1958, stands somewhat like a door between immediate post-World War II painting and the painting of more recent date. Understand and accept this

work as art, and much of what follows makes sense. Deny that it is art, and a great deal of what happened in painting between 1960 and 1975 won't — or at least won't make sense as art.

The problem is that the literature on this painting is generally as difficult to grasp as the painting itself. Underneath all its verbiage, it adds up to little more than an explanation of what Johns did within the context of his time and place, and why. That's about it. There is no real attempt to get down to the issue of why it is art, to get down to the nitty-gritty of what art is and is not, and then to determine whether or not his work falls in line with those criteria.

We have become so accustomed to evasion in this area that we accept without hesitation any and all explanations as to *why* something was produced as a waiver of, and a substitution for, the question of whether or not something is art. Thus, to the question of whether something is art, the contemporary critic will very likely launch into an analysis of how remarkable it was that at such and such a time the creator of this work could overthrow all conventions in order to paint such an image — something, we are assured, that wouldn't occur again for a full 17 years.

Or he will inform us that a particular drawing is indeed a perfect articulation of the *angst* experienced by the German intelligentsia of the early 1920s.

Now this is all fine and good, but it doesn't answer our basic question: "Is this art?" Such a response would be very much like picking up a fruit and asking, "Is this an apple?" and being told, "I saw it fall from that tree at precisely half-past two." Or, "It is round, and red in color."

Such half answers are very typical of what we get in most discussions of Johns's *Three Flags*. We are told that it is an extremely beautiful painting by a very gifted painter; that it is of great art-historical importance because it helped tilt American art from Abstract Expressionism to Pop art; that it was of pivotal importance in helping to take an entire generation's mind off the Romantic emotionalism of Pollock, Still, Rothko, and turning it toward the cooler and more detached concreteness of the art that was to follow (Pop, Hard Edge, Minimal, Conceptual, etc.); we are also told that it represents the nonmetaphoric and nonillusionistic usage of the most common and everyday objects as the explicit content of painting. And finally, that it heralds the return of geometry to painting.

We also read about Johns' ambiguity, skepticism, delight in apparent contradictions, his paintings' determined flatness, as well as his thematic absurdity and creative cunning. Around and around go the words and verbal

concepts, but all that comes out is the what and why of his paintings and sculptures, never any real consideration of how it all fits into a larger vision, idea, ideal, or concept of art.

A large part of the reason for this uncertainty derives from the continual widening of our perception of the nature of art. Our notion that art must reflect a particular reality or ideal — or fail as art — has crumbled before our realization that art has indeed existed in one form or another for as long as man. And that even such "exotic" objects as New Guinea masks or African fetish figures are art in the fullest sense, and not merely fascinating evidences of a "lesser" people's pathetic attempts to create the genuine product, as was the belief less than a century ago.

This broadening of art's identity continues unabated. The small plot of land that was called art in 1850 is now a gigantic field with various revolutionary and innovative creative figures working full-time to push the boundaries back even further. From Cézanne, Gauguin, Munch, Picasso, Kandinsky, Mondrian, to the "originals" of our own day, the job of redefining art has moved ahead at a great pace. And Jasper Johns, coming when and where he did, did as much as anyone else in this postwar era to block out and to indicate the direction and speed of this probing process.

Fine and good, but that still does not tell us if what he produced is art. After all, art ultimately represents values larger and more universal than those of one particular time and place. Our conception of the nature of art has broadened, but certain truths about it remain constant.

Or do they? It seems that every time we come to a point beyond which we insist art cannot go, someone comes along and proves (or seems to prove) that it can. Who, for instance, would have thought 75 years ago that sculpture could consist of moving pieces of wire and tin? Or that painting could consist of large areas of dribbled paint? Or that both would be highly regarded as art by most of the major museums of the world?

Where, really, do we take our final stand and say, "These things are art but those aren't"? And on what do we base that stand? What, in other words, do the works of Giotto, Sesshu, Hui-Tsung, El Greco, Monet, and Calder have in common? And, to be more specific, does Johns's *Three Flags* share these attributes?

In addition to the usual evidence of necessary skills, I personally demand four things of art: that it have formal integrity, i.e., that it be all of a piece; that it represent an individual's incisive perception of, and engagement with, crucial issues, realities, ideals, or attitudes of his time and place; that it represent a successful symbolic encapsulation of that perception and that

engagement; and that it can cause me to feel more unified, whole, and focused for having seen and experienced it.

It is symbolic or empathetic proof, great or small, of that ultimate totality of which we are all a part. That it be "a universe in a grain of sand," a moment's experience of the wholeness of life.

Does Jasper Johns's *Three Flags*, then, meet these requirements? To me it does — to a degree, though not as much as do some of his later works. To me it *is* art because it meets, to some extent, my personal criteria for art, but no more so than do the best works of Hopper, Wyeth, Marin, Rauschenberg, and not to the degree of the art of Klee, Calder, Pollock, Braque, Miró, or Mondrian.

To me, this work doesn't quite stand on its own, doesn't quite transcend its social, historical, and aesthetic reasons for being. As a result, it is a bit more art history than art.

Yet, that is not its fault, but ours, for so overloading it with importance. What it actually is, is a good painting by one of the best painters alive today. A painter who can and who has painted rings around all the theories advanced to "explain" his work. I have yet to see a Johns painting I haven't liked to at least some degree. He's a "natural" — and we should be able to accept him as such.

Art in Touch with the Divine

QUALITY is a difficult thing to define in art. There are those who claim it is primarily determined by extraordinary skill. Others see it in terms of grand or ennobling subjects, fulfillment or furtherance of tradition, or the degree to which a work probes into new and uncharted territory.

Some see it as consistency and integrity of form, harmony of mood, or subtlety or exquisiteness of touch. And a few insist that it can only come into being through a particular idea, dogma, or philosophy.

Actually, all the above (and a few others) apply at one time or an-

other. Dürer, for instance, was so breathtakingly skilled — especially as an engraver — that his identity and the quality of his art are irrevocably tied in with that skill. And there is no doubt that much of the quality in Giotto's, Leonardo's, and Poussin's art derives from their grand and noble themes, whereas Michelangelo's and Cézanne's greatness results to a large extent from the manner in which they both fulfilled and furthered the traditions into which they were born.

Picasso, Malevich, Mondrian, Pollock, and Bacon probed into new and uncharted territory, and much of the quality of their art is defined by their creative courage and pioneering spirit.

Braque, Léger, and Brancusi represent integrity and consistency of form; Friedrich, Munch, and Rothko, harmony of mood; and Redon, Whistler, and Klee, exquisiteness of touch.

And for dogma we have, among others, the Italian futurists and the American second-generation Abstract Expressionists, both of whom felt that there was no other path toward art but their own.

There have been those, on the other hand, who sought art and quality by following no set path, and who chose to pick carefully their own very private way between complex clusters of alternatives. They produced, as a result, art of profound individuality, integrity, and quality.

A prime example of this type of artist is Giorgio Morandi, a painter and etcher of still lifes and landscapes who will most assuredly go down in history books as one of the few true masters of the 20th century.

What Morandi was able to do with a few bowls, bottles, boxes, and, here and there, a vase of flowers, is almost beyond belief. The Morandi exhibition, organized by the Des Moines Art Center and subsequently on view at New York's Guggenheim Museum, consisted largely of such simple objects lined up on canvas after canvas, and yet the overall effect was profoundly moving and complex.

Leaving the exhibition, I felt the deep sense of satisfaction that comes from encountering evidence of great integrity and dedication, as well as that marvelous sense of harmony and focus that comes from experiencing art that is all of a piece, for it represents a lifetime of giving form to intuitions of what is significant and timeless about life.

Above all, a Morandi painting is classically serene; it suggests that both eternity and perfection actually exist. His simple objects, when arrayed upon a canvas, assume a monumentality totally out of proportion to their actual size. Some compositions, when viewed through half-shut eyes, resemble Stonehenge. Others give the impression of classical temples seen at

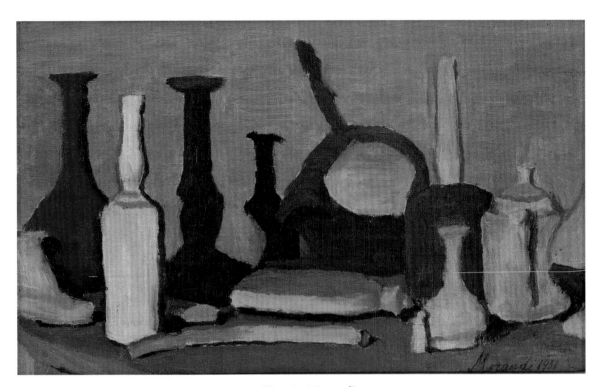

Giorgio Morandi
Still Life, 1938

twilight, or, more particularly, Greek or Roman marble fragments lined up against a still-standing portion of a Corinthian or Doric column.

These qualities are subtle and subterranean. We sense them rather than see them. What we *do* see are small, spare, almost monochromatic paintings whose overall tonality and atmosphere may conjure up memories of the art of Vermeer and Chardin, but whose stark frontality has very little precedent in Western representational art.

At first glance we don't know what to make of these scraggly lines of objects that resemble nothing so much as groups of raw Army recruits lined up for their first inspection. Where, we ask, are the complex dramas we have come to expect from the still lifes of the 17th century Dutch, from Chardin, and, most particularly, from Cézanne? The elaborate compositions, richly textured surfaces, and carefully controlled spatial progressions? And what's more, why does Morandi paint basically the same set of objects

within the same frontal format over and over again, to the point where we begin to wonder if he isn't stuck in a rut or is totally lacking in imagination?

The answers to these questions revolve around Morandi's creative motivations. He was not, as were the 17th century Dutch still life painters, trying to create images of physical opulence and material well-being as evidence of the worldly success of his patrons. Nor was he interested in giving form to notions of order within a *petit bourgeois* context, as was Chardin. And neither was he concerned with the kind of architectonic formal vision that so obsessed Cézanne.

What *did* concern him, and caused him, as a result, to see painting more as reverential ritual than rendering, was the notion that art was devotional and contemplative in nature — was very close to prayer — and that what mattered was making contact through painting with the divine, the universal, or the ideal. It was not the display of physical opulence nor the articulation of a new level of formal order.

To such an artist, the act of painting is a crucial — possibly the most crucial — channel of communication with the all-encompassing, the absolute. And every new painting is another attempt to perceive and to make contact with that ultimate level of truth.

Such an artist, having gradually evolved the formal and symbolic means most appropriate to his own vision of divine order or significance, does not then need to alter or embroider them. On the contrary, his impulse will be to simplify and to perfect them. To clarify them so that his contact with his vision or his ideal will be more immediate and direct.

What matters then is not what the "subjects" of his paintings (the bottles, boxes, bowls) are, but the manner in which they are utilized to communicate with those ideals or deeper levels of reality the artist wants to reach. Within this context, the objects themselves become mere conveniences — like words in a prayer — and what matters most is the purity of the artist's intentions and the clarity with which he can fuse those intentions with the physical means at his disposal.

And so Morandi, day after day, year after year, assembled his "vocabulary" of humble "subjects" on his tabletop and proceeded to paint them, much as others of his Italian contemporaries attended daily mass or worshiped privately or in a church. Now this may appear strange to some and blasphemous to others, but it is what art can mean to some individuals.

The result is an art of exceptional quality and depth, an art that must be approached with much the same sensitivity and reverence that Morandi experienced while producing it. This is not pretty, descriptive, entertaining,

decorative, informational, or even inspirational art. It does not sweep us up to emotional heights as does the religious art of El Greco. And neither does it inform us of orthodoxy and dogma as does the art of the Middle Ages or the Italian Renaissance.

What it does do is allow us to participate quietly with an artist of profound integrity and vision in his day by day creative activity of trying to contact the divine, and to benefit, thereby, from his lifelong devotion to a particular vision and ideal.

That at least was my experience. Viewing Morandi's show at the Guggenheim Museum was the closest thing to a religious experience I've had with 20th century art — with the exception of some of the early Cubist paintings or Picasso and Braque, the best paintings of Mondrian, and a few of the oils of Rouault.

If It's Unemotional, Is It Art?

*I*T'S easy for art to remain on the surface of things. Easy for it to consist entirely of attractively arranged shapes, colors, lines, and textures —or sentimental, historical, or exotic themes dramatically presented. In other words, it is very easy for art to be merely decoration or illustration.

There are, however, other, less obvious kinds of artistic superficiality that can seduce or confuse us into complying *with their creator's claims for artistic importance.* For example, we can be made to suspend judgment because of a work's novelty or sensationalism, its slavish mimicry of nature, or because its validity as art is insisted upon by complex and apparently learned rationalizations.

Thus we have been seduced into giving first-rate status to Pop art on the basis of its iconoclasm, its derisive attacks upon sentiment and idealism, its superficial and narrow reading of recent art history, and its noncommittal attitude toward human, social, and spiritual values. All rather perverse reasons for attributing quality and importance to art — compared to investing money with a broker *because* he has consistently gone bankrupt.

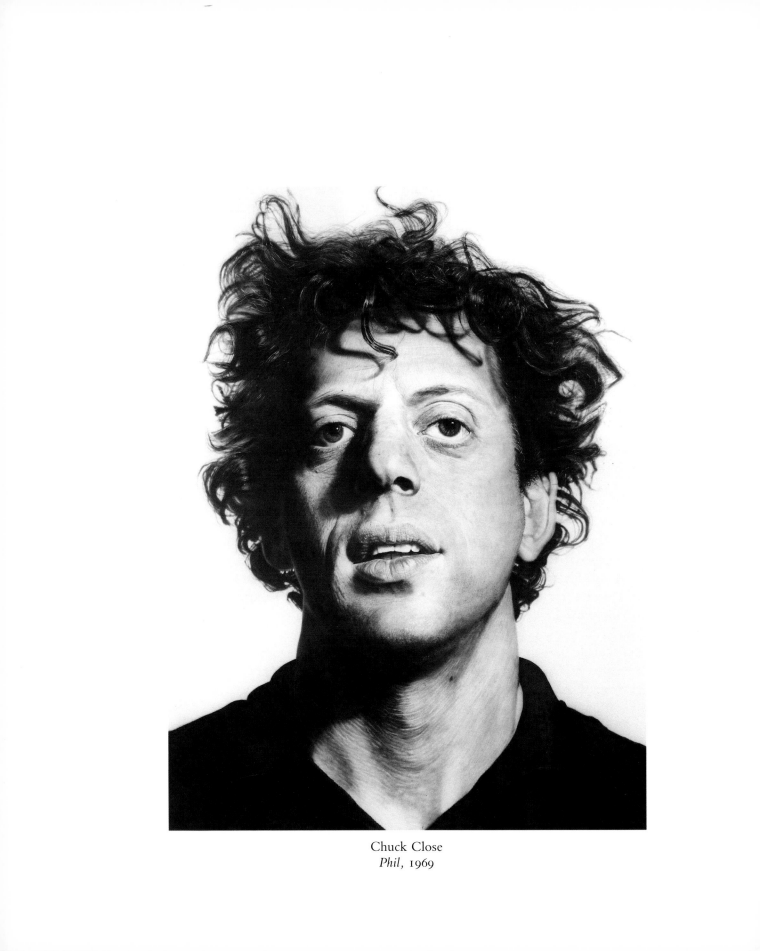

Chuck Close
Phil, 1969

We have also refused really to examine the extravagant claims made for various artists since the waning days of Pop. We have heard Kenneth Noland described as one of the three or four greatest colorists of the past two centuries — second only to Matisse. We have heard Carl Andre compared most favorably to Brancusi and Rodin, have listened to talk about the incredible genius of Warhol (I've been informed that to talk with Warhol was to "talk with tomorrow") or the crucial art-historical importance of Julian Schnabel and the profoundly significant originality of Sol Lewitt — all this without batting an eyelash or offering one word of caution.

We have, in other words, accepted the claims of these artists' advocates that they are not only good (and most of them are), but that they are also among the most original, the most profound, the most important, and the *greatest* artists who ever lived. In fact, if we accepted all the extravagant claims made on their behalf, we would have to concede that there has never before been such an artistic golden age as since the end of World War II.

Now, that's sad, and a very real distortion of art. The same kind of uncritical and adulatory mentality that declared the Beatles as great as Beethoven, and Bob Dylan as great as Shelley and Keats, has been permitted to run rampant in recent art literature. The effect of such puffery has been disastrous, and has helped undermine the very notions of quality and value — which are, after all, pretty much what art is all about.

But how do we determine artistic quality and worth if we deny or ignore the very idea of long-range or universal standards, and if we uncritically accept every new declaration of genius and importance at face value? And judge every new style or movement on the basis of its physical impact upon us, on the basis of size, novelty, sensationalism, or garishness rather than on its relevance to larger issues, or its positive effect upon our vision or our knowledge of ourselves?

When judging the overall quality of a work, I fully realize the importance of its sheer physicality and how difficult it often is to analyze that quality with any degree of objectivity. But we should at least try, and should stop seeing art as a series of circus performances with each new "act" announced by a critical or curatorial "ringmaster" as "The World's Very Greatest!" And we should stop listening to the shrill voices of individuals whose main critical standards are novelty and sensation, whose worst imaginable fate is being bored or out of fashion.

We also seem to have forgotten that fresh new talent full of bushy-tailed enthusiasm and vitality isn't everything in art. Art, like life, can mellow and improve with age.

One very noticeable effect of this sensation- and novelty-seeking process is that our artists are increasingly focusing their painterly attention upon the surface of the canvas rather than upon its depthward and inward potential, piling paint and illusion *on top* of the canvas rather than "opening it up" for us to "enter."

As a result, the viewer tends to be bombarded — even "slapped in the face" — by surface effects, sensations, and novelties rather than being permitted to enter into an empathic interior "dialogue" with the work. The unfortunate fact is that empathy has become something of a dirty word in art circles today, and has been left entirely to the painters of pets, sentimental landscapes, and glowing sunsets.

Yet the sensitive manipulation of empathy has a long and noble tradition. Consider, for instance, what Rembrandt, El Greco, and Van Gogh would have done without it — or Rouault, Kollwitz, or Rothko.

Empathy has been in short supply since the early days of Pop art, when painting became a matter of surface effectiveness and obviousness — even of outright vulgarity. This is not too surprising, considering the powerful impact commercial billboards and comic books had upon Pop art's birth and growth.

This lack of empathy is very noticeable in recent new realist art which tends to be overwhelmingly cool, detached, surface-oriented, and unemotional. And it is especially evident among the photo-realists — most particularly in Chuck Close.

Close prides himself on the total "objectivity" of his paintings of human heads. If a Rembrandt painting of a man is a window into that man's "soul," then a Chuck Close painting of a man is a drawn windowshade upon which a photographically precise copy of that man's physical appearance has been painstakingly and unfeelingly rendered.

Where Rembrandt portrays one man as Everyman, Close portrays him as nothing but an accident of flesh, skin, hair, pores, and wrinkles.

Now, the irony of this is that Close's supporters claim it is precisely this "objective" quality that makes him an important artist, that it is precisely his way of turning people into things, into "abstractions," that makes his art so valuable and so relevant. They claim he is a major artist *because* he reduces humanity to mere physicality, *because* he resists any and all temptations to work with feeling, sentiment, or empathy. They further insist that he is very possibly great because he perceives reality and truth as they *are* and not as we would wish them to be.

The truth of the matter is that his work has little if anything to do

with "reality" or "man," and everything to do with a particular perception of post-World War II painting. This perception was predicated upon pictorial effectiveness, novelty, and sensation, and when confronted toward the end of the 1960s by a need to create something even more startling and sensational, turned to the most blatant form of photographic mimicry imaginable.

What happened then is part of recent art history. Close's huge and photographically precise heads have been seen almost everywhere, and were, without doubt, among the most effective, startling, and sensational paintings of the past decade.

They are, however, beginning to lose their impact, are becoming too familiar and too much like a circus act that no longer amazes.

And so we now demand something new — and will get it. In fact that something "new" is already upon us. Not something photographically precise this time, but the exact opposite: huge, colorful, violently "expressionistic," and unbelievably garish canvases that are as "hot" and "passionate" as the art of the previous cycle was cool and detached.

It just goes to prove that we haven't learned our lesson. That our only response to the excesses of one extreme is to try those of another.

Georgia O'Keeffe: Appearances

GEORGIA O'Keeffe's remarkable career in art spanned over 70 years — from the early days of this century, when she was one of the small handful of innovative painters translating European modernism into American terms, to her position as one of this country's most respected artists.

She was also one of the outstanding and most beloved women of our age, a fact that makes a truly objective analysis of her work somewhat difficult in today's climate — as indeed being a woman created problems for her at the beginning of her career.

I have hesitated writing about Georgia O'Keeffe at any length for the

simple reason that there seems to be no way to avoid discussing the fact that she was a *woman* artist. It distresses me no end to have to do so, for I believe it is the art of an artist that should be discussed and not his or her sexual, racial, religious, or national identity. And yet, every time I try to discuss O'Keeffe's art without reference to her having been a woman, the response invariably brings the discussion hurtling back to the issue of her sex.

I have been informed, for instance, that I have failed to grasp the subtle beauty of her pictorial forms because I am a man, and because I am riddled with male prejudices against the "open" and lyrical nature of her compositions. It is stressed that she was one of the first artists to paint out of a truly womanly sensibility rather than out of a male-oriented or male-dominated one, and that my analysis of her work is invalid because I am not fully capable of taking that into account.

In short, I've been told in any number of ways that there is a very special quality about her work that no man can ever fully understand and that, as a result, no man can ever perceive her work truly — as it really is.

To me that's utter nonsense — just as it would be nonsense to say that a man should not write about Martha Graham, Virginia Woolf, or Beverly Sills because he cannot possibly know what it is like to be a woman. Or that a 20th century American shouldn't write about Rembrandt or Hiroshige because he doesn't know what it's like to be a 17th century Dutch painter or a 19th century Japanese printmaker.

I have known O'Keeffe's art for over 40 years and have liked and admired some of it very much. There can be no question of her talent, creative ingenuity, integrity, and courage — nor of her historical importance. She will always occupy an important position in American art history, and her paintings and drawings will be enjoyed for many years to come. I respected her highly. Yet, every time I venture the opinion that she is not one of the truly major artists of this century, I receive such vocal and written condemnation (even, at times, abuse), that I have been very much taken aback.

It would be a different matter if I were criticized for my opinions of her work rather than for trying to divorce her art from the mystique surrounding it. But the offending fact seems to be that I wish to see her "merely" as an artist rather than as a special kind of heroine for whom one should show immediate admiration and respect.

Try as I do, I cannot understand this position. If an artist is to be worthy of respect, then that respect must be based on something solid and art-related — not on uncritical adulation based partly on his or her art, but

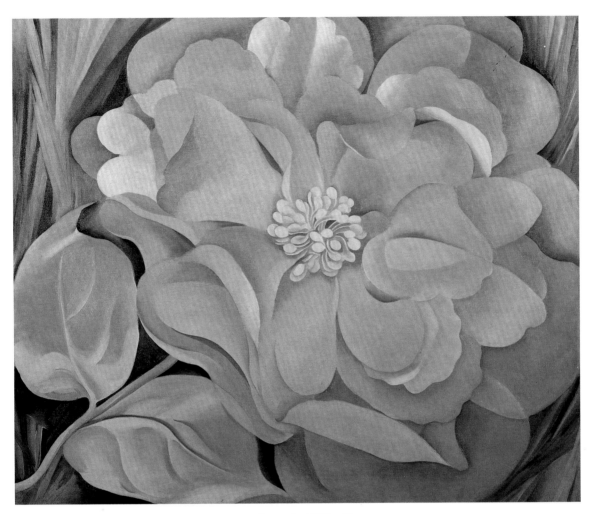

Georgia O'Keeffe
The White Calico Flower, 1931

mainly on another consideration devoid of art. If O'Keeffe is to be awarded premier status as an artist, then it must be her *art* that elevates her to that position, not the fact that she was a woman of extraordinary integrity, courage, determination, and wisdom. The only way to establish that is to examine her work as fully, directly, honestly, sensitively — and critically — as anyone else's.

In order to do so, I have tried my very best to take into account any and all "prejudices" against feminine sensibilities of which I have been ac-

115

cused. I have leaned over backward to understand the what, why, and how of O'Keeffe's art, and have made every effort to see as much of her art as possible in the original and in reproduction.

The end result has been twofold: it increased my respect for her as a creative, open, and dedicated human being but somewhat diminished my respect for her as a painter.

It is my considered opinion that Georgia O'Keeffe will go down in American art history on a par with Thomas Hart Benton, and that both will be viewed in the future as important 20th century American painters with basic flaws, but also with many extraordinary virtues and qualities.

O'Keeffe's and Benton's strengths are obvious: intense individualism; consistency in form and style; a profound awareness of the depth and range of 20th century modernism — but with a steely determination to create a personal style involving American themes and the American landscape; a clarity and precision of conception and execution; as well as a remarkable sense of pictorial organization and complete absorption in their creative vision.

In addition, O'Keeffe was blessed with a high degree of formal tact — which is another way of saying that she had extraordinary taste and sensitivity — as well as with the ability to turn something ordinary into something unusually attractive.

And last, but certainly not least, she projected an expansive and lyrical vision through her art that stirs in us a sense of orderliness and serenity, a feeling of gentleness and peace, transforming the reality we know into romantically pristine pictorial images.

It is precisely here that my criticism of O'Keeffe's art begins. Not because she transformed her perceptions of reality into something romantic and ideal (every artist does that to a degree), but because that perception, while noble and well-intentioned, is essentially only skin-deep. As a result, her art, while indisputably serious and high-minded, remains basically on the surface of things, is lovely, neat, elegant, and beautifully designed — but seldom, if ever, profoundly provocative or moving.

Her intentions for art exceeded what her art accomplishes. Almost all of her images make subtle references to the deeper human issues and realities. But to my mind that is essentially all they do: make reference to or point toward those realities. They do not genuinely perceive or come to grips with them — and then transform the experience of that perception and that engagement into art.

O'Keeffe's creative approach was more to streamline than to distill or

transmute. She simplified and "streamlined" the appearances of places and things, rather than immersed herself in their actuality, transforming that actuality through color, form, texture, line, into art.

Her "icons" and "symbols of universality" do not, as a result, ring quite true. They are certainly handsome and evocative, even genuinely beautiful in many ways. And a large number of them are definitely works of art.

But they are more lovely and fanciful than genuinely provocative or moving, are more to be looked at than experienced. In their cool, detached, and stylized elegance, they represent, at least to me, an avoidance of the fullest and deepest textures and dimensions of life. The fact that she avoided these dimensions has absolutely nothing to do with being a woman — or with being a man. But it has everything to do with being a human being or an artist of a certain sort.

Finding Art in the Everyday

CAN art lie? Or is it truth-speaking by definition?

I've posed this question to several artist friends, and their answers are as varied as their art and their personalities. The majority of them, however, feel that art is at least truth-*seeking*, that its basic impulse is toward clarity, and that its ultimate purpose is to illuminate man's path toward greater self-realization.

Now I know this sounds grandiose and a little pompous. And it would probably seem even more so if these artists' works were reproduced on this page, for what they believe about art and what their art seems to represent, would appear to be two different things entirely.

One of them paints little "squiggles" of pure color that hop and prance about on canvases roughly one-foot square; another creates complex figure compositions in which every detail interlocks as precisely with every other detail as pieces in a jigsaw puzzle; a third erects severely "abstract" structures out of steel which he then balances upon chunks of rough hewn wood; a fourth makes huge drawings consisting entirely of gradations of black and gray; another draws tiny rectangles in the middle of otherwise empty canvases; and a sixth does incredibly precise renderings of tiny "incidental" things in nature: twigs, leaves, feathers, pebbles, or dried tufts of grass.

Each of them works in a style totally unlike that of the others — and doesn't particularly care for what any of the others are doing. And yet each one believes that his own work is, at the very least, truth-seeking, if not actually truth-speaking.

The wonderful thing, as far as I'm concerned, is that all of them speak the truth through their art.

Now, how can that be? How can six artists representing six widely divergent philosophies and styles all speak the truth? Is there no such thing as a truth in art? Or at least a hierarchy of "relative" truths with one, more "perfect" than the others, at the top? There are those who insist that there is indeed only one "truth" in art for every time and place, and that it assumes a traditional or otherwise agreed-upon imagery and style that is best suited to it. Thus, Greek, Assyrian, Egyptian, Chinese, and 13th century Italian art is immediately recognizable for what it is. And any art historian who cannot differentiate between a drawing made in Florence in 1520 and one made in Nuremberg at the same time just isn't worth his salt.

These individuals, looking for what is most significant about 20th century art, see it divided into a half-dozen or so basic categories, but most specifically into representational and nonrepresentational camps — with "realistic" art fundamentally and totally at war with "abstract" art. It is interesting that this view is still held this far into the century, and that it appears to represent a profound rift in our perception of the visual arts. Be that as it may, this split only focuses attention upon the position held by the individuals mentioned here. And that is that, since art history indicates that all previous cultures had one dominant (and often only one) artistic style, it must be true that only one of these contemporary trends can be the "true" one for us today.

The problem with this position is that it represents a perception of art that places the main emphasis on its appearance rather than on its function. It sees art as a succession of attractive, interesting, and impressive *things* rather than as devices created to illuminate and to bring into focus hitherto unexpressed or even unsuspected dimensions of experience and truth. It sees art, in other words, as existing largely for its own sake, as an end in itself, and not as a window permitting access to the unknown and to the as yet unformulated.

If there is one thing this century's experience with art should have taught us it is that art is a transmitting device, not a collection of things. And that to judge a work of art on the basis of its style is as silly and beside the point as judging the truth of a message on how fashionably the messen-

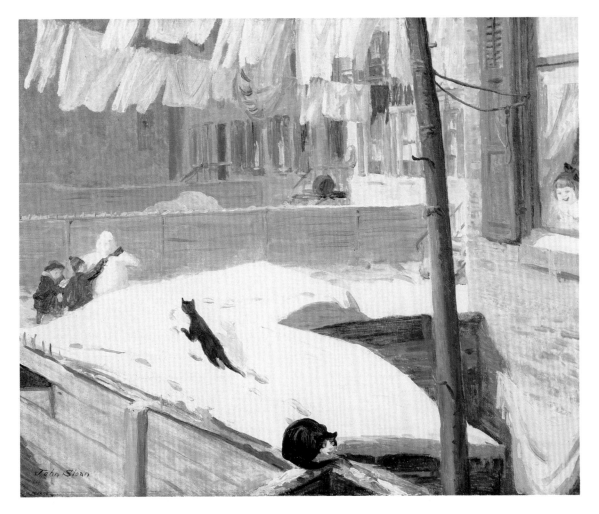

John Sloan
Backyards, Greenwich Village, 1914

ger bringing it is dressed, or on the richness of the paper upon which it is written.

Now, I do believe there are dimensions of reality that are so fugitive and ephemeral that they can best be brought to our awareness by the most intuitively sensed and projected of "abstract" forms. And that, confronted by such forms, we sense their truth by their resonances, their formal integrity, and the way they burrow into and remain a vital part of our most inner and private values and feelings.

But I also believe that there are aspects of reality that demand more specific and more physically identifiable images and forms in order to achieve actuality as art. Certain feelings and attitudes toward human experience, for instance, demand the use of human forms in order to make their point. To insist that the early Picasso, or Rouault, Nolde, Beckmann, Kollwitz, Moore, Hopper are any the less artists because they are not "abstract," is like saying that an apple is not a fruit because it is not a pear.

It is utterly simplistic to insist that anything as rich, complex, and multifaceted as reality can take only one form or style as art. Once again, to think so, is to see art as a thing rather than as a reflector, a mirror, a transmitter of truth, and to misunderstand its nature and function just as we would fail to understand the nature and function of a telescope if we studied only its form and didn't use it to examine the stars.

The search for artistic truth has dominated this century's art. It was a matter of particular importance to very early 20th century American painters since their world was dramatically divided among the academic, the "modern," and those who saw painting in starkly realistic "everyday" terms.

Among the latter was an ex-newspaper illustrator named John Sloan, who had been one of the original members of "The Eight" — better known in later years as "The Ash Can School" for its unswerving devotion to the most mundane of subjects. Sloan was a painter and etcher for whom artistic truth consisted of giving pictorial form to the everyday world around him. In his case this meant the streets, backyards, stores, apartments, and rooftops of New York City.

Although very concerned with formal matters, and a great believer in pictorial order, Sloan focused most of his attention upon capturing the precise flavor and texture of everything he painted — be it a person, a crowd, a street scene, or the activities in someone's home. In the process, he investigated and recorded as much of New York life as anyone ever has and left us an authentic account of what life was like in that city during those years.

What impresses me most about these early works of his, however, is their starkly authentic atmosphere and mood, their remarkable sense of the *actuality* of life and of living. We know, looking at these works, that the man who created them really lived, and that what we see before us, dressed up in the guise of a New York street scene, or a snow-covered backyard, is how he felt about life, and what it meant to him.

At the bottom of all theories and philosophies about art, what any artist wants most passionately is one other person on the face of this globe who will be able to share what is most precious and real to him through his

art. This can be an ideal, a belief, a faith, a sense of fun, a tragic vision of life, a particular delight — or it can be his or her sense of the reality and texture of life.

John Sloan belonged to the last category. He was a painter who created art in order to share his sense of life — not as he would have preferred it, but as he actually felt and experienced it. Nothing was as real to him as the life he lived, as it *was* — and that is what he chose to paint. It was his truth, the crux and "message" of his art.

What Links Dürer and Milton?

*I*F Dürer were alive today, and making prints in the style for which he is now so universally acclaimed, we wouldn't know what to make of him. His extraordinary draftsmanship and stunning technical skills as a printmaker would confuse us, and I'm certain any number of well-meaning art lovers would suggest to him that he "loosen up" and try to be less controlled and "tight." I wouldn't be surprised either if someone took him aside and gently hinted to him that he attend a contemporary printmaking course to catch up on the latest graphic ideas, methods, and trends. And that he try to bring his art up-to-date by studying what the successful printmakers of today are doing.

He would be startled by what he saw. Not only by the many technical innovations — many of which would fascinate him — but also by the richness, inventiveness, and complexity of the imagery that 20th century artists have seen fit to put into graphic form.

I suspect he would be particularly surprised at the many ways color has been brought into printmaking, and the ease with which an increasing number of contemporary artists transcribe their painterly ideas into one or another of the graphic processes. Or invent new ones, should the existing modes be found inadequate.

He would be intrigued by the way photographic images are combined with collage effects and with pure drawing to create complex, ambig-

uous, and often huge works that bear absolutely no resemblance to any prints he had ever seen. And by the ease with which highly complicated feats are accomplished by purely mechanical means.

And yet, when all was said and done, and Dürer had seen everything new there was to see, and had tried it all, I have not the slightest doubt that he would, at least at first, go right back to his old way of making prints. Not because he was reactionary, but because nothing he saw in printmaking today could match the sheer quality and grandeur of what he himself had produced almost 500 years ago.

I'm certain, however, that he'd remain very alert to all that was going on. And would, considering how original and innovative he was in his own day, eventually incorporate a few "modern" devices into his prints.

What he would *not* do, however, would be to abdicate control over his ideas, craft, or forms. And neither would he throw overboard his technical skills in the name of "truth," fashion, or contemporary notions of "self-expression." Whatever else he might do, I doubt very much that he would make the late 20th century mistake of believing that drawing as he practiced it is dead, that printmaking as he practiced it belongs only in the art history books and on museum walls.

He would not, in other words, accept the altogether too popular belief (at least in certain quarters) that modernism is a "corrective" for the errors and misconceptions of the past, or the notion that a new idea, once advanced, immediately negates all that went before.

One of today's most pernicious art-historical and art-critical attitudes equates artistic creativity with scientific discovery, and the artist's studio with the scientist's laboratory. Seen this way, a particular creative act is one of a sequence of similar acts leading toward the resolution of a specific problem or the discovery of a particular truth, and is of value or importance only if it specifically answers that need or "reveals" that truth.

Thus Cubism is important and is art because it advanced and "clarified" certain of Cézanne's formal ideas. And Mondrian's art is valid and of value because it projected Cubism's analytical particularizations into ideal and metaphysical areas — and thus established a formal premise and a precedent for several generations of abstract painters.

The only problem with this view of art is that it leaves out the individualist who speaks entirely from his heart, the maverick who follows no road but his own, and the artist whose art reflects an extraordinary reference to cultural problems or issues.

This exclusion of the individualistic and the idiosyncratic is very ev-

Peter Milton
Daylilies, 1975

ident in contemporary printmaking, at least as far as the influential print curators, critics, and collectors are concerned. These individuals will often exhibit, praise, or buy expensive graphic rehashings of the paintings of fashionable contemporary favorites and will ignore exquisite and lovingly hand-printed etchings or engravings by relative unknowns at one-twentieth the price. Prints that will sing out with their own special vision of life for centuries to come — provided someone collects and protects them.

One of the tragedies of the contemporary print world is the assumption that the only real difference between a painting and a print is the fact that the first is unique, that is, that it exists only in the original, while the latter comes in multiples; there may be two impressions of a print or several hundred. Any painterly image can be turned into a print if one knows the appropriate graphic process.

The fact of the matter, and this is where Dürer (and Rembrandt, Goya, and Picasso, for that matter) would be most adamant, is that print-

123

making is as separate a creative activity from painting as playing a piano is from singing a song. And that, until we once again realize this, and make it a central factor in our evaluation and understanding of fine prints, we will fail to produce a significant body of prints that is uniquely *graphic* in identity, form, and expression.

This is an age when almost every painter thinks he is also a print-maker, and almost every major museum exhibition of prints shows more technically inventive and mechanically contrived wonders than works that are truly graphic. For this reason, it is a distinct pleasure to come upon an occasional etcher, lithographer, engraver, who sees, conceives, and expresses his creative realities strictly and entirely in graphic terms.

Peter Milton is such an artist. He is also one of the very best. His generally large and extremely complex prints have already carved out a unique and distinctive place for him in 20th century printmaking. And, while there are those who see his art as too precious and obscure, there are also those who see him as probably the major 20th century heir to the rich and idiosyncratic print tradition of Giovanni Piranesi, Rodolphe Bresdin, and Odilon Redon.

Milton works entirely in black and white. He is a consummate wizard at conjuring up fantastically detailed human, animal, and architectural im-ages out of literally thousands of nearly invisible lines and dots, and then placing these images in exquisite counterpoint to photographically derived, but subjectively translated and integrated, forms. Although he is an excep-tional draftsman and a past master of "traditional" etching, the roots of his art lie almost as much in collage and photomontage, in photography and films, as in the traditional subjects and techniques of printmaking.

His is an illogically logical world within which many odd and per-plexing things happen, all of which, however, make ultimate sense in a strange and wonderful way. A gentle melancholy pervades his prints, a faint and subtle remembrance of earlier times, of dreams, and of hidden desires. To spend time with them is to enter a world totally unlike and yet remark-ably like our own, a world within which our 20th century realities, hopes, fears, dreams, desires, are magically transformed into an imagery that is clearly and beautifully realized in purely graphic terms.

Although their work is very different, I can't help but feel that Dürer would appreciate Milton's prints. At least he would recognize them as prints, as living examples of a way of perceiving and articulating reality that goes all the way back to antiquity — and which will, I hope, continue on even further into the future.

How Does an Artist Grow?

*S*IGNIFICANT creative growth is neither the goal nor the achievement of every artist. Altogether too many so-called creative individuals are essentially the same at 60 as they were at 20. They may have mellowed a bit and be able to express themselves a little more clearly through their work, but the quality, depth, and range of their art remains pretty much as they were during art school and early career days.

This lack of growth has less to do with talent than with attitude and imagination. It often results from the notion that art is more the perfection and application of skills than it is the symbolic recapitulation of insights into the quality and nature of life, more the working out of technical and formal problems than the resolution of perceptual or philosophical inconsistencies and ambiguities.

Growth in art implies movement, change, the leaving behind of earlier and "lesser" stages of understanding and actualization. It suggests a struggling or a groping toward a goal — be it clearly or dimly perceived. But most of all it reflects the most fundamental and imperative aspects of life: its dynamism, openness — and its unlimited fecundity.

Growth is easiest within a healthy and clearly defined tradition. Such a tradition not only helps the artist discover his creative identity rapidly and with precision, it also presents him with specific goals, and with the basic physical and symbolic tools necessary to achieve them. Given such a tradition, and equipped with the necessary genius or talent, an artist can evolve and grow to the point where he represents the high point of that tradition. Or, on a few rare occasions, he can become its actual flowering, its "fruit."

Today's artist, however, has no such tradition. At best he may have the example of an older artist whose style answers most of his own needs, or be the heir to a shaky kind of "mini-tradition" that permits two or three generations of painters to shape their art according to the precepts of one or two powerful figures.

Even Picasso, certainly one of the outstanding geniuses of all time, had no tradition greater than himself upon which to graft his art. And, as a result, he spent his incredible lifetime endlessly reasserting the truth of his insights in one newly invented form after another.

The question is: Did Picasso grow? Or did he merely change over and over again? I would say that, after 1925, he changed more than he grew — but I must add that I think it was through no fault of his own. If, in a way, he then resembled the proverbial bull in a china closet, smashing everything in sight, it was not because he wanted it that way, but because his genius found nothing in our culture capable of providing him with the artistic structure, focus, or momentum required to achieve the sort of grandeur reached by Giotto, Masaccio, Michelangelo, or Cézanne.

Someday I hope that a truly thorough exhibition will be attempted in which the outstanding works of the greatest geniuses of the past 500 years will be displayed together. And if that is impossible, I would like to see a two-man exhibition of Michelangelo and Picasso.

Both were giants of the first order. But where Michelangelo fulfilled himself in and through a living tradition — became, in fact, one of its crowning glories — Picasso flailed and floundered about like a whale out of water. Michelangelo challenged gods and giants and won. Picasso, with all the tools of greatness at hand, found nothing great enough outside himself to engage or challenge, and so spent the last 50 years of his life challenging himself. *Guernica*, important and magnificent as it is in many ways, is only a twisted, frustrated, cartoonlike indication and promise of what he could have achieved had he been truly encouraged culturally.

Picasso taught us all a lesson: lower your sights, for the Greek, Roman, Renaissance, and Baroque notions of artistic greatness apparently no longer apply. Only the Abstract Expressionists disagreed, and they were ill-equipped to prove art history wrong. Their heroic stance, and total dedication to a monumental ideal, led nowhere — except to the absurdities of Pop art and other recent "artistic" endeavors.

There have, however, been a few contemporary artists who held to the concept of greatness — often in human as well as in formal terms — and who sought it out. Among these have been Mondrian, Rouault, Matisse, Morandi, Kollwitz, Klee — to name only those that immediately spring to mind. And, in our own day, among a handful of others, Richard Diebenkorn. I saw my first Diebenkorn painting in a regional exhibition in San Francisco in 1952. There must have been a good hundred or so jury-selected paintings on view, all of them accomplished in one way or another. Diebenkorn's painting, however, stood out like a pine tree among willows. Not because it was unusual in any external way, but because it was so formally and technically intact — obviously painted by someone who was, heart and soul, a painter.

Richard Diebenkorn
Untitled #33, 1981

It just simply *was* a painting, the way a tree is a tree and a rock is a rock — something that is true of far fewer works on canvas than we like to admit. Most pictures are mechanical and relatively lifeless "robots," serving out their temporary terms of effectiveness on borrowed ideas and forms. Only rarely do we come across someone who *is* a painter, whose work exists with an identity and a reality — a life — of its own, whose earliest attempts at painting, while they may look like mere daubs, declare to the world that pure gold will be mined from this artist once he realizes his potential.

Diebenkorn is such a painter. It was obvious when he was a very young man, and it is obvious now that he is a painter of increasing world stature. The wonderful and remarkable thing about him, however, is that he has never rested on his laurels, has never merely allowed his talent to enjoy itself, or to reap its little harvests as so many painters of talent have done. But he has placed his abilities and his insights into continuing dialogue with our culture and our times, and has constantly grown as an artist as a result. Following his career these past 30 years has been very much like reading a fascinating novel — with every yearly exhibit a new "chapter" to be "read" and savored. Even when he occasionally seemed on the edge of disaster, most particularly during his figurative period of the late 1950s and early 1960s, I always knew he would somehow emerge with flying colors, and with paintings that were even finer than any he had done before.

That he has done so is now part of recent American art history. The works in his *Ocean Park Series*, a series of generally very large, muted, and geometric canvases, are among the most beautiful (no other word will do) paintings executed since World War II. They are also among the most significant, for they both sum up and transcend a great deal of what has gone on in 20th century modernism.

He has now entered a new phase, and is both groping toward and realizing new dimensions of painterly reality. He risked a great deal by doing so, because, to an extent, it meant beginning over again, shifting direction and focus and leaving behind the extraordinary levels of artistic and financial success he had achieved.

His recent exhibition, which included *Untitled No. 33, 1981*, was a remarkable demonstration of both creative imagination and intellectual persistence, a sort of advanced artistic seminar in which all who attended participated to the degree of their understanding of the ongoing 20th century modernist debate. It was also the occasion for viewing some of the most heartbreakingly beautiful, if still somewhat tentative, painterly statements made in recent years.

But most of all it was a celebration for a man with a talent who has continued to grow. And who has done so without a longstanding tradition to support or direct him. Who has carved a path and has followed it because he sensed, because he *knew*, that something more lay ahead.

Drawing: A Highly Intuitive Act

ARTISTS don't sketch outdoors as much as they once did — and I for one think it's a crying shame. I suppose they feel they don't have to, now that working from photographs is considered legitimate — to say the least. And landscape art as a whole is considered of less than prime importance.

There are exceptions, of course, but the sketches and drawings produced by those artists never seem to get out of their sketchbooks and portfolios and onto gallery or museum walls. And when they do, it's obvious that they are being exposed to public view only to indicate the source of a particular painting, or to illustrate the various steps the artist took toward its completion.

What I miss are the landscape sketches and studies that exist as full pictorial statements in their own right. There can be no doubt, for instance, that Van Gogh's ink studies of the landscape through which he tramped every day were final statements and not intended as studies for paintings. And the same is true of the landscape studies of Cézanne, Palmer, Constable, Claude, Leonardo, Bruegel, Rembrandt, and Dürer — to mention only those whose contributions to this form of art were particularly noteworthy. There have also been a few such artists in this century, most particularly Nolde, Marin, Burchfield, Sutherland, and Wyeth. By and large, however, landscape drawing as an end in itself has become pretty much of a lost art. It's true that there have been some stunning drawings of the Maine coast by Stow Wengenroth, and of Iowa farms by Grant Wood, but they were really studies for prints. And the sketches of Curry, Benton, Hopper, Nash, Har-

James Schmidt
Near Troutbeck

tley, and Dove had too particular a connection to specific paintings to really fit into this category.

What disturbs me most of all about altogether too many of the landscape sketches and drawings attempted by our younger artists today is that they tend to be almost entirely topographical, coldly detached, and mechanical. There seems to be little awareness of the expressive potential of paper, and even less sensitivity to the manner in which such paper can be transformed from a flat surface into the representation of light, space, and air. It seems to be fashionable today to draw strictly *upon* the paper's surface, to

"lay" the image *on* it as though it too were flat and lifeless — rather than seeing the paper's surface as space itself, as something to be "entered" and roamed around in with pencil, pen, or brush.

Why this should be so lies beyond my comprehension. Have we forgotten so quickly that much of the magic of a great Chinese or Japanese brush drawing, or of a sketch by Rembrandt or Van Gogh, lies in the extraordinary manner in which the paper itself has been "activated" and brought to life by a few well-placed lines or splashes of ink?

A true drawing, as opposed to a mechanical rendering, exists *within* the universe opened up by the artist's sensitive transformation of the paper's flatness into a representation of space. It does not — ever! — lie inertly on top of it.

For anyone who truly loves to draw, the paper, be it pure white or tinted, is a living thing, a universe whose creative potentials are limited only by the artist's talent and imagination. To merely touch it with the point of a pencil is to begin a creative journey, and to move "into" it with lines, textures, and tones is to create forms, shapes, movements, *things*, that have a life of their own.

This won't happen, however, if the paper remains just paper, if it isn't seen as a stage, or as a viable and dynamic participant in the creative act. I simply cannot understand why this elementary and obvious fact isn't the first thing taught at the beginning of the first class of the first year of art school. And why, most particularly, it isn't stressed and stressed again during all student attempts at landscape drawing.

I remember coming across a young man sketching a hillside full of magnificent trees in Central Park a few years ago. His drawing was brilliantly alive with light and form. And yet, as I drew nearer, I noticed that it consisted of nothing but a few dry-brush lines and smudges sketched in to suggest shadows, and that a good 97 percent of that passionately alive drawing was nothing but pure, untouched white paper. It was a beautiful demonstration of the fact that in art, *less* is often *more*. And of what all great draftsmen have always known: that two or three perfectly placed lines can have a greater impact than a thousand indifferently placed ones.

There is, unfortunately, little public interest in drawing, a fact that has communicated itself to the gallery world, and to the artists themselves. A goodly number of talented draftsmen, as a result, have stopped drawing in order to rush into color and paint. While this has often led to excellent results, it has also led to some disasters, for not everyone who can draw can also paint.

131

One artist who is perfectly capable of both is James Schmidt. His lively, generally semi-abstract and colorful paintings reflect a long-standing involvement with the issues and ideals of 20th century modernism. They are the works he produces from fall through spring, and the works he generally chooses to represent himself professionally.

In the summertime, however, and most especially while traveling abroad, Schmidt prefers to draw — something he does with remarkable agility and grace, and with that flair, exactitude, and grasp of place, character, and mood that distinguishes the natural landscape artist.

Most specifically, he has the knack of capturing and evoking the special qualities and personality of a particular place. If he is sketching a low mountain from which a harsh Mother Nature has plucked all but a few huddling woods and trees, we can rest assured that not only will he capture that note of harshness and survival, but that he will also see to it that the mountain itself "sits" properly in its appointed space, and that the light that bathes it is perceived and presented in all its peculiar quality and tone.

By evoking all this, rather than describing it coldly and clinically, Schmidt allows us to share with him a goodly number of his perceptual experiences. As a result, we are, in a sense, with him in the English countryside or on the Scottish moors while he is sketching away. And this sense of participation, coupled with his sharp eye for both the generalities and the specifics of a place, are what give his landscape sketches and drawings their exceptionally authentic and "lived in" air.

They are also remarkable demonstrations of how to use the felt pen and paper most effectively. One senses, in looking at his drawings of grasses and boulders, of exposed roots and tree trunks, of rolling fields and winding roads, that his hand moves at pretty much the same speed as his eye. And that his hand creates and invents the hundreds of tiny and large graphic approximations of what he sees with a freedom and verve, with an imaginative liveliness that takes him almost as much by surprise as it does us. And that the pen he holds hops and prances about on and within the paper like a frisky and merry rabbit — with the artist himself in hot pursuit.

This form of creativity, unfortunately, is very much underrated today. For all our declared love and respect for intuitive creative processes, we seem blind to the fact that drawings produced by a hand and an eye moving at top speed to register, with precision, the nature and the range of the perceptual act itself, represent as intuitively creative a process as any we are apt to encounter.

The art of drawing, once it gets beyond the point of mere description

or reporting, is a highly intuitive act. And for the simple reason that the artist, looking at the world around him for something simple and direct through which to represent what he sees and feels, at some point lets his eye and hand take over. And they, given their head, then lead the way and intuitively make the countless tiny and major creative "decisions" that add up to what drawing is all about.

Art Unified, Consistent, and Whole

I would like to take exception to the currently fashionable dogma that art can have no significant effect upon human destiny because it has failed to prevent even one war, avert even one catastrophe, or block even one tyrant.

German Expressionism, the argument goes, for all its profound human and political concerns and passionate warnings, could not delay World War I by even so much as one hour — and exercised absolutely no deterrent upon Hitler's rise to power. And Russian Constructivism, for all its working class commitments and social idealism, could do absolutely nothing to stop Stalin's totalitarian state — and was, in fact, itself destroyed by it.

Although these are the most dramatic examples trotted out to prove art's failure to affect the course of human destiny, they are by no means the only ones. Every artistic idea or style that was carried to any degree of realization has been confronted with the question of what genuine effect it has had upon anything except the course of art itself. And the verdict, handed down by those who accept this dogma, has invariably been negative. It has been that art, for all its good intentions, has had no real authority, is really nothing but a passive reflection of individual and cultural attitudes, experiences, and ideals.

I couldn't disagree more if someone told me that love has had no significant effect upon human destiny because it has failed to prevent wars, catastrophes, or the rise of tyrants. Or that good faith, respect for one's fellowman, or a belief in transcendent values were of little cultural significance for very much the same reasons.

Unless I'm very much mistaken, I've detected a note of gleeful satisfaction on the part of several critics and writers who have been particularly quick to condemn art for this "failure." I'm left with the impression that it pleases them somehow that art has "fallen on its face" trying to accomplish things beyond its supposed capabilities. They seem pleased that art, having done so, will have learned its lesson, and will now return, like a good little boy, to its neat squares and circles, its handsome colors and lovely designs, and leave the really important matters to the "grown-ups."

The trouble with this point of view is that it is predicated on the notion that art is primarily the creation of more or less perfect *things*; that the more "perfect" in form these things are, the greater they are as art; and that, therefore, anything that contributes toward this "perfection" is good, and anything that detracts from it is bad — and does not belong in art.

In other words, it is better to paint a perfect circle, signifying nothing but its own "perfection," than to paint a highly complex but not quite "perfect" work attempting to give symbolic form to a profoundly disturbing human reality or situation. Or, to be more specific, it is better to have created a "perfect" Arp, Malevich, or Noland than to have painted an "imperfect" *Guernica.*

The truth of the matter is that Picasso's *Guernica*, flawed as it might be, is worth a hundred "perfect" works by Arp, Malevich, or Noland — not only because it is a formidable formal exercise, but also because it will challenge human conscience for centuries to come. The other artists' works, on the other hand, will only be remembered — if they are remembered at all — as handsome objects, or as representative of certain 20th century formal ideas.

The important thing to remember — and I cannot, for the life of me, understand why this is not better understood — is that art is not primarily a matter of *things*, but of ideas, feelings, emotions, ideals, qualities, perceptions, given form and projected *through* things, and that art, at its truest and deepest, is not something merely to look at and to admire, but is something to confront, engage, and involve oneself within. That it is, in short, an active process, not a passive state.

Now, it is precisely this active and dynamic quality that has been so crucial to the art of the past century, and that has given it so much of its character and meaning. This has been a restless and an anxious age, and a very insecure one. Art has swung, as though on a pendulum, from one extreme to the other — and has taken a more "far out" position every time it has done so.

Paul Cézanne
Man With Crossed Arms, ca. 1899

And yet, underneath it all, it has been art, in every one of its manifestations, from dance to poetry, that has tried most desperately to come to grips with and to symbolically resolve the great issues and questions of our time. That it has failed seven out of ten times to do so, and has failed to affect the course of world affairs to any obvious extent, should not be held against it. And, most important, that "failure" should not be used as a club to force art back to its neat little pleasantries and smug islands of conformity.

It should rather be applauded for its heroic attempts to prove that reality and truth are perceivable and attainable — if only for a split second or only on a symbolic level. It should also, however, be very clearly understood that art, while it may set up goals and ideals, project qualities and values, inspire and instill hopes and good faith, is only the transmitter of these realities, never their instigator.

Art can only do as man directs, consciously or unconsciously. And so, if anyone is to "blame" for art's failure to affect the course of world affairs, it must be man. Art's potentials for true greatness and importance have not yet, I'm convinced, been truly tested. Once — and if — they are, I think we'll be astonished at what art can do.

What it has already accomplished, however, during the past 100 years is astonishing enough. During that period we have had one truly great painter, Paul Cézanne, another magnificent artist, Pablo Picasso, whose greatness may still be in question but whose genuis is not, and still another genius (or near-genius) by the name of Henri Matisse. We have also had a handful of other artists of only slightly lesser caliber or vision, from Braque, Rouault, de Chirico, Brancusi, to Klee, Mondrian, Morandi, Calder, and Pollock.

Cézanne, however, towers above the rest, not only because he was one of the most original and truly revolutionary artists of the past several centuries, but also because he was the major "gate" through which Western painting passed, in order to become 20th century modernism.

His true greatness, however, lies in something very subtle and difficult to define: his extraordinary ability to give form to a perception of reality that is unified, totally consistent, and whole, and in a manner that activates a similar perception in the alert viewer.

I remember the excitement with which a friend of mine described his first real encounter with a Cézanne painting. He was at a museum looking at paintings in his usual art-historical and basically intellectual fashion, when he came upon a Cézanne landscape. He studied it for a while, and decided to forgo analysis and to try to "give over" to it, to try to "enter" it. He

concentrated on the painting for a few moments, and then, very gradually, became aware that, in a way he still doesn't understand, it was beginning to engage his perceptions and sensibilities, and was slowly but inexorably, altering them to conform to *its* perceptual realities.

He described it as very close to a visionary experience, in which his vague and slightly disjointed everyday feelings and perceptions were redirected to give him a glimpse, *as experience*, of something whole, intact, and complete. Even more important, it left him feeling alert, focused, highly energized — and convinced that he had been on the threshold of something deep and mysterious.

Others have described similar experiences with Cézanne's paintings. And I myself have found that nothing can pull me together and redirect me as simply and as lyrically as a painting by that artist.

Man With Crossed Arms is a particularly good example of a Cézanne painting that has, over the years, exercised its remarkable effect upon me. Viewed simply as a painterly object, as a thing, it is rather unimpressive and ordinary-looking. But, if it is identified with and experienced as a clue, as a guide to a deeper and more total perception of reality than the one we normally have, viewing it can be an action-altering event. As an object, neither it nor any other Cézanne painting has prevented any wars, but as the expression of an idea, and as the activator of a deeper awareness of reality and truth, it exists as a means to undermine or dissipate the insanity that leads to war.

Rothko: Art as Meditation

*L*OVE is very much a part of art. We paint pictures of our loved ones, and manage, in this way, to communicate something of what we feel for them. We do the same in paintings of favorite dogs and cats, houses, and land to which we've become particularly attached; beautiful scenery we remember fondly; and the things, large and small, that make up our lives.

We also use art to shape and convey a love for order (Cézanne), ideal form (Brancusi), color (Matisse), or any number of other qualities, ideals,

and ideas. And it is certainly true that the relationship between the artist and his art form is often a passionate and lifelong love affair.

Love has also been the subject of art — witness the numerous French paintings of the mid to late 18th century devoted to the more secular aspects of this subject, and the many English pictures of the 19th century in which love's more spiritual nature is examined in great detail.

Love is also expressed through the way paint is handled, or the way wood or clay is treated. There are artists who caress and handle special kinds of paper as though they contained the secrets of the universe or the greatest art in the world — which of course they do if only they could be brought out.

But for all of this, it is color that seems to embody love most simply and openly, and that gives vent to painting's most lyrical and loving out-pourings and effusions.

Color can do almost anything in art and in life. It can touch the lowest and deepest notes of human experience, or it can hop and leap about as merrily as the happiest of gazelles. It can move us, delight us, excite us, and enchant us. But most of all, and this is true for all of us but most especially for those painters in love with color, it can cause the human heart to soar and to sing.

Color has the capacity to burst, to explode, even to match the effects of fireworks. One reason for this is that color is actually light, that is, every color is a "facet," a "splinter," of pure light, and is as much a part of light itself as an arc is part of a circle. Every color has a very special "dependency" relationship with every other color. Blue, for instance, is every bit as "incomplete" in itself as is the shard of a broken pot, or the number "2" of a total of 12. Colors, consequently, interact in very special ways and according to very precise laws. Blue mixed with yellow produces green. Blue mixed with red produces violet or purple. And should we mix all the colors together evenly and carefully, we would, ideally, end up with pure white. (The fact that we cannot make this happen is the fault of impure paint pigments and the inclusion of binding agents.)

A great colorist is a great dramatist, for he knows that the secret of color lies in manipulating the tensions existing between individual colors and not in giving them all equal weight or emphasis. Thus, a colorist such as Matisse will achieve his desired effects by decreasing the number of colors and maximizing the tensions between the ones he uses. In other words, were he working with numbers instead of colors, he would not state that $2+2+2+2+2+2=12$, but would, rather, say that $4 \times 3 = 12$, that

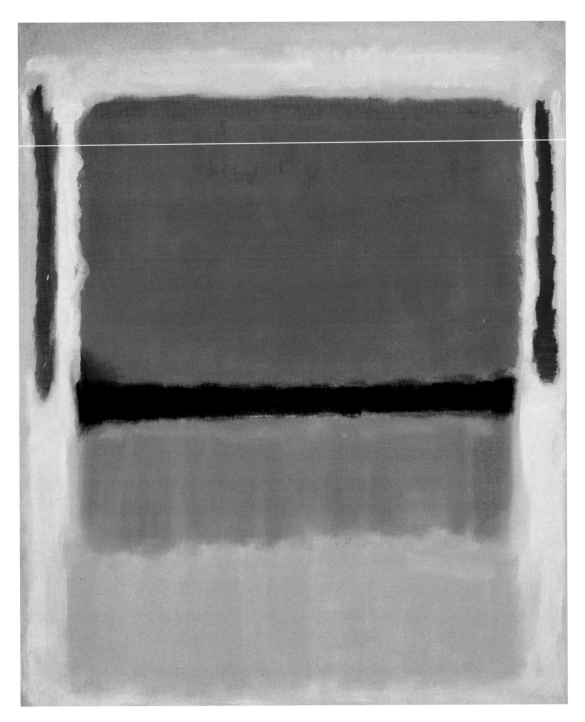

Mark Rothko
Violet, Black, Orange, Yellow on White and Red,
1949

$11\frac{1}{9} + \frac{8}{9} = 12$, or possibly even that $19 - 7 = 12$. He would, in short, try to create coloristic drama, and would leave the flat and unimaginative laying-out of color to beginning artists or to those with a poor color sense.

Since colors, like chemicals, can result in some rather startling effects when brought together, it's a crucial part of an artist's job to know what these effects are and how to bring them about. Toward this end, both intuition and science (in the form of color analysis and theory) have been brought more consistently into play today, often with remarkable results. Never-before-seen color combinations have sprung up in great profusion during this century, both because color has been intensively studied as never before and because color has achieved a level of autonomy it has never before known. With this autonomy, painting, freed from the necessity to use color in a descriptive and "realistic" sense, surged forward toward full and free color-expression much the way a hunting dog will bound toward its prey when released from its leash.

Color burst into the limelight in this century with the Fauves, and has never really taken a backseat since. One reason is the way artists themselves now see color. Kandinsky, for instance, wrote of the spiritual nature of color, and Paul Klee saw it in musical terms. And Robert Natkin speaks of using color as a verb — a concept, I suspect, no premodernist painter, except possibly Rubens and Delacroix, would have understood. But then, would our great modern forefathers Cézanne and Van Gogh have understood the totally subjective way color was used by the Abstract Expressionists or by the literal manner of the Minimalists? I doubt it. They would, I'm certain, have thought some of their color effects handsome and intriguing enough. But art? I rather think not.

What we would have no difficulty explaining to the artists before our time, however, would be color's effect upon us, its ability to move, excite, delight, or enchant us. That, apparently, has remained quite constant through the years.

Mark Rothko's paintings are a good case in point. I'm convinced that anyone from the past, even Raphael or Dürer, attending Rothko's retrospective at the Guggenheim Museum a few years ago, would have immediately grasped the broodingly interior, slightly melancholy, and occasionally even somewhat tragic nature of his art. And they would have gotten the message entirely from his color, since nothing else in his paintings would have made any sense to them.

Rothko produced some of the most hauntingly evocative paintings of this century, and he did it largely through color. True enough, size and

scale (many of his canvases are huge), the severe frontality of his images, and the subtle modulations of his surfaces were also important. But it was color that carried the main expressive burden of his mature art, and carried it well.

It was color, however, that was underplayed and kept to a minimum, and consisted generally of reds and browns, with a little black, an occasional blue, and often a slender sliver or shaft of off-white, yellow, or ochre. If Matisse's color reminds us somewhat of jazz music at its liveliest and most jubilant, Rothko's conjures up cellos and basses playing softly — with a touch of flute here and there as an accent, and to add a note of poignancy.

The result is a somber and deeply meditative art that quietly draws us in, enfolds us, and releases subtly metaphysical resonances and intimations within us. But for me it does even more. To a greater extent than any other art of recent years, Rothko's best paintings force me to confront myself and to concern myself with my identity and destiny. In front of (within) his best paintings, I stand utterly and searchingly alone.

Nothing could be simpler, and yet the work reproduced on page 139 represents the distillation of a profoundly sensitive and caring man's deepest intuitions about life and art. Intuitions that would, over the remaining 20 years of Rothko's life, take these basic forms, colors, and relationships and continually hone them until they represented the very finest and subtlest points and nuances of his insights and sensibilities. And by doing so, create some of the most questioning and moving paintings of this century.

Art as a Public Event

To see art as a public event is as old as the hills. From the earliest cave paintings and rock carvings to the most recent of Christo's outdoor projects or Oldenburg's monumental sculptures, art has served in the performance and celebration of religious rites and rituals, formal state and festive social occasions, and large-scale public recreations.

Evidence of the grandeur and the mystery created and evoked by our ancestors through public art lies scattered throughout the world. Stonehenge, the Egyptian pyramids, the Great Sphinx, the stone images of Easter

Island, the monuments of ancient Greece, Persia, Rome, and China — the list seems endless and is unbelievably rich and varied. And yet, dramatically dissimilar as these works may be, they all have one thing in common, they were conceived and designed to serve the public good.

Art created for communal purposes can also be found in any museum of "primitive" art, or anywhere in the world where age-old customs and traditions have remained largely untouched for dozens of generations. Works as diverse as wooden figures from New Guinea, masks from the African Ivory Coast, or Navajo sand paintings all represent an attitude toward art that is primarily social and public rather than individual and private.

This attitude is difficult for most of us today to understand, accustomed as we are to the notion that art is primarily a matter of an artist's "self-expression" or of private contemplation and enjoyment by the rest of us. The idea of a communal style serving the entire community rather appalls us. We prefer to shop around in art history and among the dozens of contemporary art movements for the one style that best suits our purposes. As a result, the cultural landscape is cluttered with bits and pieces of older and more recent styles, all mixed together and indiscriminately admired.

The few attempts made in this century to create a universal modern style have all proved too narrow, too ideal, or too impractical — or too dependent upon the genius of one or more individuals. Russian Constructivism was destroyed by Stalin, Neoplasticism remained pretty much Mondrian's private vision. De Stijl wandered off into other areas including design and architecture — and modern architecture itself, the showplace for stylistic internationalism, has recently found itself boxed in by its own 1920s theories and vision.

Even so, certain ideas and attitudes derived from one or another of the above have remained alive, and have continued to exert a subtle (and at times considerable) influence. Constructivism, especially, has proved to be a particularly rich source for stylistic ideas and forms, and has been "quoted" or has been subtly transformed any number of times since its official demise in the early 1920s.

In addition there have also been the high-minded and persistent attempts, continually made during this century, to establish a dominant style, school, or movement that would encapsulate both the essence of modernism and the drives, ideals, and goals of 20th century man. Each one has, to one degree or another, failed to establish its primacy — although almost every one produced a few excellent works of art.

All this, of course, makes the creation of public art something of a

Mel Leiserowitz
Orpheus, 1975–80

problem. By its very nature, public art must be of interest to, and have significance for, the entire community — not merely for a small handful of devoted advocates of one style or another. But how can this be accomplished if there is no universally agreed-upon style? Even if the community is sharply divided about what constitutes art?

The decision to commission one type of art over another is generally made by a committee, an agency, or by one or two wealthy individuals acting upon the advice of local or national experts in the field, unless it is the result of an open or limited competititon. Whatever form the decision takes, however, it is almost always made from the top down, with little opinion from the public at large.

This form of paternalism is not, of course, new. (And neither is it

necessarily a bad way of doing things.) From the early Egyptians and Greeks, through the Medici family in the Renaissance, up to our modern era, public art has almost always been commissioned by the elite of the community, and not by the general public.

In those days, however, cultural and artistic values and ideals were common property, and everyone, from top to bottom of the social scale, could identify with the central ideas and forms of the art created in the name of his society or his religion. So it made sense that those who were the most experienced, or who represented the state or its religion, should decide the works of art to be commissioned.

Things, however, are different today. Because of our profusion of artistic styles, it has become extremely difficult to choose public art that is both of value and of interest to the entire community, or of sufficient quality not to appear embarrassingly trite and old-fashioned in a decade or two.

Judging from some public art I've seen, however, such results, while difficult, are by no means impossible to achieve.

Michigan State University president Clifton R. Wharton, Jr., for instance, knew precisely what he was doing in 1975 when he commissioned Mel Leiserowitz to create a very large piece of sculpture for the grounds of MSU's new Wharton Center for the Performing Arts. Not only was the artist a highly accomplished sculptor, he was also, as a longtime member of that school's art faculty, fully aware of the particular problems and potentials of such a major on-campus project.

Right from the start, Leiserowitz was recognized as a member of the overall design team. He was invited to see and discuss the original drawings and models for the center with the architects, and was alerted to any design changes as they occurred. Since the work was to be an environmental piece that could be walked through and around, the choice of site was crucial. Here again he received full cooperation, and was permitted to choose what he felt was the most appropriate site.

Orpheus was intended to reflect qualities of both the visual and the performing arts, to serve as an introduction to the center, and to function as a sculptural entity in and of itself. Like the design of the center, it has space to spread out, but finds its formal identity by means of several large connecting geometric shapes. The design is extremely simple and follows Constructivist principles — but by no means dogmatically. If anything, this piece is wholeheartedly 20th century American, and encapsulates much of the best of what American sculpture has been trying to do these past 30 to 40 years.

It is not, however, an academic set-piece, nor one of those ubiquitous

works that follows all the rules, avoids all the pitfalls, but manages to remain totally anonymous without a life or personality of its own.

Orpheus has character, as well as a clear formal identity. It is intact and whole, and projects a quality that is much more than just the sum of all its parts. Standing next to or within it, one is aware of its strong presence, of the fact that it is a *human* statement, and not just a handsome grouping of large pieces of steel.

Its identity actually extends beyond the physical dimensions of the work itself, for its forms and tensions interact with those of the center proper in numerous visually intriguing ways. There are several framing elements in the piece through which the buildings and their surroundings can be glimpsed, and the stainless steel elements serve as "mirrors" to the immediate environment or to any social activity taking place near them. (I was also quite charmed, the day I viewed this piece, to find two students sunning themselves within the curved form at the bottom-left-center of the photograph, something that the artist said occurred frequently, and that he found totally appropriate to the work.)

Orpheus is an impressive piece of public art that beautifully holds its own within a wide-open architectural environment and gives one the impression that it absolutely belongs where it is. What pleases me most about it, however, is not only that it represents a very personal statement by the artist, but that it also stands as a sensitive and subtle distillation of the best of a particular modern "tradition." While I am by no means an apologist for Constructivism, I *am* impressed by any successful fusion of rugged individualism and tradition — especially if it takes place in a major piece of public art.

The Artist as Iconoclast

*H*UMANITY'S perception of itself has shaped the history of art. From the ancient Greeks, who celebrated the ideal human body in repose or action, to this century's Alberto Giacometti, with his depictions of men and women trembling on the edge of nonexistence, art has symbolically externalized our perceptions of ourselves and of our realities.

These perceptions may be grand (Michelangelo), spiritually idealized (El Greco), extraordinarily detailed (Van Eyck), aristocratic (Van Dyck), deeply compassionate (Rembrandt), zestful and robust (Rubens), haunted (Munch), or anxious (Kokoschka). Or they might be, as in the case of today's Neoexpressionists, desperate and alienated. But whatever, they represent the way certain artists have viewed humanity, and the way we — to the extent we accept these artists' work as significant art — also perceive it.

Even so-called primitive art deals primarily with human realities, even if such art seems exceptionally spirit- and myth-oriented, and if its images of humanity seem grossly distorted to our eyes. Primitive peoples, after all, don't share our notion that one of art's main functions is to depict the physical appearance of men and women.

Portraits, in particular, are excellent clues to what we think of ourselves and how we want others to see us. We need only compare an ancient marble portrait of a Roman senator, with every wrinkle and fold of flesh intact, to one of El Greco's elongated and ascetic portraits to see how drastically our perceptions of our fellow human beings can change from age to age.

Those changes became more frequent and dramatic as the 19th century drew to a close. Between 1890 and 1905 the face of art changed dramatically. What had been relaxed and pleasurable one moment became intense, violently expressive, or stripped down the next.

As the century advanced, so did our sense of unease and anxiety about the human condition. If Munch's *The Cry* expressed individual terror of the unknown, and Picasso's *Guernica* our collective horror of modern warfare, then some of our most recent works of art have given voice to the fear that humanity itself is on the verge of self-destruction.

This fear seems difficult to live with and almost impossible to turn into art. It seems too close and overwhelming, too liable to be translated into painterly hysteria or one-dimensional preaching.

There are some artists, however, who have pulled back from these extremes and who have, without loss of urgency, focused their attentions more intensely than ever on the basic issues of human identity and purpose.

Chief among them is Francis Bacon. No one today has probed more deeply and totally into these issues than he. And no one has produced more dramatic proof of humanity's desperate need to understand and to accept responsibility for itself.

Several other artists, including some of the younger West Germans and Italians, are confronting these issues with varying degrees of integrity

Jonathan Borofsky
Hammering Man at 2,772,489, 1981

and success. And dozens of other painters and sculptors are also at least marginally concerned.

Of particular interest are those artists who have never wavered in their search for symbolic representations of the human condition at its most vulnerable, ambiguous, and exploratory, and whose art, as a result, has become a vital clue to our better understanding of ourselves. Giacometti springs to mind here, as do Max Beckmann, Stanley Spencer, Réne Magritte, Ivan Albright, and Jean Dubuffet.

Henry Moore should also be listed here, although more for his formal explorations of the human figure than for his psychological or philosophical probings. When the history of 20th century art is finally written, after all, Moore's sculptures and drawings of human subjects will almost certainly be included among the most fully realized and truly monumental images of our age.

Balthus is another painter whose lifelong interest in human character and foibles — especially among adolescents — gives his work a unique quality and flavor. And much the same could be said of Paul Delvaux, only his subjects are somewhat older, and their world is infinitely more surreal.

Among the younger American artists who have sprung to view in the past decade or so, few have achieved the fame — and none the popularity — of Jonathan Borofsky. His freely drawn — and often free-moving — pictorial extravaganzas, sculptures, wall decorations, environments, etc., have become necessary ingredients in any exhibition of contemporary art. Generally huge, often gross, occasionally delightful — but always different — Borofsky's work attracts large audiences and fairly widespread critical approval. One of the reasons, I suspect, for his popularity, especially among art students and younger artists, is his refusal to allow rules, technical limitations, tradition, or art history to stand in his way. He is genuinely free-spirited and open to anything that will help him get his ideas across.

Like so many artists who have recently come to prominence, Borofsky deals largely with the human figure — but not in a manner that draws approval from many older artists. There is a blatant, anonymous quality to the people he depicts that turns them into stick figures or ideograms, and that causes considerable irritation among viewers accustomed to more traditionally conceived and executed human images.

Even so, there is a delightfully iconoclastic and fun-filled quality about some of his work that speaks well for his overall vision of mankind, and that creates the same sort of effect that Calder's and Miró's early work must have created when *they* first came upon the scene several decades ago.

Art Celebrating Life

I'VE quite fallen in love with the paintings of Grandma Moses — even though it's taken several decades for it to happen.

It took so long because I'd never taken her work very seriously. Her "discovery" in 1939, and her first one-woman show in 1940 when she was 80, led to a series of media events that permanently soured many who couldn't equate the extravagant words written about her with what they saw of her work. And neither did the continuing, generally uncritical adulation her work received from then on do anything to help. Many who might have accepted her as an interesting, minor primitive painter were appalled to hear her compared favorably with Henri Rousseau, and lauded to the skies as America's most genuine and significant contribution to post-World War II art.

Her many imitators only made things worse. By focusing entirely on the folksy and colorfully patterned aspects of her art, they produced a large body of sentimental, decorative paintings that debased her true intentions. And this again was not helped by the fact that several exhibitions of her work over the years included too many lesser and not quite successful pieces.

I did occasionally, however, come across a few of her paintings that caused me to wonder if I hadn't underestimated her. A particular quality about them forced me to pay close attention. Perhaps it was only something as simple as the manner in which she painted falling snow, or the subtlety with which she related several varieties of greens and blues to a pink. But whatever it was, I was invariably struck by the *art* that lay behind the picture's warmth, charm, and good cheer. And by the fact that it had been painted by an artist of uncommon sensibilities.

An exhibition of some of her best paintings at New York's Galerie St. Etienne clinched the matter of her art for me. I was won over — to the point where I've been delving into the sources and significances of her work, as well as delighting in its many fascinating nooks and crannies, ever since.

To do so, I returned several times to the exhibition, and permanently dog-eared Jane Kallir's profusely illustrated and lovingly written book on Grandma Moses that accompanied the show. What came across most dramatically was that Grandma Moses celebrated life through her art. Her paintings crackle and sparkle with it. From the tiniest flower bursting above ground as a daub of cadmium red, to a snow-covered landscape dotted with

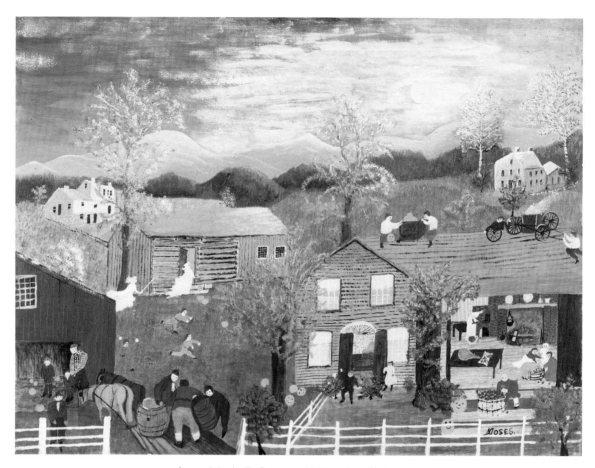

Anna Marie Robertson ("Grandma") Moses
Halloween, 1955

lovingly detailed trees and teeming with dozens of colorful ice skaters, her emphasis is always on the life-enhancing and life-perpetuating. Enthusiasm for life is her primary subject. Looking at her paintings, we feel the crispness of the air, the heat of a roaring fire, the coldness of snow, the pleasure derived from simple acts. Whatever other skills and levels of sophistication she may have lacked, Grandma Moses was a past master of the art of living. And it is this mastery, coupled with an exquisitely subtle sense of color and a remarkable gift for placement and design, that gives her art its special warmth and grace.

We need only glance at the work of her imitators to realize how

deeply her paintings are grounded in reality and experience, and how super-ficially sentimental the works of her followers are in intent and effect. *They* were the ones who set out to be charming, cute, and decorative — not Grandma Moses. Her intention was to depict life as fully and richly as she had experienced it. Theirs, to create a whimsical and charmingly escapist fantasy world.

She didn't, in other words, set out to be a delightful or charming primitive painter, she just ended up that way. If anything, she probably saw herself as a realist.

Everything in her paintings conveys character and particularity. While her many people, animals, and objects may at first glance appear cast from the same mold, careful examination will reveal that every one is indi-vidually perceived and characterized. It would not, as a matter of fact, be incorrect to describe her paintings as consisting of hundreds of tiny "por-traits" of people and things adding up to one full "portrait" of the occasion she is celebrating.

This particularity also applies to her color, which is always realisti-cally based. A color might be simplified and made brighter by laying it out flat and unmodulated, but it was never "invented" to accommodate her fancy. On the other hand, she was capable of achieving extraordinarily subtle and beautiful coloristic effects by juxtaposing several realistically derived color areas to form quilt-like patterns or designs.

If she was incapable of fully orchestrating color, she *was* capable of creating some lovely "melodies" with it. As a matter of fact, it is her color, as much as anything, that legitimizes her work as art. If her drawing was weak, and her understanding of form and perspective limited, her sense of color was, to say the least, remarkable. And this was particularly true when it came to atmospheric effects. From the fresh green of early spring, to the sparkling white of deep winter, she knew precisely how to manipulate her colors to achieve maximum seasonal effects.

This ability to create compositional unity through atmospheric effect is one of Grandma Moses' outstanding virtues — especially since she often applied it in paintings teeming with literally hundreds of people and things. Some of her compositions are as complex and bursting with humanity and life as any of Bruegel's, and yet they stand whole and unified, thanks to her uncanny ability to make the nature and quality of a particular season the real subject of such a composition.

Some of her loveliest paintings, on the other hand, consist largely of subtle variations of soft greens dramatically punctuated here and there by

the white of distant houses, the bright colors of a farmer's shirt or a young girl's dress, or the winding blue of a river or stream. One in particular, *Hoosick Valley (From the Window)*, a heartbreakingly beautiful color study of the hills, woods, and farmland glimpsed from Grandma Moses' window, is as exquisite a painting as one could hope to find. It is, in every sense of the word, a work of art. Minor, perhaps, but utterly true as art. And another work, *Halloween*, makes *its* point by allowing subtle colors to "frame" the brighter colors of the various people depicted in it.

Also exceptional is the ease with which her paintings can bear structural analysis, and the pleasure that can be derived from studying their thematic and formal intricacies. Many of her paintings actually become stronger and richer the longer we study them, and those that rank among her best actually create amazement if studied long enough. How, we wonder, could anyone so untrained and "unsophisticated" in artistic matters have composed so elegantly, fashioned such exquisite color harmonies, and painted with such a lyrical touch?

It's a fascinating and important question, and one that touches upon many crucial issues. Among them are the nature of creativity, talent, authenticity, and skill; the importance of art education; the role of tradition in art; and the advantages and disadvantages of professionalism. A good example of Grandma Moses' art throws all these questions into sharp relief — if for no other reason than that she paid little if any attention to any of them.

She had a simple, direct, and no-nonsense attitude toward her art. In her autobiography we read, "If I didn't start painting I would have raised chickens. I could still do it now." And in a letter to her grandson she wrote, "As for myself, I shall continue painting. I can make more money that way, as it is easier for me than taking in boarders."

To Grandma, art was only one more facet of a very long and rich life. What really mattered was living itself, and the quality of the life lived. Small wonder then that her paintings, embodying as they do this attitude toward life, should be as popular and well loved as they are.

Who Says Portraits for Pay Have to Be Bad?

PROFESSIONAL portrait painters are generally viewed as second-class citizens by the art world at large. It's perfectly all right for an Andy Warhol or Alice Neel to paint portraits. They, after all, are "expressing themselves" through this kind of work. But to do it for a living, to paint portraits to a client's specifications, strikes most people in the art world as unworthy of the high calling that is art.

I've never understood why. Some of the world's greatest paintings were commissioned portraits. Titian, Velázquez, Holbein, Rembrandt, Hals, Goya, to name only a few, did portraits to suit their clients. Some (El Greco and Rubens) may have been more individualistic than others, and others still may have seen portraiture as a lesser aspect of their art. But all were very much aware that unless they did what their patrons or clients wanted, there would be no money for food and clothing.

These artists had one great advantage, however. They and their patrons and clients shared a common artistic tradition. A beginning artist didn't have to shop around among dozens of different styles for a suitable one. Nor, failing that, did he or she feel obligated to invent a new one.

Art was a common language shared by artist and patron alike. The latter knew precisely what he or she wanted, and the former provided it to order. What resulted always bore the artist's personal stamp, of course, but it nevertheless shared a common "family resemblance" with everything else painted at that time and in that place.

All that changed, however, with our recent, more romantic notion that the artist is a unique and very special individual superior to society as a whole. And that his or her art must articulate and "express" this uniqueness — or find itself denied the status of true art.

Seen this way, anyone's attempt to modify or redirect an artist's near-sacred "individuality" must result in something other than art — a hack illustration, perhaps, or an academic portrait, but certainly not "real" art. With this in mind, it is easy to see why commissioned work has such a low standing in art today. (Although, oddly enough, it doesn't in architecture.) And why professional portraiture in particular is seen as a contaminated art form at best, and the lowest form of expedient commercialism at worst.

Professional portrait painters see things differently. While most will probably agree that some of their fellow professionals are hacks grinding out one characterless likeness after another, they will also insist that the best of their peers are concerned artists whose intention is to probe and to reveal character as well as to produce "speaking" likenesses.

Having seen a large number of contemporary portraits recently, I would have to agree. If one sets aside the obvious hacks (and they existed in the time of Holbein and Hals as well as today), one is left with a number of professional portraitists who are good painters in the simplest and best sense of that term. They draw well and imaginatively, handle brush and paint with flair, sensitivity, and conviction, and do their best to paint pictures that are at least as interesting as paintings as they are successful as portraits.

Among them is an artist who only recently decided to become a professional portrait painter, but who has already produced a number of excellent commissioned portraits, including several of presidents and deans of colleges, law schools, and universities.

Sarah Swenson sees the relationship between artist and client as challenging and satisfying, and not at all damaging to her art. In fact, as she writes: "The freedom of style in painting today has some advantages but it is not without its drawbacks. Deciding *what* to paint can be a real drain on one's creative energies. In portraiture, particularly in the commissioned portrait, much is given at the outset, yet, strange as it may seem, these constraints provide a structure which can in fact free one's painterly powers to operate more effectively."

She also likes the businesslike nature of portrait commissions and the fact that she doesn't have to depend upon art dealers to market her work. Once contacted by a client, and after discussions about how and where her subject is to be painted, Swenson decides upon the work's composition, color scheme, and overall treatment. Preliminary sketches are made, and several black and white photographs are taken as reference material. Once that is set, work on the canvas begins.

Her style is lean, discreet, and precise. Although she admires the painterly flair of John Singer Sargent, her own portraits are less fluid and more dependent upon pure drawing than his. Her ability to identify with her subjects is remarkable — with the result that they come across in their portraits as highly individual human beings.

Although most of her portraits are of adults, she does occasionally paint children. *Lucas and Laura Congdon*, for instance, was commissioned by the children's grandmother when they were four and two respectively. Since

155

Sarah Swenson
Lucas and Laura Congdon, 1983

Lucas enjoys playing the violin, it was decided to show him holding it — a decision Swenson used to good compositional advantage.

Another decision was to make this an indoor rather than an outdoor portrait as originally planned, and to use a large chair as the connecting device between brother and sister.

The result is a beautifully painted double portrait of children that is neither sweet nor sentimental. Young as they are, these children are real people. Careful study will also reveal how sensitively this picture has been composed, and how exquisitely every line, tone, and form interrelates with every other nuance or detail, and with the composition as a whole.

Gouged, Scratched, Scumbled, Beautiful

ENRICO Donati's recent paintings seem both millions of years old and as modern as anything painted this year. On the one hand, they resonate with primal memories of geologically distant times, of an age when saber-toothed tigers and our earliest ancestors roamed the earth; on the other, they partake of distinctly modern ideas on how an artist should produce art.

Donati's paintings are enchanting works, with textures and colors so sumptuous and vibrant that no reproduction can do them justice, and with such a wonderful physical presence that one cannot resist reaching out to touch their timeworn, scarred, and pitted surfaces. These surfaces are fashioned from generous portions of carefully ground quartz mixed with paint and medium, which are then molded and troweled until they become up to one inch thick. They are then incised, gouged, scratched, and scumbled to resemble the walls of ancient caves, calcified deposits, or the rough exteriors of boulders.

But that's only the beginning of it, for these richly textured surfaces are always positioned so as to act in maximum dramatic counterpoint to smoother, more purely painterly areas, and to give particular emphasis to

colors that run the gamut from hot reds and purples to cool blues, delicate ochers, pinks, grays, lime yellows, and soft greens.

All this, however, is only Donati's shrewd and seductive way of gaining our attention before introducing us to the mysterious and provocative things and ideas he wants us to see and to share with him. Without our quite realizing it, he leads us from surface charm and sumptuousness to deeper dimensions of wonder, and ultimately to the central questions of life, death, and eternity that have engaged him and dominated his art these past 40 or so years.

The recounting of a crucial and illuminating experience Donati had on the beach at Dover in 1949 should illustrate my point. He found a smooth stone, cracked it open, and discovered a perfect fossil inside. Although small enough to fit in the palm of his hand, it yet seemed charged with endless implications about the meaning of life, and about the significance of the universe itself.

As he wrote later: "To me the stone is the most pure form of the expression of nature. . . . It is the element that contains the greatest antiquity and is, at the same time, the purest in its shape. It contains something in its depths that is still alive. The fossil, in particular, has an incredibly animated inside form, while regular rock has a more animated outside shape. The fossil carries the whole cycle of creation, destruction, and rebirth within it. Nature has destroyed the life it once was and has reincarnated it in a new life that will have perpetual existence. This is essentially what I try to do in my work."

This image of the fossil embedded within rock does indeed relate to many of Donati's most recent works. Not only do they seem incredibly old, they also seem to present secrets and enigmas for us to unravel. We may not sense this immediately upon first seeing his work — thanks to its extraordinary surface charm — but it will gradually become apparent as we study his paintings and get to know them better.

The remarkable thing is that these secrets and enigmas remain intact no matter how intently we probe his paintings for their hidden meanings. The reason, of course, is that these works are in themselves enigmatic. Like the Mona Lisa and de Chirico's earlier paintings, Donati's best paintings embody mystery and do not depict it — as would be the case with an illustration or a painting that is not art. As a result — and I for one am glad of it — the secrets locked up within his paintings will never be known to us.

At the same time, Donati has forged his art so expertly that we keep right on thinking we are just about to get to the heart of the matter, and to

Enrico Donati
The Walls of Thebes, 1983

discover once and for all what his art is really all about. But of course we
never do. We may come close, may feel that we finally understand — only
to realize the next time we see the work that there's still a great deal that
eludes us.

Now, only an artist can keep a painting (or a poem, play, novel, or
piece of music) so perpetually alive and challenging. Only an artist can fash-
ion images that pulsate with energy or keep asking questions as long as they
physically survive. Others may paint pictures, write poems, or compose
musical works that delight or entertain for a moment but that then shrivel

up and die like a balloon from which all air has been withdrawn once their charm and entertainment value have been exhausted.

All true art is capable of repeated exposure, be it a landscape whose sense of light and life never dims, an abstraction whose forms perpetually interlock with exquisite precision, a portrait that never ceases to reveal new nuances of character, or a painting like Donati's that never stops being beautiful and mysterious.

Donati's paintings incorporate evidences of intense geological activity; archaeological fragments and allusions; rich, sensuous color; primitive calligraphic inscriptions; the calcified remains of tiny sea creatures; references to embryonic forms; and numerous hints that more wonderful things are hidden beneath earth's surfaces than anyone can imagine.

This is an art that reveals, that induces insights, that moves the viewer to share the artist's awe at life's mysteries and unfoldings. At the same time, it insists that we accept Donati's paintings as enigmas, as evidences of something beautiful that we simply will never fully understand.

The Delights of Sketching

ONE of the real delights of sketching is that it enables us to capture and communicate the most fleeting of impressions and emotions. Even the most unskilled of draftsmen, if sufficiently moved or interested, can produce a convincing sketch. And in the hands of a master, a few scribbles and smudges can easily achieve the status of high art.

Having once seen them, who can ever forget Michelangelo's tiny but awesomely alive chalk renderings of the human figure; Rembrandt's dashed-off landscape and animal studies; Constable's fleeting impressions of clouds; Goya's grotesqueries; Degas's dancers; and Toulouse-Lautrec's bursting-with-life night people? Or, closer to our own time, Giacometti's penetrating pencil portraits, or Käthe Kollwitz's fiercely maternal charcoal sketch *Mother and Children*?

Each of these is remarkable because it represents a crisply conveyed perceptual experience, a highly charged moment when an exceptional human being was able to transcribe precisely onto paper what he or she had

Paula Modersohn-Becker
Child in the Cradle, 1902/3

seen or felt. As such, they are at least as much about the artists who made them as about the subjects they depict. It is what we sense of Michelangelo's grand passions and visions as he grappled with the expressive potentials of the human anatomy that moves us, not the sight of a few accurately drawn muscles. And it is Kollwitz's extraordinary ability to project her own deepest feelings into her images that makes her picture of a woman desperately hugging her children so effective and true.

We must not, of course, underestimate the importance of skill and tradition, the first because it helps speed recognition of *what* is drawn, and the second because it facilitates understanding of *why* it was drawn and

160

what, if anything, it signifies in a symbolic or metaphoric sense. Not only will an ink sketch of a mountain landscape by a 15th century Chinese painter, for instance, look very unlike one by a Flemish or Persian contemporary, but also it will represent very different aesthetic and philosophical attitudes.

Tradition's impact on creativity cannot be overlooked, for it not only guarantees stylistic and thematic continuity, but actually affects the way individual artists look at and perceive the world as well.

It can also affect the way they feel — or at least respond to — culturally supported ideas, beliefs, and activities. Art, after all, has a long history of serving dogma and orthodoxy, of preferring conformity to originality. The notion that an artist may freely vent his or her emotions, or give form to a private vision or ideal, is a fairly recent one, and the belief that an artist *should* do so is still being argued today.

There has always been one area, however, where artists could express themselves as freely as they wished. The sketch, from time immemorial, has been every artist's most immediate method of responding to and recording what he or she saw, sensed, and imagined. The history of the sketch, as a result, presents us with a remarkable record of human individuality, of personal and specific reactions to people, places, things, and events drawn in a manner only minimally dictated by the official style of the place and time.

No style was ever more rigidly formal than that of ancient Egypt, for instance, and yet quite a few rapidly executed and delightfully informal studies of boating activities along the Nile, native birds and animals, and craftsmen, dancers, and farmers at work or at play have come down to us.

Thanks to these carefully observed but swiftly drawn sketches, we not only can sense how very much like ourselves Egyptian men and women of 2000 or 3000 BC actually were, but we also can see that artists of that time had as many technical difficulties drawing the world around them as do those of today.

Art history has many other examples of such pictorial informality, ranging from quick character studies of very human popes and emperors to delicate renderings of such things as blades of grass or the wings of tiny birds.

There are blunt, powerful images made with a few smudges of chalk by artists whose normal styles were extremely refined; wonderfully expressive portraits by painters famous for their geometric abstractions; linear explosions by classical draftsmen; and simple, direct transcriptions of the most ordinary of sights, objects, and events by artists for whom sketching was the most normal of activities.

Outstanding among the latter is Paula Modersohn-Becker's *Child in the Cradle*. Looking at it, we see exactly what the artist saw. Nothing has been edited or sentimentalized. Modersohn-Becker has given us the pure, unvarnished truth about a very young baby who is holding what appears to be a spoon and has its mouth wide open. Nothing could be further from the usual cute picture of an infant, and yet it is all the more appealing because of that.

As the world judges such things, it may not be one of this German Expressionist's major drawings. And yet it probably will be as alive and delightful a thousand years from now as it is today and will prove to those who see it then that we were every bit as real and vulnerable as they are.

Small, Unassuming, Profound

ART can have a profound effect upon us.

I remember standing the midnight-to-4 a.m. watch on a troop transport on its way to Okinawa during the last year of World War II and looking down into the pitch-black ocean with something very close to terror. I was totally alone for the first time in my life, and confronting a war that seemed unending and endlessly destructive. I didn't know who I was or what I was doing. And worse, I seemed ridiculously insignificant in a universe so huge and complex that I couldn't even begin to understand it or my place within it.

I remember exchanging a few words with another soldier, glancing down at the ocean and shuddering at its depth — and then suddenly, without warning, the image of Morris Graves's *Bird Singing in the Moonlight* flashed before me. Immediately, something inside me relaxed. I began to feel wonderfully, miraculously at peace with myself, with the universe, and with whatever the war might bring.

Although especially significant because of the occasion, that was neither the first nor the last time art has affected me that way. From the age of 11, when I discovered Rembrandt and knew he was a friend and "confidant,"

162

Morris Graves
Bird Singing in the Moonlight, 1938–39

to only yesterday, when the work of a young painter gave me a strong, singing surge of hope for the future of mankind, I have been reassured, amused, challenged, and inspired by various works of art. In every case, I've felt keenly grateful to the person whose pictorial image helped pull me through a difficult or confusing moment by giving me a fleeting and healing glimpse of the beauty and wholeness of life, or a clue to its meaning.

I've learned I'm far from alone in this. Many benefit from art in this fashion — if not from painting, then from poetry, music, dance, or any of the other forms of art. The ability to reveal truth, after all, is not limited to one type of creative effort.

Even so, there is one kind of art particularly precious to me. It is generally small and unassuming, exists as often on paper as on canvas, and is so perfectly realized and endlessly illuminating that it can easily be absorbed and kept shining within us for the rest of our lives. We may forget its presence at times, and wonder if it has lost its effectiveness, but when the need arises it emerges with precisely the insight, intuition, or encouragement we require.

Such art need not be serious or solemn. My memory of Klee's *Twittering Machine* has caused me to smile at times when life seemed oppressive. And Calder's delicate mobiles, Miró's colorful images, and Steinberg's light-headed satires have reminded me at crucial moments that life can indeed be pleasant as well as fun.

Some art is so deeply moving, however, that we tend to keep it at a distance, and to call upon it only for very special occasions. Several people have told me they couldn't live with a Rembrandt, because it would make too great an emotional demand on them. And others have said they prefer to keep the pictures on their walls as light and general as possible.

I find this unfortunate, if perhaps understandable. It's good, I believe, to live with something that makes demands, that causes us to question the banality, vulgarity, and spiritual indifference so much of our culture seems to take for granted. And art, because of its ability to embody depth, wit, warmth, and character in lovely and captivating images, strikes me as a particularly painless and effective way to learn how to acquire more of those qualities for ourselves.

Not all art, of course, is easy or accessible, and neither does it all belong in homes. Much is so broad in scope, large in size, and weighty in meaning that it must be approached as one would an architectural wonder or a grove of redwood trees. Viewing Michelangelo's *Last Judgment* or El Greco's *Burial of Count Orgaz* is a pilgrimage event, an occasion so grand that it lifts us out of our everyday selves and makes us overwhelmingly aware — if only for a few minutes — of the scope of human greatness.

Fine and good, but we also need art that is more intimate and personal, more compact and "portable," that we can treasure and carry with us throughout our lives.

Graves's *Bird Singing in the Moonlight* is such a work, as are Blake's

When the Morning Stars Sang Together; Dürer's *Young Hare*; the fourth state of Rembrandt's etching *The Three Crosses*; Goya's print *The Dead Branch*; Redon's best florals; Munch's *The Cry*; Klee's *Dance You Monster to My Sweet Song*; several of Giacometti's figures, and many, many others.

Anyone who loves art will be able to add his or her special favorites, and some individuals will add dozens, since they don't at all care for the kind of painting and sculpture that takes up so much space in our museums and other public places.

I, too, have a special affection and respect for art so distilled that it remains with us as clearly and provocatively as Blake's "Tyger, Tyger, burning bright/In the forests of the night," or Shakespeare's "To be, or not to be." Such images don't just sit passively within us but bubble away asking questions and suggesting new ways to respond to life. In that respect they are like seeds planted in fertile ground that germinate over the years and bear fruit whenever the occasion demands. In some quarters, such art doesn't rate as highly as the monumental works of the old masters.

But I'm not at all certain. Is an eagle, after all, more significant than a sparrow? Or a rosebush less alive than a giant oak?

Paintings to Walk Around In

*E*VEN art critics deserve an occasional vacation from the hothouse atmosphere of the big-city gallery world, with its overabundance of gimmicks and plans for overnight success and its tendency to equate quality with what sells, talent with effectiveness, and greatness with whatever is biggest.

I am due for just such a few days off. But I'm not going very far. My vacation will be brief and will require neither packing nor planning. It will consist of a few leisurely walks through the Frick Collection, the Metropolitan Museum, and the Museum of Modern Art — and of my writing exclusively on what I love most about certain kinds of art.

Since it is summer and my thoughts keep turning to cool mountain

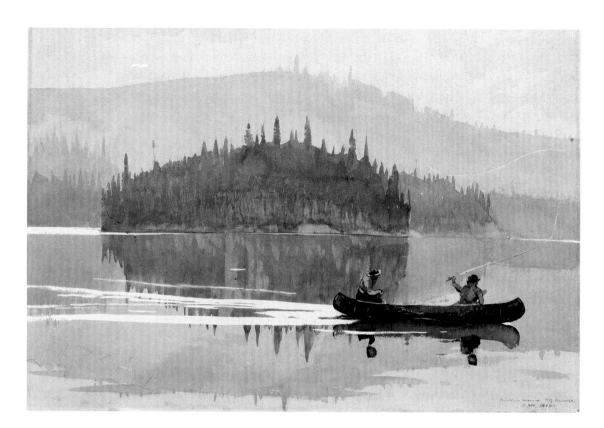

Winslow Homer
Two Men in a Canoe, 1895

lakes, fragrant forests, blue skies over rolling fields, and small animals glimpsed dashing about behind bushes. I intend to look at, enjoy, and write only about such art as gives form to these realities. I will pass by work that insists I must first "understand" what the artist is doing, that proclaims it is good precisely because it seems so bad, or that shouts for attention, but then has nothing to say when I respond.

I will concentrate on paintings I can *enter* and walk around in, and ignore those I can only look *at.* For that I shall choose the landscapes of Bruegel, Van Ruisdael, Constable, Friedrich, and the Hudson River School rather than those by Claude, Poussin or Cézanne — no matter how I may prefer the latter at other times. I will delight in the great landscape images of the Chinese and Japanese, enjoy the visual delicacies spread out in Near Eastern miniatures, and savor the charms and details of nature spelled out in

the watercolors and drawings of Dürer, Rembrandt, Palmer, Turner, and Redon.

I will relish the tactful revelations of nature's most intimate secrets made by Klee, Dove, Graves, and Stamos, and will accept with gratitude the calls of Marin, Burchfield, Curry, Wyeth, Hopper, and Porter to share with them what they loved about their local scenery. And, if I feel particularly brave, I'll haul out the drawings I made in Central Park over two decades ago and see how well they hold up.

In choosing the landscapes I'll enjoy writing about, I'll be looking not so much for faithfulness to nature's appearances as for evidence that it was approached lovingly and with respect. It's been my experience that only those who love it can turn what nature is into art, and that only those who respond respectfully to nature's regenerative powers will fashion art that is alive.

Life, after all, is what art is all about. The painter who cannot transmit something of the life-force through paint isn't an artist — no matter how brilliant or dedicated he or she might otherwise be. And if that is true of art in general, it is particularly so of landscape painting.

The problem with nature as a subject for art is that it is everywhere and is everything, and it becomes more grand, elusive, complex, beautiful — you name it — the more it is studied. Confronted by nature in all its glory, it is difficult for an artist to know where to begin.

The true artist ultimately discovers just how much of nature he or she can transform into art — and what formal and technical devices will best accomplish it. John Constable, working directly in the English countryside, translated what he saw and felt into thickly painted, solidly constructed oil studies. Whereas John Marin, poised on a rock along the Maine coast, translated what he saw and felt into dots, dashes, washes, and slashes of watercolor paint that resembled nothing so much as a private pictorial code.

Both artists loved what they painted, however, and were able to share that love with us. This ability of art to communicate emotion and experience helps us to break down national and cultural barriers and to roam throughout human history. With minimum effort, we can reexperience the awe a 12th century Chinese painter felt before a particularly majestic mountain range, the delight a 15th century Persian miniaturist felt before a desert garden full of flowers, or the intimations of life's meanings that overcame Caspar David Friedrich in the early 19th century when he came upon a cluster of dead trees near a deserted monastery.

I'm especially fond of those artists who project an enthusiasm for life.

High on my list of painters who thoroughly enjoyed the great outdoors is Winslow Homer. His watercolors and oils prove not only that he loved nature but that he also, in some ways, saw himself as its equal. Not arrogantly, certainly, but casually and lovingly in the manner of a good friend.

Homer, as a matter of fact, would be the ideal guide for my vacation. His landscapes can definitely be "entered," and the life he depicted in them is obviously low key and refreshing. If I spend a few days with them I'll go hiking up and down mountains, fishing in quiet Canadian lakes, canoeing in dark, narrow streams, trailing after deer, or simply sitting beside an open fire while Homer fries the fish we caught.

To some that may not sound like much of a vacation, but to me it sounds ideal. Especially if I can take my own watercolors along and work beside him.

Neighbors as Art

CAN a plaster cast be art? Especially if it is brightly colored and hung in a public place?

John Ahearn thinks it can — and he's working very hard to prove it. Of course, he's not the first. George Segal has had a very successful career making plaster casts of people, then grouping them in socially and psychologically thought-provoking situations. And a number of younger artists have recently used casts as components of complex, allegorical sculptures.

Ahearn, however, has carved a very special niche for himself. He does colorful and very lively portraits that begin as casts taken directly from his subjects and end up as reliefs on both interior and exterior walls. Most of his models are his Hispanic and black neighbors in New York City's South Bronx, where he moved a few years ago to be at "the farthest reaches from the center of the art world." They sit for him as much out of friendship as for the little bit of local fame the finished art will bring them, and generally don't seem to mind the casting process.

That can usually be done rather quickly, thanks to Ahearn's discovery that alginate, a soft, rubbery substance used by dentists to make molds, sets fast and doesn't stick to his subjects' faces.

Once the plaster cast has hardened, it is painted for both "realistic" and expressive purposes. He pays very special attention to all details of clothing and jewelry, makes certain he has caught the individual's expression and personality, and does whatever else he feels is necessary to make the piece as truthful and effective as possible.

His intention throughout is to capture and to project the individuality of his subject, the special qualities and characteristics that set him or her apart from all others. At the same time, he is careful not to remove the individual from his or her social and ethnic context, or to push characterization to the point of caricature.

Color helps greatly in this. Since he accepts his subjects' tastes and preferences in dress, makeup, and accessories, he is not at all intimidated by what some might view as outlandish or garish color combinations. If that is what they like and wear, then that is part of their individual and social identity — and he would no sooner change that than he would the color of their eyes or skin.

Here again, he is primarily concerned about remaining true to the actual person from whom the cast was made. In this respect, he comes close to Norman Rockwell's practice of painting *his* neighbors' faces and figures. Just as Rockwell's acquaintances delighted in finding themselves on the cover of *The Saturday Evening Post*, so do the people of Ahearn's community enjoy seeing themselves on gallery or museum walls.

In some instances, they can also find themselves in fiberglass groupings attached to the outside of buildings in their own neighborhoods. Some of these groupings are merely informally arranged individual portraits (*We Are Family*), while others, such as *Homage to the People of the Bronx, Double Dutch at Kelly Street I.*, depict several people engaged in a very specific activity. In the latter, four young girls are shown skipping rope. It is an extremely handsome composition that in no way detracts from the unique characteristics of each girl.

Ahearn's populist leanings make themselves known not only through his choice of subjects and his work's occasional final disposition on the building exteriors of the South Bronx, but also through his insistence that art should extol human values rather than strictly formal ones. To that end, empathy becomes his most effective tool, and he will sacrifice whatever he must in order to achieve it.

The first reaction to his reliefs, as a result, is certainly that they derive from and represent actual human beings. They are too authentic and precisely defined, too lively and alive, to be imaginary or composites. Unlike

169

John Ahearn with
Rigoberto Torres
Luis (Out of Work), 1982

Segal's anonymous and static figures, which never look like anything but the plaster casts they are, Ahearn's subjects appear real and caught in the act of smiling, skipping rope, hugging, running, or any of the many other things actual people do.

All that, of course, presents problems of creative tact and sensibility. How, for instance, does one prevent such works from resembling nothing but frozen, three-dimensional colored "snapshots" or illustrations? Or how does one give them sculptural substance when their identities are largely established by empathy and painterly illusion? There is also the matter of mindless mimicry, the slavish duplication of nature that must concern any sculptor working exclusively with plaster casts.

John Ahearn
*Homage to the People
of the Bronx,
Double Dutch at Kelly Street I.,*
1981–82

By and large, Ahearn has managed to avoid these pitfalls, and has transformed the raw material of life into rich human images that can sustain constant critical attention. Still, some of his reliefs do fall short, and remain a bit too sympathy-provoking, or never make it beyond being painted plaster casts.

The vast majority do enter the realm of art, however — even if still only on a somewhat minor level. I suspect that that minor status will soon change. His large groupings, after all, already project an aura of authenticity and "inevitability" seldom encountered in public sculpture today. And some of his most recent figures reveal an increased ability to make plaster casting do *his* bidding.

171

More Talent than Fame

*I*T'S amazing how reputations in art can fade in and out, often for reasons that have little or nothing to do with the quality or importance of what the artist produced.

John Singer Sargent is a perfect example. His reputation couldn't have been higher during his lifetime, and yet, a decade after his death, he was considered little more than a flashy virtuoso. That's how he was perceived until roughly 1970, when a number of influential art professionals decided it was time once again to give him his due.

Albert Pinkham Ryder stands at the other extreme. He achieved extraordinary fame after *his* death in 1917 — many art experts during the 1930s and 1940s, in fact, thought him America's greatest artist to date — but now he is viewed as only one of several interesting artists of his generation.

Not every creative individual is subject to this kind of career vacillation, of course, but enough of them are for it to raise serious questions about the manner in which we judge art, and the degree to which we permit fashion, dogma, theory, and the pursuit of novelty to influence our critical opinions.

At no time in recent history was this issue more relevant than during the years following World War II. Literally dozens of outstanding reputations, some of 20 or 30 years duration, were "plowed under" by critical attacks or simple neglect, primarily because the painterly approach that would soon be known as Abstract Expressionism had captured the attention of several of the period's most brilliant critics and they, in their new-found enthusiasm, had decreed that it and only it should reign.

For a while, however, it appeared as though American art could also support a few younger painters whose ideas and ideals ran parallel to, or even diverged dramatically from, the work of Pollock, de Kooning, Still, Rothko, and their colleagues.

High on the list of these independents was Hyman Bloom, a Boston Expressionist whose emotionally charged canvases of religious ritual and spiritual ecstasy had begun to receive national attention as early as 1942. Together with Jack Levine, Abraham Rattner, Byron Browne, Ben Shahn, Morris Graves, and Philip Evergood, he represented — for a large portion of the art world, at least — the true hope for American art. Not only were his paintings, and those of the others, remarkably accomplished and origi-

nal, but also they promised to lead American art out of the trap into which it had fallen by virtue of its militant provincialism on the one hand, and its overdependence on European modernism on the other.

In Bloom, the United States had a champion who was young (he was born in 1913), passionate, committed, and extraordinarily gifted. Two drawings in the possession of Harvard University's Fogg Art Museum, executed when he was 15 and 17 years of age, reveal talent and performance almost unbelievable in one so young. And if he had the natural inclination and the skills, he also had the imagination and discipline needed to produce art of very high quality.

A few of his intense, slightly exotic, and psychologically provocative depictions of Jewish temple and home life were included in the Museum of Modern Art's important "Americans 1942" exhibition and were seen by several of the emerging Abstract Expressionists. De Kooning, in fact, who had visited the show, indicated in a 1954 conversation that "he and Jackson Pollock considered Bloom . . . the first Abstract Expressionist artist in America."

They were not alone in that opinion. Thomas Hess, in his influential 1951 book *Abstract Painting*, included reproductions of two of Bloom's paintings and indicated that they were there because, "In Bloom America has another artist who fuses the abstract and expressionist traditions, and who has achieved this difficult task within the limits of his personal metaphor."

Bloom, in short, was sitting on top of the world. Not only was he viewed as one of America's best younger independents, but also he had won the approval of Abstract Expressionism's two most famous painters, and one of its major apologists.

Unfortunately, however, that's as far as he got. For all his ability at fusing "abstract and expressionist traditions," his work ultimately was perceived as too idiosyncratic by those very same figures, and he was packed off to join the ranks of painters deemed insufficiently "pure" for critical canonization.

His "exile" wasn't immediately apparent, of course, but such things seldom are. His reputation continued to grow, and as late as the early 1960s, he was still almost as well-known as anyone else in American art.

The signs were there, however, for those who knew where to look. He was increasingly described as a good painter rather than as an important artist; his work was at first seldom and then never included in exhibitions of "significant" recent American art; and his name was gradually dropped from the lists of those discussed in art and art history classes.

173

174

Hyman Bloom
Still Life on Butcher Block Table, 1982–83

Quite simply, he had fallen out of favor and out of fashion, even though his work continued to grow in depth and range until well into the 1970s. True enough, he has been honored now and again in print and in specialized exhibitions as one of the major Boston Expressionists, and he exhibits regularly in one of New York's better galleries. But for all intents and purposes, he has been forgotten. Ask any of today's art or art history students for the names of even second- and third-level Abstract Expressionists, or minor Pop artists, and they'll rattle them off with ease. But ask them if they've ever heard of Hyman Bloom, and you'll almost certainly receive a blank stare.

The Matter of Talent

ONE of the great things about drawing is that it's so immediate and autographic. With only a few lines, scribbles, or smudges, we can transform an idea into an image; record the appearance of reality or evoke imaginary things and places; give form to our intuitions and emotions; and invent abstract patterns and designs.

All it takes is the desire and the decision to do it. Contrary to popular belief, everyone *can* draw — not as well, perhaps, as we might wish, but certainly well enough to fashion a passable record of what interests us, or to produce a rough idea of what we want to communicate. And if we're really eager to draw better than we have so far, we almost always can — providing we focus on "seeing" rather than on merely looking, and remember that drawing is a *shaping* process as well as a recording and communicating device.

Of course, there is the matter of talent. Unlike some of my colleagues, I believe it really exists. Not that I'm certain I know what it is or why it appears so strongly in some people and hardly, if at all, in others. I suspect it has something to do with interest and enthusiasm.

But then, that begs the question of which came first, the talent or the interest? Does interest derive from talent, or does a young artist's special enthusiasm trigger the necessary degree of talent?

Take my own case, for instance. I'm fairly good at drawing heads,

less good at drawing hands, and awful when it comes to feet. My excuse is that I'm really only interested in heads because they can communicate almost everything I want to "say"; that hands interest me only to the extent they make a head more expressive; and that feet bore me. But, do feet bore me because they fall outside the range of my expressive intent — or because what talent I have fails me in this area?

I tend to believe it's the former, that I'd learn very quickly how to draw feet well should what I wanted to "say" ever require it. But even were I able to do so, I would only have brought a particular, less-developed skill up to my highest level of performance. I would not suddenly become a superb draftsman, and I would most emphatically not suddenly become a genius.

That doesn't, of course, mean that an artist must remain forever "stuck" at what appears to be the limit of his or her talent or facility. Art, as we have discovered over and over again during the past century, can soar beyond skill and technical accomplishment. Van Gogh, for instance, never learned to draw "properly." And Cézanne, if judged purely on his draftsmanship, comes across more as a clumsy amateur than as one of the greatest artists of all time.

The list goes on and on. Where would Henri Rousseau be today if he were judged exclusively by the standards of the academy? Or Paul Klee, who had a modest drawing skill and who yet, thanks to his vision and brilliant utilization of every intellectual and intuitive resource at his disposal, became one of the best and most important artists of his age? Or how about Brancusi, Mondrian, Calder, Miró, and Pollock? Or even Picasso who, almost overnight, went from talented art student to innovative genius? Where would he be if he had settled for what he could do so brilliantly at 16?

On the other hand, there are artists who've spent 40 or 50 years perfecting every aspect of their art until, at the age of 60 or 70, hardly anything is beyond them. And who yet, in the deepest sense, are neither better nor more creative than they were at 20.

Art, in short, must be permitted to emerge on its own terms and in whatever form is most appropriate for its time and place. It cannot be willed or coerced into being — although its skills can be developed and polished to a point close to technical or formal perfection. And if that is true of art in general, it is true of drawing in particular. There is danger here, of course, largely because the ease with which drawing techniques can be learned leaves any young artist open to the temptation of producing work that is merely clever and facile.

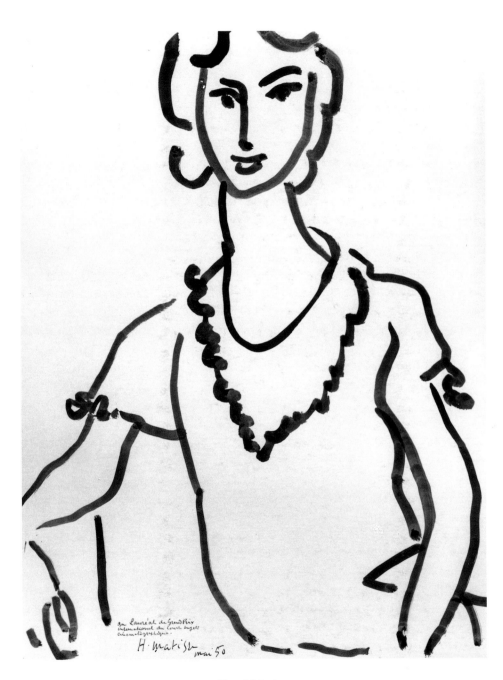

Henri Matisse
Jeune Fille au Collier, May 1, 1950

For proof, we need only consider the many exquisitely rendered, incredibly detailed drawings that bedazzle their way into our galleries and museums every year. Every one required considerable skill to execute, and more than a few show evidence of genuine talent. But that's about it. Beyond their superb technique and brilliant craftsmanship, these clever and highly polished works on paper convey little, if anything, of genuine substance or interest.

Their very showiness, in fact, can produce negative results. Quite a few art lovers, awed by such extraordinary virtuosity, find it difficult thereafter to take less sensational examples of the art seriously. Conditioned as they are to technical brilliance, they cannot understand why a quickly dashed off sketch by Nolde could be special, or why anyone would wax enthusiastic in front of a Paul Klee "doodle."

This "blindness" is particularly evident in the case of Matisse, whose drawings strike many as too "unfinished" or simplistic to be significant art. Which really is a pity, for among them are a number of modernism's finest creations. Perhaps we should study them a bit more open-mindedly and give Matisse credit for never showing off, for always communicating to us simply and directly.

Painters of Nouns and Verbs

I'M not at all certain they'd agree, but I've long felt that most modernists can be divided into two general groups: those who paint "nouns," and those who paint "verbs." Thus Piet Mondrian, with his precisely defined, irreducible images of right angles and primary colors, is modernism's champion painter of "nouns." And Jackson Pollock, with his passionate hurlings and dribblings of paint, is its outstanding producer of "verbs."

Not that these categories are exact or should be taken too seriously. No artist, and certainly no work of art, fits perfectly into any pigeonhole. And only a handful of painters systematically shape their styles to conform exclusively to a single point of view.

Quite a few, in fact, move from one category to the other — or jump back and forth between them — as their careers advance. Wassily Kandinsky, for instance, began as a modest painter of "nouns," established an international reputation as an enthusiastic "verbalist," and then settled down to produce increasingly precise geometric abstractions.

And a few others, such as Van Gogh, Matisse, Rouault, Beckmann, and Rothko, achieved such a neat balance between the two extremes that it would be meaningless to attempt to categorize them along these lines.

But what's the point, one may well ask, of classifying artists in this fashion? Will it tell us anything important about their art or about why they paint? Or, better still, about how good they are?

Absolutely not, as far as the last question is concerned, and only in the most general sense in response to the other two. This is not an aid to critical judgment, but merely a simple and convenient device for gaining some measure of insight into the nature of work that is new and possibly disturbingly unfamiliar. We must, after all, have a clear idea of *what* we are looking at before we can begin to decide how good or important it is.

One way to achieve such an insight is by determining whether the primary emphasis of the painting in question is on *what* is depicted (be it representational or abstract) or on *how* it is painted. By asking ourselves whether everything in it is directed mainly toward establishing the reality, the actuality of the subject — or toward conveying the artist's feelings, his or her passions or enthusiasms, through such formal means as exaggerated brushwork, heightened color, or structural distortions.

The former approach, as I see it, by concentrating on defining the subject's identity and form as clearly and objectively as possible, produces "nouns." The latter, because it focuses on the painter's feelings and experiences and is primarily interested in transmitting energy and emotion, results in "verbs."

To illustrate this distinction, I've chosen a representative example from each category. Igor Galanin's *Samovar* is all "noun," John Marin's *Brooklyn Bridge* is almost entirely "verb." The former is a crisply delineated rendering *of* an object, in this case, a clearly identifiable Russian samovar. The latter is *about* an experience, the somewhat ecstatic one, the highly impressionable John Marin had one bright but windy morning in 1912 as he approached the Brooklyn Bridge.

It is fascinating to see how totally these two pictures differ in motivation, conception, and execution. Galanin informs us fully of his subject's identity, shape, dimensions, texture, volume, and color, but allows none of

Igor Galanin
Samovar, 1985

John Marin
Brooklyn Bridge, 1910

his feelings toward it to show. True enough, he adds a touch of mystery by dramatizing the samovar's setting and by heightening its mood, but that is more a matter of effective picturemaking than of genuine self-revelation.

Marin, on the other hand, lets his emotions erupt like fireworks but tells us almost nothing of the structure that triggered them. In fact, if it weren't for the title and our familiarity with that particular bridge's famous pointed arches, we'd be at a loss to know where Marin was the morning he felt all that excitement.

There are other important differences. *Samovar* is serene and timeless, cool in mood and streamlined in execution. *Brooklyn Bridge* is an agitated, split-second occurrence and is so bursting with life that it seems to be "happening" at this very moment — over 75 years after it actually *did* occur and was translated into wash, color, and line.

Both artists have given us something very special. Thanks to Marin's extraordinary skill at transcribing emotion and sensation into a brilliantly effective — and universally comprehensible — form of pictorial shorthand, we can share a great deal of what he saw and felt so many years ago. And because Galanin was sufficiently intrigued by an old family heirloom to dignify and monumentalize it as a kind of cultural icon, we are able to enjoy the beautiful shapes and exquisite linear and coloristic nuances of a remarkably elegant, subtly evocative work of art.

Andrew Wyeth: Beyond Helga

*I*T'S too bad that Andrew Wyeth let the world know about his so-called Helga pictures, for the publicity surrounding these paintings and drawings of a woman friend has diverted attention from the real issues of his art. Once again, he has become the object of controversy, and at a time when several of his critics were beginning to reconsider their original objections to his work.

Not that they or anyone else questions his talent or skill. Both were already very much in evidence during his teens. No, what his critics have

difficulty with is the creative use to which he puts his natural gifts. Has he used them properly? Is what he produces with them truly art?

A sizable number say, no, it is not. That what he paints is really first-rate illustration or, at best, a bittersweet, heavily romanticized evocation of a rural America that no longer exists. A few go even further and insist he's little more than a clever hack.

Most, however, believe he is sincere, and that if he cannot legitimately be classified as a "significant" artist, it is only because he's ignorant of modernist goals and ideals and doesn't understand what the great artists since Cézanne and Van Gogh attempted and achieved.

All of which, of course, is utter nonsense. Wyeth is perfectly aware of what's been going on in art these past hundred years. If he has chosen another path from that taken by such other Americans as Jasper Johns and Richard Diebenkorn, it is for solid creative and professional reasons, not because he is ignorant of modernist ideas or because he is naive.

Many of his critics are so caught up with the notion of "mainstream" art, with the idea that an artist, in order to be taken seriously, must paint in a manner that reflects the current art world consensus of what constitutes relevancy or significance, that they have lost the ability to look beyond a work's style to what it represents or communicates.

It seems never to occur to them that a deeply committed artist of genuine talent and substance could turn his or her back on any or all modernist or postmodernist approaches without batting an eyelash. And yet it happens all the time, whether the art establishment cares to admit it or not.

Wyeth, of course, is the outstanding American example of someone who has done just that — and who has achieved an extraordinary amount of popular success in the process.

That, above all, is Wyeth's unforgivable crime. If there is one thing the elite of the art world cannot abide, it is the realization that an artist they admire is also a particular favorite of plumbers and farmers. They find that intolerable, for it threatens their claim to be "special," to have insights and sensitivities beyond those of "ordinary" human beings.

It's ironic that art, the great humanizer, should also be the refuge of individuals whose only claim to fame is that they are "better" than others by virtue of their exquisite sensibilities and commitment to advanced ideas.

Not surprisingly, it is important to these people that art be perceived in the most precious and progressive of terms, as something so subtle and innovative that only persons of unusual refinement and imagination could possibly understand and appreciate it.

Andrew Wyeth
Night Sleeper, 1979

Given this fact, it is understandable that Wyeth, because of his no-nonsense approach to art, insistence on cultural continuity, disinterest in modernistic rhetoric and formalist theory, and extraordinary popularity, should find himself the prime target of his more "perceptive" and "forward looking" peers and contemporaries.

To them he is the great debaser, the painter who most cleverly and persistently brings art down to its lowest common denominator to make it accessible to all.

For that he cannot be forgiven — and indeed he won't be, unless a group of influential critics and curators decides he is special after all. That he is, in fact, a kind of latter-day Thomas Eakins, an artist of hitherto unsuspected depths and subtleties whose qualities (of course) go just a little beyond the comprehension of ordinary men and women.

Should that ever happen (and I suspect it will, sooner or later), he could easily end up as one of America's most highly acclaimed 20th century painters. He has the substance, consistency, and body of work — to say nothing of the art — for that to occur.

Face to Face

WE all keep mementos from our youth, and three of mine are drawings. One is a sketch of Abraham Lincoln (complete with log cabin) made when I was 9; another a copy of a Michelangelo figure I worked on for at least a week when I was 12; and the third, a charcoal self-portrait I did as a class project in Madison, Wisconsin, when I was 16.

Precious as they are to me (I still remember the excitement of solving the problem of drawing Lincoln's nose and the thrill of seeing the Michelangelo taking shape), I've paid little attention to them these past 20 or so years. They've been in a box with other items from my early days, and they'd still be there if I hadn't decided to haul them out a few days ago for a reappraisal.

I must have spent a good half-hour studying the self-portrait and remembering where I was and what I believed and expected out of life when I drew it. I was particularly intrigued by the strong, positive impression it conveyed. Could that really be me, I wondered, and could I really draw that well in those days?

I felt curiously detached from, and yet somewhat intimidated by, the teenager looking out at me. What, he seemed to be saying, have you done with your life? Were we to meet today, would I *like* you, let alone respect you? Be honest, have you lived up to my expectations, fulfilled the promise of my talent, remained true to my ideals and dreams?

Responding was not easy, for the young man in the picture was a demanding and highly idealistic individual whose closest "friends" were Rembrandt, Michelangelo, and Leonardo, and whose idea of heaven was to stay up all night drawing to the music of Wagner and Sibelius. How could I explain to this intense young perfectionist that while his perception of art may have been good, his understanding of life and human reality were not?

Or was I only making excuses? Trying to divert a potentially painful confrontation by insisting that the unforeseen complications and temptations I had encountered during my lifetime were really beyond my control? Perhaps, but I rather doubt it, for I knew my younger self would see through such a subterfuge and would hold me accountable, no matter how I rationalized my life to date.

And besides, I felt rather good about myself. True enough, I might have some difficulty explaining to my young friend why I stopped painting in my early fifties to become an art critic, and why I did a few other things along the way. But all in all, I could look him straight in the eye and tell him that while things may not have turned out quite as he had expected, I had, nevertheless, remained essentially "on course."

Had I really wanted to divert his attention, I could easily have done so by describing all that's happened in art since 1942. That would have thrown him for a loop and taken up many hours of explanation. In 1942 modernism, after all, let alone Abstract Expressionism, hadn't as yet taken over American art, and in the Midwest, especially, painters like John Steuart Curry, Thomas Hart Benton, and Grant Wood were regarded at least as highly as Picasso and Matisse.

I had met Curry and Benton and had recently received short letters from both in response to my request for advice about where to study art. Curry had recommended the University of Wisconsin and had included a landscape sketch (another of my treasured mementos). Benton, on the other hand, scribbled that "any good art school will do. After you've worked hard for ten years, write me again."

I had just discovered the early drawings and paintings of Picasso, but the joys and mysteries of Cézanne were still two years off for me. And as for such modernists as Miró, Mondrian, and Klee, it would be another four or five years before I would catch on to what they and their colleagues were up to.

I would never, I realized, be able to explain Jackson Pollock's work to my 16-year-old self. He might like it, but he would never accept it as art. And if Pollock was difficult, I dread to think of what I would encounter were I to introduce him to Conceptualism, Earth art, Body art, Minimalism, or most of the other movements that erupted and then largely disappeared over the past 40 years.

His rejection of them all would be total and complete — and generally for good, solid, traditional reasons. He would represent an excellent case and would make a special point of reminding me that not everything new is

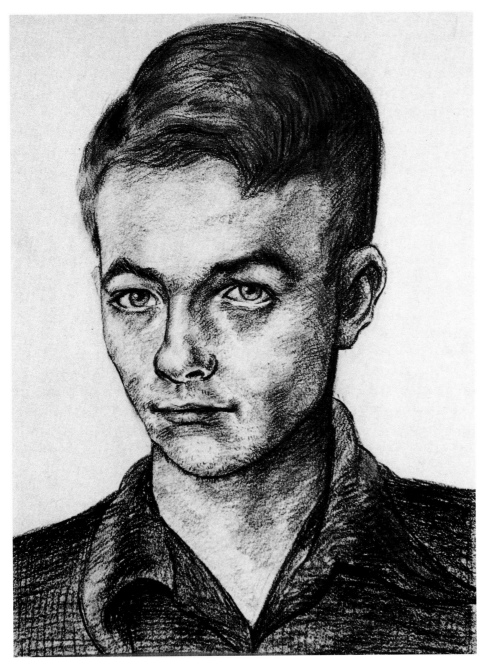

Theodore F. Wolff
Self-Portrait at 16, 1942

good, and that novelty, "originality," and innovative procedures do not necessarily produce art.

For that and several other reasons — most particularly its ability to challenge me to remain true to my ideas and dreams — I've decided to have the self-portrait framed and hung over my desk. Not only will it keep me on my toes, it will also serve as a kind of "spokesman" for those of my readers who have the same difficulties with some of the more extreme forms of modernism and post-modernism my younger self would have today.

Out in the Sun and the Wind

TODAY'S landscape painting tends to be cool, crisp, and detached, more concerned with topographical and atmospheric accuracy than with its ability to convey mood or emotion. Some younger painters may utilize landscape as an expressive vehicle, but mostly for formal or purely idiosyncratic reasons.

The expression of a passionate or deeply empathetic involvement with mountains, trees, the sky, fields — whatever — is not fashionable in art today, and those few artists who are so involved generally aren't receiving the attention they deserve.

It's acceptable, of course, to respond enthusiastically to the romantic scenic views of the Hudson River School and to the dramatic landscapes and seascapes of such historical figures as Ruisdael, Turner, Friedrich, Ryder, or Van Gogh. But anything similar in mood and closer to our own time is mildly suspect — whether it be something as celebratory as the watercolors of Charles Burchfield or as self-contained and brooding as the paintings of Andrew Wyeth.

The closest we come to accepting this kind of approach is in work that distills or transforms nature's qualities and moods into forms bearing little or no resemblance to their sources.

Some of the original Abstract Expressionists, for instance, as well as such slightly later painters as Helen Frankenthaler and Morris Louis, evoke

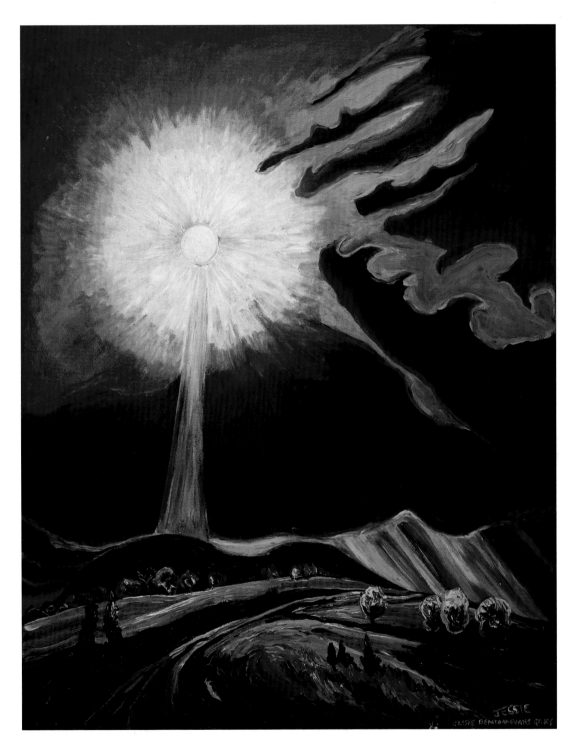

Jessie Benton-Evans
Red Sky

much the same feeling at times as we receive from the expansive 19th century landscapes of Thomas Cole and Frederick Church. The same is true of the recent canvases of Richard Diebenkorn, Robert Natkin, Tino Zago, and Louisa Chase — as well as the light-works of James Turrell.

In every case, light, spaciousness, and a radiant, occasionally even an exultant, mood help make the artist's point — as they once did for the majority of American landscape painters. Even as recently as the 1930s and early 1940s, the grandeur and sweep of the great outdoors was a commonly accepted theme, and no national or regional exhibition was complete without its dozen or so emotionally charged depictions of forests, mountains, or wide-open spaces.

All that began to change, however, as Abstract Expressionism gained momentum after World War II and then ended rather precipitously when Pop art and Photo-realism took command. Even the advent of such talented landscapists as Fairfield Porter and Neil Welliver did little to change the situation, since both took a strong stand against sentiment and emotionalism in art and made their reputations as advocates of a more calculated approach to landscape painting.

Not everyone followed their example, of course, although those who didn't generally found themselves sidelined or ignored. Things began to loosen up a bit by the mid-1970s, however, thanks largely to the art world's increasing tolerance of nonmodernist styles and procedures, and to the decision by a number of younger artists to paint only what they saw and felt regardless of dogma or theory.

Interestingly enough, only a small minority put the emphasis on what they felt rather than on what they saw, and even fewer committed themselves to striking a balance between emotion and observation. Among the latter was Jessie Benton-Evans, a painter of large, bold, highly subjective landscape images that were painted in the field and that always represented a particular place and time.

As a matter of fact, to describe her pictures as large and boldly painted is to understate the case — as anyone who has seen her working on an eight-foot-wide canvas attached to her van for support can testify. Even Van Gogh, were he painting nearby, would have been surprised at the breadth and directness of her execution and would have wandered over to take a closer look. What he saw might or might not have impressed him — but he almost certainly would have approved of her manner of working and of her passionate response to the landscape that lay before her.

And passionate it is, what with her swirling brushwork, churning

skies, sweeping, low-lying horizons, and hearty daubs of paint that become trees, hills, buildings, and forests if viewed from the proper distance. The result, depending on one's point of view, is art that is visionary, ecstatic, ominous, highly romantic — or, possibly, even a combination of all the above.

What it is *not* is dull and like everyone else's. Even someone wishing to criticize her work has to admit that it's totally hers. And why shouldn't it be? It comes from deep within her, reflects her own profoundly personal view of life and the world around her, and was brought into being only after years of dedication and hard work.

It is also somewhat unusual in that it is painted outdoors, often under difficult weather conditions, and in direct confrontation with the view that inspired it. An artist's only recourse in a situation like that is to get right to the point and be as honest and effective as possible. There is no time for rationalizing or theorizing. Nature demands that the artist pay close attention, and that he or she enter into deep and challenging dialogue with it.

But then, that's exactly what an artist like Jessie Benton-Evans wants and why she is painting out in the sun and wind in the first place.

The Sculptor as Herdsman

*S*CULPTURE doesn't just sit around filling up space. It energizes and defines it, carves it up and redistributes it, and transforms it into something dynamic and almost tangibly real.

Not every piece of sculpture, however, utilizes or affects the area around it in the same way. The differences, in fact, are striking, and range from the massive manner in which the Egyptian sphinx dominates its space to the restless, purely linear manner in which a Calder mobile continually redefines both its formal identity and the space it occupies as it moves around and around, in and out, at the instigation of a breeze or a finger's gentle push.

And then there are the exceptional three-dimensional pieces, Michelangelo's *David*, for instance, or Brancusi's *Bird in Space*, which are so holistically conceived and artfully crafted that they electrify the spaces around

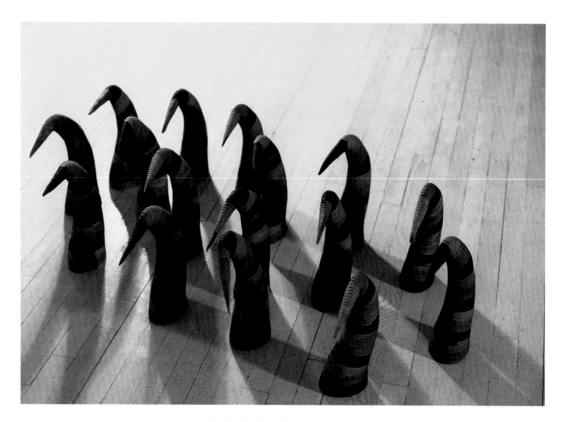

Leslie Bohnenkamp
Herd—Green and Black, 1986

them and make the works themselves more crisply alive than inanimate objects have any right to be.

The list of such interrelationships is long and impressive. They run the gamut from sculptural forms that invade space by thrusting themselves into or against it (Ernst Barlach's *The Avenger*); that lovingly enfold it (Henry Moore's 1934 *Two Forms*); or that compartmentalize it (Sol LeWitt's *Open Modular Cube*); to those that agitate it (Jean Tinguely's motorized kinetic sculptures); or charge it with psychological overtones (Alberto Giacometti's *City Square*).

Twentieth century artists, in particular, have paid an enormous amount of attention to the many subtle and dramatic ways in which sculptural objects and space can be made to interact. Major movements, from

Constructivism to Minimalism, have made that one of their primary concerns, and quite a number of sculptors have achieved fame and fortune by pushing their investigations in hitherto unexplored directions.

Richard Lippold, for instance, found a way to intermesh object and space by fashioning fragile, shimmering geometric forms out of thousands of gold and silver wires. Dan Flavin, on the other hand, created an entirely new sculptural environment with the help of colored lights and neon tubing. And Christo, as almost everyone knows, produces his highly regarded works by wrapping everything from buildings and bridges to tiny islands in one or another form of plastic fabric.

Probably the most revolutionary and open-ended method is the one best represented by James Turrell and Robert Irwin. Both utilize a carefully orchestrated interplay of light, space, and form to create highly charged visual environments that challenge the viewer's habitual way of looking at and responding to art. The hoped-for result is a heightened level of awareness, as well as a deeper understanding of the nature and implications of the creative act.

Less dramatic but no less effective is an approach that has won increasing favor over the past two decades. It calls for a number of separate but identical items to be placed together in a prescribed fashion and within a defined area. These can be stationary, such as large metal rods or carved boulders set into the earth. Or they can be mobile and consist of small, handcrafted pieces easily moved about on a floor or table. But whatever form they take, they must all be alike, occupy their space as a close-knit group, and make their point collectively rather than individually.

The result can be deeply moving, as in Magdalena Abakanowicz's *Backs*, an installation of 80 life-size, hollowed torsos — each headless, armless, and legless — made of burlap stiffened with glue. Individually, each figure is mildly interesting. Collectively, they produce a haunting, otherworldly effect, due at least partly to the fact that they appear to be deep in prayer or meditation.

The result can also be purely formal or conceptual, as is the case with Walter De Maria's *Lightning Field*, which occupies part of a valley floor 200 miles southwest of Albuquerque, New Mexico. It consists of 400 stainless steel poles, each sharpened to a needlepoint and set in the ground along a precisely measured grid exactly one mile long. Described this way, *Lightning Field* may sound dull, but it isn't, for every one of these poles is a potential lightning rod, and the electrical effects during a storm can be quite spectacular.

Increasingly, however, this method is applied to work that is colorful and lighthearted. Leslie Bohnenkamp's charming groupings consisting of small paper sculptures standing anywhere from an inch to a little more than a foot in height are good examples. They are designed to balance on the floor and to resemble living creatures, designated by the artist as "herds." A roomful of these sculptures, each group painted a different color and looking expectantly toward something unseen, might not be exactly what a traditionalist would describe as art, but from a modernist point of view, they most certainly are.

Unlike Bohnenkamp's earlier, individual pieces, which were more than six feet tall and made of fabric, these little figures are constructed of paper and are then painted with watercolor. That they are so small and fragile gives them an air of vulnerability that adds immeasurably to their charm. Few art lovers can resist them, and even art critics and curators have been known to smile at the sight of them.

Morality Plays of Jerome Witkin

*F*EW artists today are able to do what Jerome Witkin can do with paint. Even fewer are able to maintain an ongoing working dialogue with the great creative figures of the past. But then, not many have his talent, dedication, or imagination. Nor have many worked as hard or as long as he to fashion a style sufficiently dynamic and inclusive to tackle some of the most challenging and disturbing issues of our time. Also, few insist, as he does, on perceiving art in moral and ethical as well as in aesthetic terms.

Confronted by man's cruelty and indifference toward his fellow humans, or the pain and terror that often lie beneath the placid exterior of everyday existence, Witkin calls upon us to respond compassionately to the victims and to become more fully aware of what we might have in common with the aggressors.

His *Death as an Usher: Germany, 1933* (1978–81), for example, chillingly depicts individual acts of Nazi brutality and murder. His 1986 *Unseen*

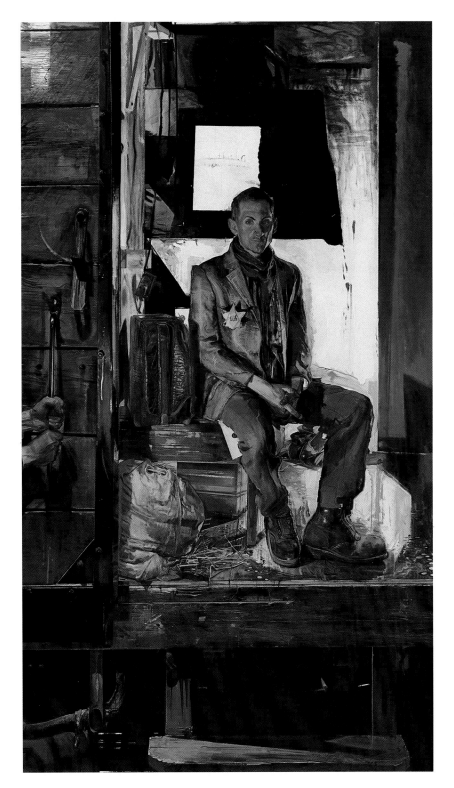

Jerome Witkin
Terminal, 1986–87

and Unheard exposes institutionalized cruelty as it has seldom been exposed before. Witkin unrelentingly insists that we assume our portion of the responsibility for what one human, class, or system inflicts upon another.

Toward that end, he has devised a highly effective pictorial method, one that utilizes cinematic and comic-strip narrative devices. The individual images are precisely realistic and are executed in a straightforward painterly manner, with considerable emphasis on draftsmanship. And finally, to achieve the exact touch of authenticity he deems essential, he builds elaborate "stage sets" for his models. The models participate in the evolution of their poses by offering suggestions and experimenting with various positions and gestures.

Witkin's painted morality plays — for that is what they are — pack a cumulative wallop far in excess of what one would expect from work executed so straightforwardly. There are no provocative distortions and very few exaggerations. Everything is shaped and communicated simply, in line with the artist's belief in "accessibility without confusion and barrier."

Terminal, a ten-foot-high, single-panel canvas painted in 1986–87, depicts a young Jew about to exit a cattle car into one of Nazi Germany's death camps. It is among the best examples of his quieter, more empathetic approach. Everything in it is precisely and unemotionally composed and rendered. In fact, the only clues we have as to what is taking place are the yellow star on the man's chest and the two hands on the right opening the large doors.

And yet, thanks to Witkin's thoughtful conception, formal tact, and sensitive concern for the most appropriate and telling detail, we not only feel we know this young man, but know his fate as well.

Witkin sometimes employs a serial format consisting of from two to five panels. The action in his paintings generally unfolds from left to right, with each panel serving to advance his theme in much the same fashion as the story line of a comic strip moves from square to square. *A Jesus for Our Time*, for example, a five-part, 38-foot narrative painting, projects the story of a young man who believes he will bring peace to the world, but who fails and ends up with the realization that he is no better and no worse than everyone. The entire story is relayed in five separate incidents that occur sequentially from Panel 1 through Panel 5.

One of the more fascinating aspects of Witkin's art is the degree to which it draws upon a shrewd and sophisticated reading of post-World War II modernist formal and technical devices for at least some of its power. Thus, some of his best works project the surface energy and restless move-

ment that characterize the paintings of the leading Abstract Expressionists. Seen from a distance, and in its entirety, *A Jesus for Our Time* could almost be mistaken for a purely expressionist picture. And *Terminal*, for all its precise representationalism, draws heavily upon the abstract imagery of Franz Kline and Robert Motherwell.

The insistence on accessibility, on being clear and direct, rather than obscure and evasive, is of crucial importance to Witkin. He writes, "My art is about meditations of life experience using, during every moment of creating it, the knowledge that someone will join in with my caring about this." And he is not afraid to add, "I believe . . . in words like tender and sharing."

Witkin's insistence on seeing art in moral and ethical terms sets him apart. Ethics and morality, after all, the art world maintains, are the responsibility of the teacher and preacher, not the artist, whose work must remain "pure" and above contamination by such matters as the distinctions between right and wrong, and good and evil.

Witkin realizes, of course, the pitfalls inherent in his approach, most particularly the danger of moralizing and propagandizing, of producing work that leaves no room for a vital, insight-inducing exchange between artist and viewer. This is a critical issue with him because of the passionate nature of much of his art, especially that aspect of it that asks us to bear witness to the dark underside of the human condition.

The urge to share and clarify motivates many of his major paintings. Not, however, in a manner that neatly explains away life's more difficult and painful experiences. Instead, Witkin challenges us to extend and deepen our encounters with, and our perception of, reality.

What Rembrandt Has to Teach Us: Dignity, Character, Compassion

*N*ONE of the old masters is more relevant today than Rembrandt — not only because of his profound humanity and emphasis on character, but also because he and his art can be understood, even at its deepest level, without specialized knowledge or training.

The latter is important in a time when obscurity and ambiguity in art are almost certain to be intentional and when painting all too frequently is perceived as a pictorial code only a few are sufficiently sophisticated to comprehend.

With Rembrandt, everything is frank, open, and accessible — even to a child of ten. Of course, a child might not like the dignified, often solemn older people half hidden in shadow that he delighted to paint. But even a child would know that these were real men and women and that the mood they project represents something special and true.

What that something is has intrigued art lovers since the late 17th century. Opinions have varied, sometimes dramatically, but most experts have agreed that the key to Rembrandt's greatness is depth, and the source of his extraordinary effectiveness lay in his ability to infuse even the most ordinary objects with dignity and character.

He may not have been the most exemplary of men (witness Gary Schwartz's recent book, *Rembrandt, His Life, His Paintings*), but as an artist he was both wise and profound — and possibly more compassionate than any painter before or since.

His achievement came about because of his enormous capacity for creative growth. One of art's all-time miracles is Rembrandt's transformation from a moderately talented and insensitive youth to one of the world's greatest artists. It's a process one can follow by watching his art unfold, by observing its progress from youthful clumsiness to mature, heartwarming depth and grandeur. It is this amazing progression that sets Rembrandt apart from everyone else and makes him so relevant today.

Depth, after all, is out of fashion in the art of the 1980s. And so, by and large, are dignity, character, and compassion. What we have, instead,

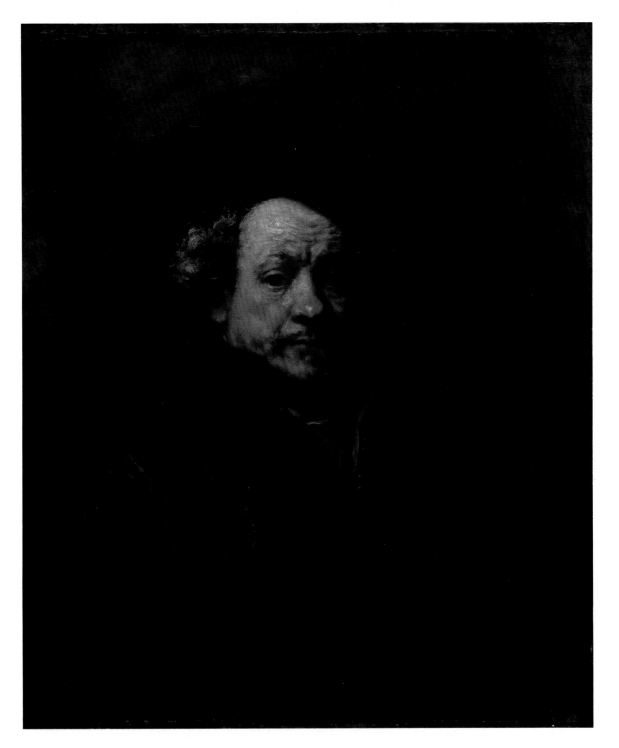

Rembrandt
Portrait of the Artist, 1660

are impressive amounts of inventiveness, wit, passion, and entertainment; a modicum of brilliance; and many more self-conscious and silly attempts at profundity and originality than anyone could have imagined even three decades ago. But why should we be surprised? Aren't we the ones, after all, who defined originality as being different and creative growth as always trying something new?

Fortunately, we do realize that Rembrandt and his peers can give us something we can't get elsewhere. And so we go to the museums in ever-greater numbers to pay homage to him and the other old masters. But we do so, all too often, in the same spirit in which we sometimes attend church — with self-congratulatory awareness that we are doing the "right thing."

Now, by itself, there's nothing very wrong with that. It can be harmful, though, if we believe that those few reverential moments in a museum entitle us to ignore the rather limited nature of our own art. Or to conclude that our respectful acknowledgment of artistic greatness in earlier centuries excuses us from insisting on it in our own.

It's true, of course, that art cannot be willed into existence, that it must take root and evolve in its own manner within an artist's consciousness. And great art, because it is a profound and often highly complex manifestation of the human spirit striving for ever-greater symbolic realization, is always something of a surprise and a miracle. As such we must accept it. We cannot dictate it or decree that it must meet certain standards or follow a set pattern, for to do so would turn it into something lifeless and predictable.

What we *can* do, however, is to provide fertile ground within which it can be conceived and grow. And support the ideals of depth and greatness with at least as much passion as we expend in our pursuit of sensation and the "new." That, in itself, won't produce artistic miracles, but it might create the climate in which they can more frequently occur. If, on the other hand, we do nothing but express satisfaction at whatever the art world throws our way, we may very well end up looking to the past for *everything* truly significant in art.

Given this situation, we would be wise to look more seriously to the old masters for standards of excellence, integrity, and commitment. (But not, let me hasten to add, for examples of style or technique.) And, if asked which of the old masters I consider most relevant today, I'd name Rembrandt, for none is more worthy or more challenging to our often limited goals and ideals than he.

Credits

Andrew Wyeth, *Ground Hog Day*. Tempera. Courtesy Philadelphia Museum of Art. Given by Henry F. DuPont and Mrs. John Wintersteen.

Jackson Pollock, *Autumn Rhythm*, 1950. Oil on canvas, 105 × 207 inches. Courtesy The Metropolitan Museum of Art, George A. Hearn Fund, 1957. Copyright 1989 Pollock-Krasner Foundation / ARS N.Y.

Andrew Wyeth, *Study for Toll Rope*. Watercolor, 20 × 14 inches. Courtesy Coe Kerr Gallery, Inc., New York.

Edvard Munch, *The Cry*, 1896. Lithograph, printed in black, on cream smooth wove. Sheet 20⅝ × 16³⁄₁₆ inches. Collection, The Museum of Modern Art, New York. Matthew T. Mellon Fund.

Georges Rouault, *L'Homme du Cirque*, 1936. Oil on canvas, 25 × 15⅛ inches. Courtesy Perls Galleries, New York. Copyright 1989 ARS N.Y. / ADAGP.

Alberto Giacometti, *Diego*, 1953. Oil on canvas, 39½ × 31¾ inches. Collection, Solomon R. Guggenheim Museum, New York. 1431. Photo: David Heald. Copyright 1989 ARS N.Y. / ADAGP.

Käthe Kollwitz, *Self-Portrait in Profile Facing Right*, 1938. 19 × 11½ inches. Courtesy Galerie St. Etienne, New York. Copyright 1989 Käthe Kollwitz / VAGA New York.

Laszlo Moholy-Nagy, *AXL II*, 1927. Oil on canvas. Collection, Solomon R. Guggenheim Museum, New York. Gift of Mr. and Mrs. Andrew Fuller. 65.1754. Photo: David Heald.

Charles Sheeler, *Interior*, 1926. Oil on canvas, 33 × 22 inches. Collection of Whitney Museum of American Art. Gift of Gertrude Vanderbilt Whitney. 31.344.

Piet Mondrian, *Composition 2*, 1922. Oil on canvas, 21⅞ × 21⅛ inches. Collection, Solomon R. Guggenheim Museum, New York. Photo: Myles Aronowitz. Copyright Piet Mondrian / VAGA New York.

Edward Hopper, *Office in a Small City*, 1953. Oil on canvas, 28 × 40 inches. Courtesy The Metropolitan Museum of Art, George A. Hearn Fund, 1953.

John Steuart Curry, *Baptism in Kansas*, 1928. Oil on canvas, 40 × 50 inches. Collection of Whitney Museum of American Art. Gift of Gertrude Vanderbilt Whitney. 31.159.

Stow Wengenroth, *The October Afternoon*, 1964. Lithograph.

Alexander Calder, *Red Lily Pads,* 1956. Painted sheet metal, rods and wire, 42 inches high × 201 × 109 inches. Collection, Solomon R. Guggenheim Museum, New York. 1737. Photo: Carmelo Guadagno and David Heald. Copyright 1989 ARS N.Y. / ADAGP.

Paul Klee, *Dance You Monster to My Soft Song!,* 1922. Watercolor and oil transfer drawing on plaster grounded gauze, mounted on gouache-painted paper. Approximate dimensions of unevenly cut gauze support: 13¾ × 11½ inches. Approximate height of gauze plus painted borders: 15¾ inches. Paper mount: 17⅝ × 12⅞ inches. Collection, Solomon R. Guggenheim Museum, New York. 38.508. Photo: Myles Aronowitz. Copyright 1989 ARS N.Y. / Cosmopress.

Andy Warhol, *Green Coca-Cola Bottles,* 1962. Oil on canvas, 82¼ × 57 inches. Collection of Whitney Museum of American Art. Purchase, with Funds from The Friends of the Whitney Museum of American Art. 68.25. Copyright 1989 The Estate and Foundation of Andy Warhol / ARS N.Y.

Theodoros Stamos, *Infinity Field—Lefkada Series,* 1980. Acrylic on canvas, 30 × 22 inches. Courtesy Camillos Kouros Gallery, New York.

Marc Chagall, *Green Violinist,* 1923–24. Oil on canvas, 78 × 42¾. Collection, Solomon R. Guggenheim Museum, New York. Gift, Solomon R. Guggenheim, 1937. 37.446. Photo: David Heald. Copyright 1989 ARS N.Y. / ADAGP.

Constantin Brancusi, *King of Kings,* early 1930s. Wood sculpture, oak, 118⅛ inches high. Collection, Solomon R. Guggenheim Museum, New York. 56.1449. Photo: Carmelo Guadagno and David Heald. Copyright 1989 ARS N.Y. / ADAGP.

Grant Wood, *Honorary Degree,* 1938. Lithograph, ed. of 250. 11 feet ⅞ inches × 6 feet ⅞ inches. Courtesy Associated American Artists, New York. Copyright 1989 Grant Wood / VAGA New York.

Joseph Cornell, *Untitled "Medici Boy",* 1953. Wood, glass, oil and paper, 18¼ × 11½ × 5½ inches. 1968.16.P.S. Collection of the Modern Art Museum of Fort Worth. Museum purchase, The Benjamin J. Tillar Memorial Trust.

Ida Kohlmeyer, *Circus Series 3—No. 1,* 1978. Mixed media. 66 × 75 inches. The Robert M. Cochran Collection. (A1342.) Photo: Ray Kutos.

David Ray, *Self-Portrait,* 1980. Oil on canvas. Courtesy of the artist.

Robert Natkin, *Epiphany,* 1989. Acrylic on canvas. Collection of the artist. Courtesy Klonaridis Gallery, Toronto.

Charles Burchfield, *Winter Light, Backyard,* 1949–60. Watercolor on paper, 40 × 26 inches. Collection of Whitney Museum of American Art. Gift of Mr. and Mrs. Solomon K. Gross. 76.34.

Norman Rockwell, *Love Ouanga,* 1936. Oil on canvas, 30 × 62 inches. Courtesy Norman Rockwell Estate. Photo courtesy Judy Goffman Fine Art, New York.

Athena Tacha, *Charles River Step—Sculpture,* 1974. Concrete, earth, pebbles, 750 foot long area. Courtesy of the artist.

Ivan Le Lorraine Albright, *The Poor Room—There is no time, no end, no today, no yesterday, no tomorrow, only the forever, and forever and forever without end,* 1941–62. Oil on canvas. 121.9 × 94 cm. gift of Ivan Albright. 1977.35. Copyright 1989 The Art Institute of Chicago. All rights reserved.

Raphael Soyer, *José De Creeft,* 1980. Oil on canvas, 40 × 30 inches. Courtesy Forum Gallery, New York.

Roy De Forest, *Canine Point of View,* 1974. Polymer paint on canvas, 60 × 73½ inches. AFG#4502. Courtesy Frumkin-Adams Gallery, New York.

Morris Graves, *Winter Still Life #1,* 1983. Tempera on paper, 26½ × 46½ inches. Courtesy Schmidt Bingham Gallery.

Jasper Johns, *Three Flags,* 1958. Encaustic on canvas, 30⅞ × 45½ × 5 inches. Collection of Whitney Museum of American Art. 50th Anniversary Gift of the Gilman Foundation, Inc., The Lauder Foundation, A. Alfred Taubman, an anonymous donor, and purchase. 80.32. Copyright 1989 Jasper Johns / VAGA New York.

Giorgio Morandi, *Still Life,* 1938. Oil on canvas, 9½ × 15⅝ inches. Collection, The Museum of Modern Art, New York. Purchase.

Chuck Close, *Phil,* 1969. Synthetic polymer on canvas, 108 × 84 inches. Collection of Whitney Museum of American Art. Gift of Mrs. Robert M. Benjamin. 69.102.

Georgia O'Keeffe, *The White Calico Flower,* 1931. Oil on canvas, 30 × 36 inches. Collection of Whitney Museum of American Art. Purchase. 32.26.

John Sloan, *Backyards, Greenwich Village,* 1914. Oil on canvas, 26 × 32 inches. Collection of Whitney Museum of American Art. Purchase. 36.153.

Peter Milton, *Daylilies,* 1975. Etching. Courtesy John Szoke Graphics, New York.

Richard Diebenkorn, *Untitled #33,* 1981. Gouache and crayon on paper, 25 × 27 inches. Collection of Marina Rubin. Courtesy of M. Knoedler & Co., Inc., New York.

James Schmidt, *Near Troutbeck*. Felt tip pen and chalk on toned paper, 22 × 28 inches. Courtesy of the artist.

Paul Cézanne, *Man With Crossed Arms,* ca. 1899. Oil on canvas, 36¼ × 28⅝ inches. Collection, Solomon R. Guggenheim Museum, New York. 1387. Photo: Carmelo Guadagno.

Mark Rothko, *Violet, Black, Orange, Yellow on White and Red,* 1949. Oil on canvas. Collection, Solomon R. Guggenheim Museum, New York. 2461. Gift, Elaine and Werner Dannheisser and The Dannheisser Foundation. Photo: David Heald. Copyright 1989 Kate Rothko Prizel and Christopher Rothko / ARS N.Y.

Mel Leiserowitz, *Orpheus,* 1975–80. Painted black steel and stainless steel, 35 feet high. Courtesy of the artist. Photo: Balthazar Korab.

Jonathan Borofsky, *Hammering Man at 2,772,489,* 1981. Aluminum, steel, composition board, paint, motor. 25 feet high. Flying Figure #2. 1981. Carved styrofoam, gauze, acrylic. 99 × 83 × 19 inches. Photo courtesy Paula Cooper Gallery, New York. Installation: Kunsthalle, Basel, June 12–Sept 13, 1981.

Anna Marie Robertson ("Grandma") Moses, *Halloween,* 1955. Oil on masonite. Copyright © 1979, Grandma Moses Properties Co., New York.

Sarah Swenson, *Lucas and Laura Congdon,* 1983. Oil on canvas, 26 × 23 inches. Collection of Mrs. Johns H. Congdon. Photo courtesy of the artist.

Enrico Donati, *The Walls of Thebes,* 1983. Ground quartz and acrylic on canvas, 50 × 50 inches. Collection of James Robison, Armonk, N.Y.

Paula Modersohn-Becker, *Child in the Cradle,* 1902/3. Charcoal and pencil on buff wove paper. Kunsthalle Bremen. Courtesy Galerie St. Etienne, New York.

Morris Graves, *Bird Singing in the Moonlight,* 1938–39. Tempera and watercolor on mulberry paper. 26¾ × 30⅛ inches. Collection, The Museum of Modern Art, New York. Purchase.

Winslow Homer, *Two Men in a Canoe,* 1895. Watercolor. Courtesy The Portland Museum of Art, Portland, Maine. Bequest of Charles Shipman Payson, 1988.

John Ahearn with Rigoberto Torres, *Luis (Out of Work),* 1982. Oil on cast plaster, 22 × 23 × 7 inches. Courtesy Brook Alexander, New York. Photo: Ivan Dalla Tana.

John Ahearn, *Homage to the People of the Bronx, Double Dutch at Kelly Street I.,* 1981-82. Cast fiberglass, oil, cable. 54 × 54 × 12 inches each figure. Courtesy Brook Alexander, New York. Photo: Ivan Dalla Tana.

Hyman Bloom, *Still Life on Butcher Block Table,* 1982–83. Oil on canvas, 56 × 40 inches. Courtesy Kennedy Galleries, Inc., New York.

Henri Matisse, *Jeune Fille au Collier,* May 1, 1950. India ink on paper. 20⅞ × 16 inches. Courtesy Perls Galleries, New York. Copyright 1989 Succession H. Matisse / ARS N.Y.

Igor Galanin, *Samovar,* 1985. Oil on canvas. Courtesy of the artist.

John Marin, *Brooklyn Bridge,* 1910. Watercolor and charcoal on paper, 18½ × 15½ inches. Courtesy The Metropolitan Museum of Art, Alfred Stieglitz Collection, 1949.

Andrew Wyeth, *Night Sleeper,* 1979. Tempera on panel. 48 × 72 inches. Private Collection. Photograph Courtesy Brandywine River Museum, Chadds Ford, PA.

Theodore F. Wolff, *Self-Portrait at 16,* 1942. Charcoal drawing.

Jessie Benton-Evans, *Red Sky.* Acrylic on canvas. Courtesy of the artist.

Leslie Bohnenkamp, *Herd—Green and Black,* 1986. Paper sculpture and watercolor. 13¾ × 4½ × 3½ inches. Courtesy Gimpel & Weitzenhoffer Ltd., New York. Photograph by Pollitzer, Strong & Meyer, New York.

Jerome Witkin, *Terminal,* 1986–87. Single panel canvas, 10 feet high. Courtesy Sherry French Gallery, New York.

Rembrandt, *Portrait of the Artist,* 1660. Courtesy The Metropolitan Museum of Art, New York.